John Ruskin

Titles in the series Critical Lives present the work of leading cultural figures of the modern period. Each book explores the life of the artist, writer, philosopher or architect in question and relates it to their major works.

In the same series

John Ruskin

Andrew Ballantyne

REAKTION BOOKS

À Cyrille Capelli et son équipe

Published by Reaktion Books Ltd
33 Great Sutton Street
London EC1V 0DX, UK
www.reaktionbooks.co.uk

First published 2015
Copyright © Andrew Ballantyne 2015

Printed and bound in Great Britain
by Bell & Bain, Glasgow

A catalogue record for this book is available from the British Library

ISBN 978 1 78023 429 8

Contents

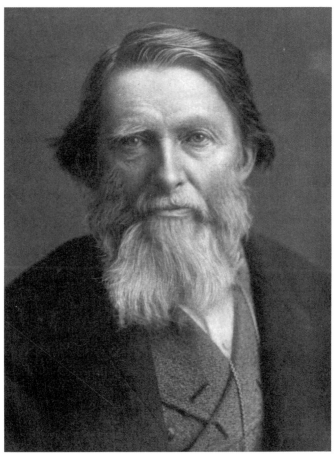

John Ruskin, *c.* 1879, at the age of 60, frontispiece to Ada Earland, *Ruskin and his Circle* (1910).

Introduction

I remember as a teenager going round an exhibition of water-colours in Kendal with an aged great-aunt, who in the family was known as Tante. She was not well educated – her father had not believed in educating girls – but she had a well-developed sense of her own gentility. At the time of my visit she had cataracts and did not see particularly clearly. We came to a study of rocks and trees by John Ruskin: roots of trees fused with rocks, intensely detailed but not composed into a conventional image.

'I don't like this modern stuff', said Tante.

'That's not modern,' I said, 'it's by Ruskin.'

'Oh well,' she said with a sigh, 'it must be marvellous.'

She said it without a trace of irony: she knew Ruskin's reputation, and she knew that the image in the frame must be good if he had done it, but she could not see the goodness and the cataracts served to cloud the issue of whether it was her eyes or her critical faculties that were letting her down.

Ruskin's reputation in Kendal was then, and I think remains, that of a faded celebrity. He had lived at Brantwood, about 30 miles away, by a winding road that has to go round the largest lake in England – half that distance for a bird. In the other direction, at Kirkby Lonsdale, there is a plaque to commemorate the fact that Ruskin once admired the view there. By Derwentwater, near Keswick, there is a monument on the spot where Ruskin said he

could first remember seeing the world. Locally he has a reputation for being famous that outweighs actual contact with his works. His writings are still with us, but they are little read. The big ideas are diffused across his writings, often appearing as lengthy 'asides', digressing from the topic that is announced in the title, such as the lengthy geological treatment of the Matterhorn in *Modern Painters*. His rhetoric can have tumultuous power. He could call on all the agencies of Heaven to make the Earth tremble and to persuade you to change your mind.

There is much careful quiet thought besides, and the moments of grandstanding are less admired now than when Ruskin wrote them. The writings made Ruskin's one of the key voices in nineteenth-century culture. He made pronouncements on art and architecture, and their roles in a worthwhile life – and people listened. They went to his lectures, bought his books, read his letters to the newspapers. Ruskin's life was unusual and privileged, but his thoughts reached a mainstream audience. The eccentricity of his personal life has attracted film-makers, and he has done duty as a conspicuous example of the Victorian prude. His life was in the nineteenth century, and his behaviour unfolded in the bourgeois circles of that time. He did not always manage to conform with all the proprieties, but he absolutely belonged to his own time and culture – as we all do. The really remarkable thing about Ruskin's thoughts and deeds are how often they escaped his own rarefied circumstances to speak to others outside his class and time. He was a profound moralist and very religious in his outlook; he tried to do the right thing for humanity rather for himself; he inherited a great fortune, and one way or another gave most of it away. He tried to bring wonder and an appreciation of beauty to the lives of the working classes in the new industrial towns. He decried mechanization and railways, and loved crafts-manship. He praised art that had good moral character, taking for granted that artists would strive for a flawless technique.

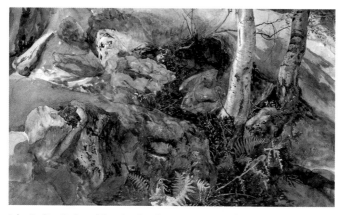

John Ruskin, *Rocks and Ferns in a Wood at Crossmount, Perthshire*, 1847, ink and watercolour.

The progressive thinkers of the early twentieth century had little time for him, and saw the spirit of their age embodied in the machine – the steam engine, the *machine à habiter*, the automobile. Especially between the World Wars, Victorian painting and architecture came to be seen as embarrassing, and Ruskin along with them. A revaluation began in the 1960s, when people started to campaign for the preservation of Victorian buildings and to bid for Pre-Raphaelite paintings when they came up for sale. Perhaps these works no longer showed the way ahead, but now they could be seen as having historical value. The modern age would produce nothing like them. Now the ideas again connect, but with a world that has changed. Links between art and life are reaffirmed, and an ethical sense has a role to play in our dealings with other people and our planet. There are times when Ruskin can sound unappealingly self-righteous and sanctimonious, others when he seems to be cranky or petulant, but at his best he addresses fundamental issues about the world and our relationship with it, and with one another. In his responses to nature, geology, monuments and machinery he

comes down against exploitative relations in favour of marvelling at beauty and goodness. When humane responses seemed to be decoupled from the machinery of progress and wealth accumulation, Ruskin asserted the importance of re-establishing connections. The forces at work through globalization and the idea that prosperity means the acquisition of consumer goods have intensified since Ruskin's day, and his fundamental lessons still have importance, even though his language and terms of reference sometimes sound quaint. His conviction that a properly human life must be sustained by a sense of beauty and wonder should be more widely shared. Given a little time for contemplation, it can be nurtured by whatever comes to hand, but especially by the close scrutiny of natural objects – even things that at first seem as unpromisingly inert as rocks. Not only are they in themselves evidence of the formation of the world, but somehow they sustain life, as root fibres spread their delicate filigree through invisible fissures, searching out the elemental nutrients that sustain the growth above, precariously placed, but securely held over the abyss.

1
A Start in Life

On 8 February 1819, when John Ruskin was born in London, George IV was on the throne. Alexandrina Victoria, who would go on to become Queen Victoria, would be born in May of that year. Karl Marx had not yet had his first birthday and Sigmund Freud, far from being conceived, would not take on his first psychoanalytic patient until over 60 years later. Ruskin's writings engaged with intellectual and political ideas, but his terms of reference were profoundly different from ours. He founded the Guild of St George, which sounds like a fanciful order of chivalry, but it did and continues to do practical good work. In Europe we live with the relics of industrial capitalism, which was in full vigour in Ruskin's day, generating a new world. Its contours were not yet clear, but Ruskin knew that he did not want to belong to it. In retrospect Ruskin's personal and family life cries out for a psychoanalytic understanding that was not available to him, and the whole of his emotional development seems to be clouded in a naivety that would be impossible today for someone with Ruskin's level of education and sophistication. But still sometimes people show astonishingly low levels of self-awareness, so perhaps the world has moved on less decisively than one might think. There are plenty of examples in the news media, and some closer to home.

Ruskin is one of the key figures for understanding nineteenth-century British culture, because he was read so reverently and so widely. He had something like the role of the nation's conscience,

reminding the people who wanted such a thing as a conscience what they should be striving to do. They could hold these ideals in mind even if their daily grind for a living produced the conditions against which Ruskin railed. His sermon-like speeches reached a wide and appreciative audience, but other, more powerful forces were at work. He decried the dismal mechanisms that dehumanized the working life, pumped smoke into the atmosphere and ran railway lines across the countryside, and he tried to remind people that beauty and truth should be part of everyone's daily life. He did what he could to salvage what could be rescued of the joy and freedom that he found in medieval craftsmanship, in clear air and mountain scenery, and in the high-minded mercantile culture of medieval Venice.

Ruskin's childhood is important to understanding him, and not just in the way that every childhood is important ('The child is father of the man', as Wordsworth put it.[1]) By any standard Ruskin's childhood was an unusual one, and he never really outgrew it. His parents always remained the most important people in his life. When Ruskin's father died in 1864 the son (aged 45) wrote the following epigraph for the funerary monument:

Here rests from day's well-sustained burden,
JOHN JAMES RUSKIN,
he was an entirely honest merchant
and his memory is, to all who keep it, dear and helpful.
His son, whom he loved to the uttermost
and taught to speak truth, says this of him.[2]

It is touching and heartfelt, and distils into a few well-weighted words a surprising number of Ruskinian themes: honesty and truth, hard work, memory and love. His mother joined her husband in the grave seven years later, at the age of 90, and an inscription was added witnessing her dearness and purity. These

were the people whose influence shaped Ruskin's character and who remained his principal companions into middle age. What kind of people were they? They are remembered now only as the parents of John Ruskin, but they were both strong and distinct characters who were devoted to their only son and encouraged his ambition and sense of destiny.

They were cousins before they married and had only seven grandparents between them. Margaret Ruskin, our John Ruskin's grandmother, married a publican, Thomas Cock, in Croydon and in the 1780s gave birth to two daughters, Margaret and Bridget. Thomas died at 33 from an infection in his leg after it was crushed against a wall while he was riding a horse, and Margaret Cock continued to run the pub. The older daughter, Margaret, was good at school work and while at school took an interest in evangelical Christianity. At about the age of twenty she was sent to live with an aunt and uncle in Edinburgh. At that point, in 1801, she polished her name to 'Margaret Cox'.[3] Meanwhile her sister Bridget stayed in Croydon and married a baker, at which point her name changed to Richardson.[4]

The uncle in Edinburgh was the older Margaret Cock's brother, John Thomas Ruskin. He had grown up in London but started a grocery business in Edinburgh and married Catherine Tweddale, the daughter of a minister of the Church. On her mother's side Catherine had relatives with social graces and education, but she aspired to a level of social pretension that neither her father's stipend nor her husband's business could properly sustain. The household moved from Edinburgh to Perth to cut costs. It was perhaps Margaret Cox's piety that made her seem suitable as a companion for her Aunt Catherine, and the two were to grow very close. Margaret arrived at the house, Bowerswell, when John James Ruskin was sixteen. By 1809 they had decided to marry one another, but his father John Thomas Ruskin forbade it. He was in debt, his business foundering, and perhaps he had hoped that his son might

marry into enough money to solve the family's problems. He had himself married a woman of higher social rank, who did inherit some money, while his sister (and indeed his wife) had married beneath her. Margaret was four years older than John James, so her age and the level of consanguinity would have counted against her, but if John Thomas projected his own social ambition and practical needs on to his son, he would have seen that John James could do much better than marrying this humble niece. John Thomas had mental health problems and was increasingly difficult to live with. His wife and niece looked after him until his wife died, and whatever it was he had been hoping for from life, he gave up on in 1817 when, at home, he committed suicide.[5]

The son, John James Ruskin, had taken it upon himself to save the family's reputation. While he was at Edinburgh High School he was aiming to become a lawyer, but presumably because the family was short of money he gave up on that idea and went into business in London. His long-term prospects as a lawyer would have been good, but the long period of study would have deferred his ability to make money, for which there was a pressing need. He left for London in about 1802, when his father's business seemed to the outside world to be in reasonable shape, but it folded in 1808.[6] As John Thomas became less able to deal with the world John James, still based in London, took over as the family's breadwinner. The main obstacle to his marriage shifted. He might have overcome or defied his father's objections, but personally he felt driven to pay off the family's debts before marrying. That was not quite how it worked out, but in London he lived modestly and made a series of astute business moves that, coupled with his absolute probity and capacity for hard work, brought him to be running his own business as an importer of sherry and wines from 1814: Ruskin, Telford and Domecq. Henry Telford put up the capital, but beyond that had little involvement with the business. Pedro Domecq, the Spanish partner, lived in Paris and supplied the wines and sherry,

which Ruskin then sold by travelling around 'every town in England, most in Scotland, and some in Ireland'.[7] The wine was good, it sold well, and in time handsomely repaid the efforts.

In 1917, while Margaret Cox was in Perth, her mother died in Croydon. She went down for the funeral and while she was away her aunt in Perth died. Within a few days of her return her uncle committed suicide. She leaned on her religion to help her through the trauma and loneliness. It made no sense to stay alone at Bowerswell when for eight or nine years she and John Thomas had wanted to marry, and now no one raised any objections. They married at Bowerswell in 1818, on the evening of 2 February, so discreetly that even the servants in the house did not know about it.[8] They moved to London and their son, John Ruskin, was born the following year, when his mother was 37 and his father 33.

If this were their story, we would have reached the point for the most obvious ending. After their various ordeals and obstacles they married and lived happily ever after. From a certain point of view this is almost true. They remained devoted to each other and to their son and only child. Their prosperity increased. John Thomas Ruskin's debts were paid off, and the future was secure; but their experiences had shaped their characters, and made them unbending in their adherence to their principles. If John James Ruskin seems like an industrious Dickensian businessman, perhaps that is only to be expected. The father and son avidly read Dickens's novels, but Ruskin the son said:

> Dickens taught us nothing with which we were not familiar,
> – only painted it perfectly for us. We knew quite as much
> about coachmen and hostlers as he did; and rather more
> about Yorkshire.[9]

That was the Ruskins' world by the time the boy was in it; but if we look back to the family home in which the parents met, it seems

rather to belong to the world of the Brontës, with the romantic longing, insanity and suicide. John James was a family member, and financially supported the household when it moved to Perth, but he knew Bowerswell only as a visitor. Margaret was living there when things were at their worst, and had to deal with it daily. She came to London with a sense of her own social inferiority to her husband, a determination to strive to improve herself so as not to let him down, and an unusually passionate attachment to a version of rectitude and Christian virtue. She was never one to put company at its ease, and her reticence – which was really the result of social timidity – must often have been interpreted as stern and judgemental. She was conscious that her lack of education had left her ill-equipped to join in with some conversations, and did not enjoy the experience of finding herself wanting in that way, so her regular visits were to people whom she regarded as her social inferiors. Some of them at least must have noticed her attitude of condescension.[10]

John James had a comparable inflexibility in his ideas about prudent business. He had seen his father's business ruined, and his first employer in London seemed to be set on a similar course. He was never relaxed in his attitude to speculation, and his business prospered. It would be a serious mistake, though, to think that he was interested in no more than money grubbing, even though that had to be his priority for a while. His interest in paintings had been awakened while he was still at school, but it was fostered in the course of his travels. Some of his customers lived in grand country houses, which were in those days the main repository of fine paintings. When John Ruskin was born there was just one public art gallery in England: Dulwich College Picture Gallery, which had opened only recently (the building was designed by Sir John Soane in 1817). It was a twenty-minute walk away from the house at 28 Herne Hill that the Ruskin family moved into when John was four years old.

The National Gallery's endowments began a few years later, and from the 1820s a limited number of pictures given by John Julius Angerstein and Sir George Beaumont were on view at Angerstein's house in Pall Mall. The National Gallery did not open its doors in Trafalgar Square until 1838, when Ruskin was nineteen. By the time he died, every significant British city had its own public art collection. At first sight this seems to mark a sea change in attitudes to art as it moved from the private sphere into the public arena, from being a personal treasure to something that was good for society as a whole. There was some such change, and John Ruskin's writings did much to encourage it, but there was a corresponding change in attitudes to the home.

In London new paintings could be seen at the Royal Academy and the British Institution, but at the beginning of the nineteenth century the Old Masters were hanging in drawing rooms, salons, on grand stairs and in hallways, and sometimes in libraries and galleries. They were in private homes – the palatial town houses of the aristocracy, such as Devonshire House in Piccadilly, and Norfolk House in St James's Square (belonging respectively to the Duke of Devonshire and the Duke of Norfolk). However, the homes were less private then than they would be now – had they survived as dwellings. Only a few of the buildings survive, and they have changed their uses. For example, Hertford House in Manchester Square was once a town house, but it is now a museum and gallery housing the Wallace Collection. Such a house was never solely the domain of a private individual, but would have been the London headquarters of the estate that would be needed to support such a building. The Duke of Devonshire might have lived at Devonshire House when Parliament was in session, but his principal seat was at Chatsworth in Derbyshire, while the Duke of Norfolk was based at Arundel Castle in West Sussex. The household staff would keep the places secure and in good order, even when no members of the noble family were in residence. The works of art, antiquities and

curiosities that were in such houses (in town or country) could be seen by respectably dressed members of the public, if they had the interest, leisure and social self-confidence to ask to view them. The places were listed in guide books, and were easily accessible.[11] In *Pride and Prejudice,* published in 1813, there is a scene where the housekeeper at Pemberley shows Elizabeth Bennet, her aunt and uncle round the house in the owner's absence.[12] It is a work of fiction, but the behaviour was normal: the landscapes around the house are appreciated on the approach and, once indoors, from the windows; the furnishings are admired, the pictures that are of interest to the heroine being the family portraits.

The art collections that are now in provincial British galleries were endowed by nineteenth-century industrialists who did not feel obliged to allow people into their private realms. The bounds between public and private space were redrawn and shifted, and would continue to shift. The National Gallery has made acquisitions, with the state sometimes accepting art treasures in settlement for tax; but in Ruskin's day the *Wilton Diptych* was at Wilton House in Wiltshire, and the *Rokeby Venus* was at Rokeby Park in County Durham. John James Ruskin visited such houses on his travels as a salesman, and looked round them when he did so. His enthusiasm for artworks was an important part of his son's education, and would not have been included in a standard school curriculum.

It is a great privilege to have the attention of two devoted parents with no brothers or sisters to compete for it, and young John lapped it up. He was a very happy child, but did not have much regular contact with other children. In the summer the family took regular holidays in Perth, where he played with cousins from his father's side of the family. John became rather attached to his cousin Jessie, but she died when she was eight and disappeared from his life.[13] At some point John contracted tuberculosis, maybe as a child, and its symptoms would continue to recur. There were always worries about his health, and they

were at least sometimes well founded. On his mother's side there were cousins in Croydon, the baker's children, who were much more accessible. Margaret Ruskin enjoyed visiting her sister, and John entered into the cousins' games in high spirits, but John James did not think these cousins suitable company for his son, fearing that – ever quick on the uptake – John might pick up manners or patterns of speech that would be an obstacle to his later social advancement.[14] Why take the risk? And infections could pass from child to child. There would be reasons on both sides to keep John protected and quarantined, with plenty of fresh air.

The result of the caution was a degree of social isolation. The Ruskins at this stage did not regularly entertain. John James went into Cornhill in the City of London each weekday, and returned in time for the main meal of the day at four-thirty.[15] There was a very strong sense of the family unit that excluded the rest of the world, and they seem to have been delighted with one another's company. 'My father', said John Ruskin, 'had the exceedingly bad habit of yielding to my mother in large things and making his own way in little ones.'[16] He acquiesced in the idea that the child should be destined for the Church, rather than the sherry trade, and John's education was framed with that end in mind.

He was educated at home, first by his mother and later by tutors, then as a teenager he attended but did not go away to school. The education began – at least so far as Ruskin remembered it – with the Bible, memorizing passages from it and repeating them back to his mother.[17] He also spent time with her in the garden, and that is where he started to show curiosity about natural things. In retrospect, looking back on his childhood from old age, Ruskin could see that this education had great virtues and some drawbacks. It was a protected environment: he never heard people raising their voices in anger or felt any kind of anxiety. He had learnt, he said,

the perfect understanding of the natures of Obedience and Faith. I obeyed word, or lifted finger, of father or mother, simply as a ship her helm; not only without idea of resistance, but receiving the direction as a part of my own life and force, and helpful law, as necessary to me in every moral action as the law of gravity in leaping.[18]

Where do children learn mischief? Probably from other children when they are remote from parental supervision. Ruskin never learned it, and the bond with his parents remained close. Ruskin mentions that in childhood in these serene circumstances he developed a habit of fixed attention, which he called 'the main practical faculty of my life'.[19] He was also pleased that he had developed 'an extreme perfection in palate and all other bodily senses', because his diet was carefully restricted (no cakes or sweets).[20] The 'calamities' of his childhood he lists as follows: (1) He had nothing to love, so when affection came it overwhelmed him: he did not know how to manage it. He loved his parents, of course, but saw them as forces of nature, 'no more loved than the sun and moon'; (2) He had nothing to endure, so 'my strength was never exercised, my patience was never tried, and my courage never fortified'; (3) He was never taught good manners, and later in life felt that he lacked any social skills, which made him shy; (4) Because he was never allowed to be free from supervision, he never learned as a child to judge between right and wrong. He was allowed in his thoughts to be 'too independent', but in his actions he was constrained, so did not until much later learn about 'the barebacked horse of [his] own will'. He found that when he had to take responsibility for his own life in the world he was 'unable for some time to do more than drift with its vortices'. Therein lies the higher power of mischief in a child's life, and its absence was the 'chief of evils'.[21]

Ruskin made this analysis of his upbringing long after the event, in his incomplete autobiography *Praeterita*. The title means

'of past things' and it was written when he was in his late sixties. It gives a good sense of Ruskin's personality, but it is his own sense of himself. Elsewhere a few notes survive from his childhood which tell a different story – or at least give a very different perspective, that of the child – on the same story. This note was written by his mother soon after her son's fourth birthday. He could not at that stage write, but she noted down what he said he wanted to say:

My Dear Papa

I love you – I have got new things Waterloo Bridge – Aunt brought me it – John and Aunt helped to put it up but the pillars they did not put right upside down instead of a book bring me a whip coloured red and black which my fingers used to stick to and which I pulled off and pulled down – tomorrow is sabbath tuesday I go to Croydon on monday I go to Chelsea papa loves me as well as Mamma does and Mamma loves me as well as papa does –[22]

The regrets about the childhood education are not complaints about how it felt at the time, but an adult's reflections on his upbringing, which was over-protective and calculated to nurture his genius, but which left him unprepared for social life and ordinary happiness. In most ways, of course, it suited his development extremely well, and he became one of the most eminent writers of his age, but he was not at his ease in company making pleasant conversation, nor was he quite comfortable when he was alone and lacked the guidance to make up his own mind. These were not complaints that he made in print during his parents' lifetime. In their company he was complete and at home with himself.

The parents were in no doubt that their son was a genius, and that he needed special handling. 'He is surely the most intellectual creature of his age that ever appeared in any age', said John James

in 1827, when the boy was eight.[23] There was a daily routine of reading aloud three chapters of the Bible, John and his mother reading alternate verses. When they reached the end of the last book they would go back to the beginning and start again.[24] From the late 1820s Margaret was supplemented as a teacher by their local preacher, the Revd Dr Edward Andrews. From 1831 to 1834 a Mr Rowbotham came to teach the young Ruskin English and mathematics, and from 1832 he went to Charles Runciman, who taught him drawing and watercolour. He had Adam Smith's *Theory of Moral Sentiments* read to him by his mother when he was twelve. We do not know what he made of it. She thought he seemed to understand and like it, but she took care that she dispensed it in small doses.[25]

Although Ruskin said that he was completely obedient to his parents, it is equally clear that he had a will of his own and that they indulged it when they thought it would be good for him, as in matters of intellectual curiosity. In addition to set texts, Ruskin learned a great deal by devising his own projects, which he pursued in an independent way, absorbed in the evenings in his 'works' at a table in the drawing room, while his parents sat reading novels aloud to one another.[26] He began more works than he finished, and felt pressed for time. There was always writing on the go; he tried his hand at building an orrery in order to learn about the movements of the planets; and he started to compile a dictionary of mineralogy – the primary source for which seems to have been Robert Jameson's *System of Mineralogy*.[27] John was very well capable of bending his parents' will to his own. It was he who wanted at the age of ten or eleven to visit caves in order to see minerals, not they, but they took him wherever he wanted to go, he said, despite the fact that 'my mother could not bear dirty places, and my father had a nervous feeling that the ladders would break'.[28]

While John the prodigy was the focus of this attention, it is worth noticing that his education also turned Margaret into a

highly learned woman. Every junior lecturer knows that the most effective way to learn a subject is to teach it. She lacked grounding in Latin and mathematics, so tutors were brought in for that, but she was teaching John Hebrew and in the course of giving him intellectual stimulation over the years she certainly read many more books than most students who graduate with a degree, even though she continued to lack the intellectual self-confidence that a graduate would have had. Indeed, her achievements are in some ways even more remarkable than her son's. He was always brought up to think of himself as remarkable, and it seemed natural to him as well as to others that he would be the centre of attention. If Margaret had played the role that others had in mind for her, she would have had a destiny similar to her sister's, and might have lived just as contentedly with closer family ties in a warm atmosphere of baking bread.

Some of the things that happened to her could not have been planned, but clearly had she been a less remarkable person she would not have exercised the influence that she did. A publican's daughter, she oversaw the education of one of the most prominent figures of the age, and remained one of his closest interlocutors until she died at the age of 90. At key moments hers seems to have been the family's decisive voice, and certainly she reminded the family of its duties. There are thousands of Ruskin family letters, which give an indication of how closely they must have communicated when they were at home together and how they felt the compulsion to continue that communication when any one of them was away. This family was a very close unit. Margaret's trajectory was extraordinary, and she could not have managed it without native intelligence and quick wits. Surely those qualities, along with good character, were what she and John James saw in one another when they made up their minds that they had a future together. Margaret's great projects were of self-invention, self-improvement and self-reinvention alongside the shaping of

her son. He did not become the bishop that she designed him to be, but then he did have a mind of his own that was not wholly under her control; or his.

The father's influence was equally important, but had a different character. He was capable in running his company of keeping exact accounts and making firm-minded strategic decisions, so there was no lack of rigour and method in his working days when he went into his office; but he was also a salesman, selling Domecq's sherry, which was a luxurious and sensuous product. It was not a basic necessity for life, but a pleasure that would appeal to the sophisticated and the well-to-do. Each summer John James would borrow the carriage of his partner, Henry Telford, for two months and travel round Britain, spending some time with his Scottish relatives, but also stopping at towns and calling in on grand country houses to drum up orders for sherry. The travels worked

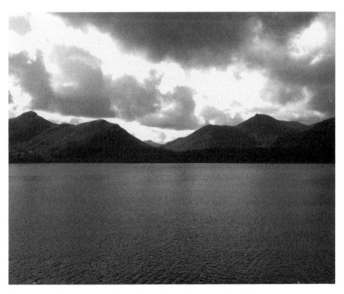

View across Derwentwater from Friar's Crag, the site of Ruskin's avowed 'first memory of life'.

well so far as the business was concerned, and from 1822 the whole family came along for the ride. John first visited the Lake District at the age of three, and he counted Friar's Crag on Derwentwater his 'first memory of life'.[29] He wrote *Praeterita* (and much besides) at Brantwood, his house in that area, by Coniston Water, where he went to settle after his parents' deaths. Reminiscing about his childhood travels, he is again rueful about the lack of independence in his upbringing. He remembered going up Mount Snowdon in Wales as

> the most exciting event, the finding for the first time in my life a real 'mineral' for myself, a piece of copper pyrites! . . .

> And if only then my father and mother had seen the real strengths and weaknesses of their little John; – if they had given me but a shaggy scrap of a Welsh pony, and left me in charge of a good Welsh guide, and of his wife, if I needed any coddling, they would have made a man of me there and then, and after-wards the comfort of their own hearts, and probably the first geologist of my time in Europe.

> If only![30]

He never did learn to ride. There were some carefully super-vised lessons, repeated disappointments with his performance on the horse, and the business was given up as a bad job. The caution was underpinned by Margaret's father having died following a riding accident, but John wryly remarks that his parents drew the conclusion that 'my not being able to learn to ride was the sign of a singular genius'.[31] So again in old age he could look back and regretfully see that as a child he was not given the chance to develop independence.

What he did get from these travels was a very thorough grounding in the Picturesque. John and his mother seem to

have stayed in some scenic spot or other while John James went off to make sales in the towns that lay around. John James had been tutored while at school by Alexander Nasmyth (1758–1840), the pre-eminent Scottish landscape painter. A watercolour that John James did under his tuition hung above his dressing table at Herne Hill – not a prominent place in the house, but the place where he shaved, often in the company of his son, who liked watching. The picture later hung in the son's own bedroom at Brantwood (as he notes when reminiscing about the way his father would make up stories about it – it depicted Conway Castle, with a fisherman, a boat and a cottage).[32]

Ruskin grew up with the conventions of the Picturesque in the culture around him from infancy, habituated in the appreciation of mountain scenery and depictions of peasant life. He was brought up to see at least the scenic parts of the world through those conventions, and that was mainly his father's doing. Back in the eighteenth century there had been times when the Picturesque looked experimental or radical, but by the time Ruskin was taking up its practices it was naturalized as a cultivated but usually middlebrow taste. William Gilpin's Picturesque tours of the 1760s and '70s were (at some remove) the inspiration for the Ruskin family's visits to Wales and the Lake District. They were appreciative without being pioneers, but they were there before the mass tourism that the railways would bring.[33] There had been a 'Picturesque controversy' in the early years of the nineteenth century, when Richard Payne Knight and Sir Uvedale Price fell out with one another very publicly over what seemed to be their different convictions about aesthetic theory. Knight was propagating the Associationist ideas that had been expounded from Edinburgh by the Revd Archibald Alison. Price argued along different lines, but the major nineteenth-century edition of his work, edited by Thomas Dick Lauder, glossed Price's text with footnotes that made it seem as if Price had been an Associationist all along.[34] Associationist theory proposes that the

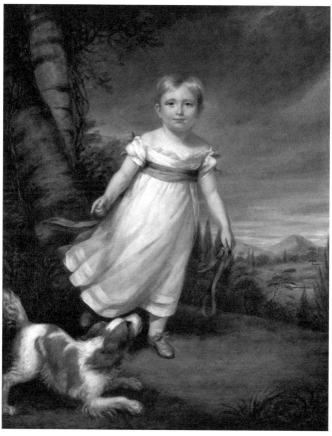

James Northcote, *John Ruskin*, 1822, oil on linen; Ruskin at the age of three.

reason we find ourselves having aesthetic responses to things –
whether natural scenery or artworks – importantly involves the
associations of ideas in our minds. So, for example, even the beauty
of a colour might have associational overtones: a particular shade
of green might be beautiful in a leaf, but ugly and disturbing if it
were the colour of someone's face. In one case the colour is to be
expected and is a sign of the natural vitality and good health of

the leaf; in the other case something would have gone wrong in the body that would be manifesting itself in this way on the surface. There might be some intrinsic beauty in the hue, but it would be negligible compared with the reactions to the hue that came from the association of ideas in the mind. Ruskin made occasional specific reference to Alison's essays, but more often made use of the main ideas of Associationism in a way that makes it clear that he did not feel that they had to be justified. They were already an established part of his world before he noticed it. His first published work is completely Picturesque in its outlook and ways of assessing the merits of different styles of buildings in their landscapes; but even in old age, when he had revised many of his views, Associationism is still there, for example when he remembered his early exposure to the Lake District scenery and said that 'it needed no charm of association to deepen the appeal of its realities'.[35] So Ruskin was not being a hard-line Associationist, who might want to claim that 'intrinsic' qualities of things were negligible, but saw associations of ideas as admirable adjuncts to an object, such as the piece of iron oxide that he found as a child (no. 51 of the Brantwood collection) which had 'bright Bristol diamonds . . . bright with many an association besides'.[36] Similarly the little picture of Conway Castle had a place in John James's closet not because he took it to be a fine work of art (in which case it would have deserved a more prominent place) but because he had painted it himself, at a time in his life when he might have hoped his talent would develop much further. And in John's bedroom at Brantwood it had a similarly private place, and was there as a memento to his father and his own early childhood. There are associational reasons for wanting to keep the painting close, quite independent of any merit it might have had as an artwork.

J.M.W. Turner (1775–1851) played an important role in Ruskin's development, as will become apparent, and he made frequent use of poetic allusion in his paintings, often including lines of verse

(sometimes of his own composition) in exhibition catalogues. These words were intended to prompt particular associations of ideas in the minds of his viewers. In the days before photography the most straightforward way to make a living for a painter who could catch a likeness was by painting portraits. There was also a good market for topographical paintings that caught the likeness of a particular place, and Turner made his youthful reputation with brilliantly executed topographical images. However, the high-status images were 'history paintings', which showed dramatic compositions peopled by ideal or historic characters, often biblical or mythological, at decisive moments in their narratives. They would demonstrate acts of courage or moral probity, and set a good example for the viewer. In history paintings the wisdom or virtue on display would be seen as part of the morally uplifting aesthetic experience because of the associations of ideas that could be made with the depicted scene. Ruskin credited Turner with lifting landscape painting to the level of the greatest history painting.

Samuel Prout (1783–1852) was a meticulous and accurate watercolourist, who painted images of historic buildings – not unlike early Turner. The Ruskins knew Turner's work as that of a great painter, and though they did not put Prout's work in the same league, they nevertheless had a special affection for it. Turner's work was sometimes in the grand manner, for aristocratic patrons, but Prout's never was. It was, as Ruskin said, suited to middle-class tastes. 'The great people always bought Canaletto, not Prout.'[37] They would be lost on the walls of state rooms, but 'gave an unquestionable tone of liberal-mindedness to a suburban villa'.[38] Ruskin's starting point as a critic is not in the aristocratic tradition of grand paintings, but in the drawing room at Herne Hill. Without embarrassment he was a bourgeois not an aristocratic writer. Ruskin's enthusiasm for Turner takes no modern reader by surprise, now that Turner is deservedly recognized as the greatest

British painter, and the annual Turner Prize keeps his name in the newspapers. Prout's name is now known only to specialists, but in the Ruskins' little world Prout was a great figure – and one who came to dinner, as did Turner. On the other hand Ruskin thought that Canaletto was overrated, that his mannerisms might lead others astray because he was generally admired, so he felt it was his duty to denounce him. Thus by the time Ruskin published his views in 1843 his attitude is a promotion of the quiet domestic virtues of the nineteenth-century middle classes, against the impostures of aristocratic swagger, and that attitude is certainly something he learned as a teenager at Herne Hill.

Ruskin mentions 'the little water-colour by Prout of a wayside cottage, which was the foundation of our future water-colour collection, being then our only possession of that kind'.[39] There was also a gift from his Aunt Bridget, a copy of a small-format literary annual designed as a New Year gift book, so it would have reached him as a precocious eight-year-old. Its illustrations included two Prouts: one of St Mark's, Venice, the other a 'Sepulchral Monument at Verona', which evidently made a strong impression on him, as he later said of it:

> Strange, that the true first impulse to the most refined instincts of my mind should have been given by my totally uneducated, but entirely good and right-minded, mother's sister.[40]

In Ruskin's personal story it is Prout more than anyone who shows him the way to his destiny, striking a chord with him even as a child and leading him on to consider greater things. The family's great Prout moment was in 1833, when Ruskin was fourteen. John James Ruskin had subscribed ahead of publication to Prout's *Sketches in Flanders and Germany*. It was just before their usual touring holiday when Ruskin went with his father to collect the book. When they brought it home:

as my mother watched my father's pleasure and mine in looking at the wonderful places, she said, why should not we go and see some of them in reality? My father hesitated a little, then with glittering eyes said – why not? And there were two or three weeks of entirely rapturous and amazed preparation.[41]

It was quite a journey, taking the family much further than Flanders and Germany, into Switzerland, Italy and France. They reached Genoa in June, and the heat warned them to turn back rather than continue to Rome as by then they had intended. It was the first time they visited Italy, and they travelled in carriages or by boat, with long days of trundling along. 'I certainly had more passionate happiness, of a quality utterly indescribable to people who never felt the like, and more, in solid quantity, in those three months, than most people have in all their lives.'[42]

It was a landmark event in the whole family's life, and they soon made continental travel a family habit. It was an expensive thing to do, but it was thrilling, and John James carefully weighed the cost and found it worthwhile. The way John tells the story, it sounds as if his mother was the instigator, but that she was voicing desires that were really her son's and husband's, except that they had not quite crystallized their thoughts. A no less accurate description would be to say that the trip was her idea and that she made it happen. She enlisted the support of her husband to make it possible as a practical proposition. The three were certainly acting as a unit, and it seems quite incidental that John's cousin Mary Richardson, who was living with them at the time, came too, as did their forthright and loyal Scottish maid, Anne Strachan.[43] There was also a courier, Salvador, who went on ahead of them to arrange accommodation. He would need to know that they had arrived at one place before setting off for the next and was certainly part of the company even though he travelled separately. There are times when John Ruskin, looking back on these years, gives the

impression that he lived a very isolated life as a child, but in fact there were usually other people around; it is just that they did not matter much to him. One person who managed to establish a presence in the family circle was a Croydon cousin, Charles Richardson, who had found work with a publisher (Smith, Elder) in the City of London, close to John James's office. He joined the Ruskins at lunch on Sundays. He had a bright complexion and 'crisply Achillean curls of hair'.[44] It was through him that a connection was made with the publishers. Charles made it possible for John to be taken seriously when he produced verses, and some were published from 1835 in their annual gift volume, *Friendship's Offering*.[45] The nascent talent for writing turned out to be evident not only to the teenager's doting parents, but remarkably found recognition in the wider world. John liked Charles, and over decades Smith, Elder would publish all of Ruskin's important works, until towards the end of his career he took control himself.

The closest relations of course were with his parents, which is only to be expected for an only child. He was always closer to them than was usual in a nineteenth-century bourgeois household, where the children might expect to be confined to the nursery, meeting their rather remote parents for limited hours each day. In the Ruskin family the bond continued into adulthood without the level of its intensity seeming to dwindle. Even as an adolescent John can be found turning down invitations on the grounds that he wants to be with his parents: 'Hitherto I have scarcely left them for a day, and I wished to be with them as much as possible, till it is necessary for me to go to the university.'[46]

When the family party crossed the Channel it was pleased with the realities that had inspired Prout's images, and pleased with the accuracy of his depictions. However, it was the Alps that were the great revelation – presumably for the whole family, but it was young John who was taking notes. He was already interested in geology, and that interest would erupt later in the fourth volume

of *Modern Painters* to be seen as a major preoccupation. For now it is remarkable to see that Ruskin's notes were as much about the geological detail as they were about Picturesque effects in the terrain through which they were passing, and it is worth holding in mind that speculation made in old age about what might have happened to him had he been allowed more independence: that he would have been 'probably the first geologist of my time in Europe'.[47] This is not a stray remark, but a rueful consideration of his own independent propensity. The geology was a personal fascination that his parents did not share, and it was not given great parental encouragement, unlike the fascination with painting, and indeed with poetry that John James Ruskin encouraged his son to write – and the son obligingly and enthusiastically produced great screeds of doggerel that did not awaken a poetic muse. Having made his name in the world of art criticism and architecture, in his memoir he gravitated back to geology as the thing was especially his own.

Ruskin kept a journal through this expedition, doing his best to make sketches from the carriage while it was on the move, then writing up his notes once the party reached their hotel. Reminiscing about this time with the benefit of hindsight, and more highly developed literary skill and judgement than he had had at fourteen, Ruskin described how the journey to Schaffhausen entailed some delays. The hills made the going difficult, and once or twice they had to wait for horses. By the time they arrived it was midnight, and they had to be let into the walled town by the night watchman.

They spent the next day looking round the town, went to church and, having dined at their usual four o'clock, saw that it was going to be a fine evening, and went out to explore further. Towards sunset they wandered along a garden promenade with views across vast Alpine distances, with the bulk of Mont Blanc, tinged pink, in sharp focus on the horizon. 'The seen walls of lost Eden could not have been more beautiful to us; not more awful, round heaven, the walls of sacred Death', said Ruskin. 'I went

J.M.W. Turner, *The Valley of Chamouni*, photogravure by George Allen, from *Modern Painters*, 1 (1843).

down that evening from the garden-terrace of Schaffhausen with my destiny fixed in all of it that was to be sacred and useful.'[48]

This was one of the turning points in Ruskin's life, though that was not immediately apparent to the fourteen-year-old boy. It is the 66-year-old Ruskin in Brantwood trying to make sense of his life, looking out at the fells across Coniston where he ended up, who triangulates his destiny as a child of the mountains – his earliest memory of being held aloft to see the view towards Keswick across Derwentwater, then being born again by being inducted into the sublime beauty of the Alps, Mont Blanc in particular.

From Schaffhausen the party went on to Italy by way of the Via Mala – the most dramatic of the Alpine passes – and subsequently returned by way of the St Bernard Pass to Chamonix, where Mont Blanc loomed large. Ruskin witnessed a thunderstorm there, and a sunset: 'before me soared the needles of Mont Blanc, splintered and crashed and shivered', bearing 'the marks of the tempest for three score centuries'.[49]

His verses and his mode of expression here owe something to Shelley (1792–1822), whose poem 'Mont Blanc' he certainly knew. Its wonderful opening, 'The everlasting universe of things/ Flows through the mind . . .'[50] suggests a challenge to reflect and understand, or to stand in awe. It certainly echoes the activity in Ruskin's notebooks. Shelley was writing in 1816, describing his own response to the mountain, and his relation with it:

> Dizzy Ravine! and when I gaze on thee
> I seem as in a trance sublime and strange
> To muse on my own separate fantasy,
> My own, my human mind, which passively
> Now renders and receives fast influencings,
> Holding an unremitting interchange
> With the clear universe of things around . . .[51]

One of the remarkable things about Shelley's poem is that it was written when geology was still a very speculative subject, but it nevertheless carries in it some powerful geological ideas. Shelley's geological thinking was influenced predominantly by the work of the Scottish Enlightenment figure James Hutton (1726–1797), whose *Theory of the Earth* was published in 1788, presenting the world as we know it as having been formed over aeons, through upheavals, erosions and sedimentations.[52] The projected timescale for these speculations was so vastly at odds with the biblical account of creation that Hutton was accused of atheism (as were some of his friends, such as David Hume). This would have been no obstacle to Shelley's acceptance of Hutton's ideas. As a student at Oxford in 1811, Shelley had published *The Necessity of Atheism*, and had to leave the university.[53] Hutton seems to have been the main source for Shelley's geological allusions in 'Mont Blanc'.

Is this the scene
Where the old Earthquake-demon taught her young
Ruin? Were these their toys? or did a sea
Of fire envelop once this silent snow?
None can reply – all seems eternal now.[54]

In 1818 the Revd William Buckland (1784–1856) became Oxford University's first Reader in Geology.[55] He sought to reconcile geological evidence with the Bible, and for a time thought that he had found evidence of Noah's flood. Geology promoted the idea of the Earth as developing over time, and continuing to change, by way of processes that are so slow as normally to be indiscernible to human perceptions. Rare events like earthquakes and volcanic eruptions are in this view exceptional in being apparent to us, but slow processes of change are going on all around us, at a glacial – or even slower – pace. The geological view was a precursor of scientific evolutionism. There had been a Professor of Fossils at the University of Cambridge since 1731, and the post's title changed at some point to Professor of Geology. Adam Sedgwick (1785–1873) was a clergyman's son from Dent on the edge of the Lake District, and he was appointed to the post in 1818. John Phillips (1800–1874) also did important geological work in the Lake District, and brought his findings to the Geological Society in London (founded in 1807). Both Phillips and Sedgwick spoke highly of the 'humble but sagacious pioneer' Jonathan Otley of Keswick (1766–1856).[56] Sedgwick is remembered now chiefly as one of Charles Darwin's teachers; but when using geological evidence Darwin actually cited Charles Lyell's *Principles of Geology* (1830).[57]

The Ruskin parents cannot have seen the fascination with rocks as leading directly to atheism, or else they would have steered their son firmly away from it, but the son was certainly susceptible to its persuasion and would find himself doubting his faith. 'If only the geologists would let me alone', he said on a later occasion, 'but

John Ruskin,
'Aiguille Structure',
engraving by J. C.
Armytage, from
Modern Painters, IV
(1856).

those dreadful hammers! I hear the clink of them at the end of every cadence of the Bible verse.'[58] By the time of the Ruskins' journey geology was an established subject of intellectual inquiry – the 'heroic age' of its formation was put at 1790–1820.[59] In the 1830s mineral resources were becoming important as industry looked to steam to power the new machinery, replacing the water power of the early Industrial Revolution. For Ruskin geology was intellectually fascinating, but for others it held the prospect of riches. The drive to understand came from different quarters, but the collective intellectual project was still rapidly developing and causing people to reflect on the upheavals that the Earth had undergone long before there were humans on the scene to witness them. When Ruskin was twelve he had already been reading Robert Jameson's *System of Mineralogy*, maybe with something more like a collector's mentality, documenting different specimens, but by the time of the journey through the Alps his interest had far outstripped that of someone collecting interesting pebbles from a beach. As he saw it he was confronting the absolute, embodied in the Alps, which remained at that time largely unexplored.

Ruskin's mountain destiny has echoes in Wordsworth (when he described the hills of the Lake District as 'the heart, the soul of all my moral being') and in Byron ('High places are a feeling . . .').[60] Shelley's response to Mont Blanc is, like Wordsworth's and Byron's poetry, focused on the personal reaction to the place (how does the mountain make me feel?) but unlike the others he sees the landscape itself as mutable ('did a sea of fire envelop once this silent snow?'), which is how Ruskin came to understand it, though it is uncertain whether he had quite reached this point in his intuitive under-standing when he first encountered Mont Blanc. He imagines that the mountain carries 'the marks of the tempest for three score centuries', which is to say for 6,000 years. The period seems to be fairly arbitrary – an appropriate rhetorical flourish suggestive of a great period of time. However 'six thousand years before' was in

round figures the traditional date that had been worked out as the time of the creation of the world – a date that the evidence of geology was challenging (the age of the Earth is now put at about 4.5 billion years). For young Ruskin with his intensely religious home education, the mountains seemed to carry intact the image of the original creation, unsoftened by the activities of man and utterly undomesticated. In his maturity he was well aware that his sensibility was itself historically formed. His temperament, he said,

> belonged to the age: a very few years, – within the hundred, – before that, no child could have been born to care for mountains, or for the men who lived among them, in that way. Till Rousseau's time, there had been no 'sentimental' love of nature; and till Scott's, no such apprehensive love of 'all sorts and conditions of men', not in the soul merely, but in the flesh.[61]

Ruskin often made appreciative remarks about Sir Walter Scott (1771–1832), who may well have helped him to a wider understanding of humanity than he would have managed from his sheltered upbringing in Herne Hill, his gentle Garden of Eden. The family left Herne Hill on their tour in May, and returned in September, having spent some time in Paris with the family of Pedro Domecq, John James's partner, where John had to deal with four Domecq daughters (the fifth was away). He made up his mind to learn French. The family's itinerary had taken them almost as far as an eighteenth-century Grand Tour might have done, but in a fraction of the time. A Grand Tour was seen as part of a gentleman's education and could last for a year or more, so there would not have been the daily routine of carriage rides in order to travel the great distances. The introduction of railways during Ruskin's lifetime changed the sense of the distances involved. He found the railways useful for his long journeys, though he always disparaged them, but his early journeys were made at horse pace.

Longer journeys could be made by sea, powered by sail. Cousin Charles weighed up his chances at his publishing house, and decided that they were limited. If his boss had had a daughter, he might have married her and eventually found himself running the firm; but the boss had no daughter, only a son, who would inevitably take over the business, so Charles thought he would improve his prospects if he went to join his brother in Australia, who was doing well there. John was upset that Charles was going and Christmas 'passed heavily', with the departure imminent. In the event his ship was kept waiting for so long by strong headwinds off Cowes, that a party decided to go ashore to stock up on fresh water and suchlike. Charles joined them, despite the heaving of the sea, but the little boat went down soon after leaving the ship. There were plenty of other craft around: 'Two or three scudded to the spot in a minute, and every soul was saved, except Charles, who went down like a stone.'[62] The date of his death is set on the page of Ruskin's memoir like a date on a tombstone: 22 January 1834, given a paragraph all to itself. 'The death of Charles', said Ruskin, 'closed the doors of my heart again for that time; and the self-engrossed quiet of the Herne Hill life continued for another year, leaving little to be remembered, and less to be told.'[63]

It was at about this time, though, that Ruskin started to go to school from home each morning – and only for the morning. He must have seemed a wayward pupil with little discipline, and the standard curriculum did little to fire his imagination, but the schoolmaster was less indulgent than his tutor at home had been and made him argue his points more forcefully. The real and distinctive intellectual developments belonged to the home. For his fifteenth birthday (8 February 1834) Ruskin asked for the four-volume *Voyages dans les Alpes*, by Horace Bénédict Saussure, and his father gave it to him, adding two more volumes of William Brockendon's *Illustrations of the Passes of the Alps*.[64] 'Papa is spoiling you', said his mother, but undoubtedly John James was

also interested in having the books in the house.[65] Young John's
first published article appeared in September of the same year,
analysing the causes of the colours of the Rhine, whose course
the family had followed on the way to Switzerland. It appeared in
John Claudius Loudon's *Magazine of Natural History*, where it was
presented as an authoritative piece, not as the work of a prodigy.[66]
John also contracted pleurisy, which made it painful to breathe and
kept him away from school for a while, but he was never short of
time for his own books and for the development of 'the unabated,
never to be abated, geological instinct'.[67] By the time his birthday
came round again, plans for another visit to the Continent were
forming. Salvador the courier came calling in February with draft
itineraries, and the Alps and Italy were firmly on the agenda for
the summer.[68]

This expedition lasted from 1 June to 10 December 1835, and
took the family through France (notably beginning with Abbeville
and Rouen) to the Alps and then on to Venice. For John James it
must have seemed like the Grand Tour he had not had as a young
man when his prospects were blighted by the family's debts. He
was 50 and his wife 54 when they made this tour, which must for
them have had something of the character of a reward for a life of
hard work. For their son it was an education. So far as personal
development went, the great difference between this tour and
a tradition Grand Tour was that his parents were with him.
He was not getting caught up in romantic adventures and learning
to be a man of the world, but continued in his role as the diligent
precocious boy. The other main difference is that instead of heading
straight for Rome and the antiquities there, they stayed in the
mountains for two months. They had heard that there was cholera
in Rome. On the way there John had been writing verses modelled
on Byron, and his diary mixed passages recording rapturous
impressions of Picturesque scenery and detailed notes about
geology, which took over almost completely once they were in

the mountains. Inspired by Saussure, his understanding of rock formations and large-scale structures was deepening, but there are still meticulous observations of detail. He was making studious notes, and the diary does not mention anyone else in the family party.[69] In *Praeterita* Ruskin tried to dismiss the idea that his mother was like Esther Summerson's religious aunt in Dickens's *Bleak House*, by showing that she had a gift for laughing at the misfortunes of others.[70] In their travels, though, the Ruskins seem to resemble more closely the Meagles family in *Little Dorrit*.

Given Ruskin's later writings, one would expect the first impressions of Venice to have been climactic, but they are not recorded as such, and in *Praeterita* the place is unexpectedly dismissed: 'There have been three centres in my life's thought: Rouen, Geneva, and Pisa. All that I did at Venice was bye-work.'[71] That has not been the view of others, and there will be more to say about Venice in due course. Perhaps it carried too great a freight of expectation and anticipation. Geology was the great obsession of this expedition, and the personal preoccupation. There was also enthusiastic relish for Picturesque effects and sketches of mountains and Gothic architecture, especially at Abbeville and Rouen. 'Geneva' in this list is the base camp for the Alps, and Ruskin would take in Pisa on a later tour. There is no doubt that he learned a huge amount on this voyage of discovery, but of course the things he learned were not on the standard school curriculum.

The Europe through which the Ruskins travelled still had a post-Napoleonic character. John James had taken his six-year-old son (on his very first trip abroad) to see the battlefield at Waterloo, where Napoleon had been defeated in 1815, only ten years earlier. By the time the Ruskins were in Venice, the four cast-copper Roman horses were back in place on the facade of the cathedral of San Marco. Napoleon had taken them to Paris and mounted them on a triumphal arch between the palaces of the Louvre and the

Tuileries. The symbolism was apt because at the time of the Fourth Crusade (1204) the Venetians had looted them from Constantinople, where the horses had presided over the imperial Hippodrome. The Venetian Republic had had its own empire, which fell to the Austrians at the end of the eighteenth century; they then ceded parts to Napoleon, the eastern Mediterranean parts to the Turks. When the Ruskins visited Venice it was back under Austrian rule. Milan and the area round it (Lombardy) and Tuscany, where Pisa and Florence are located, were also part of the Austrian Empire. 'Italy' was not a nation-state, but a zone where the Italian language was dominant. Sardinia had its own king, as did Naples (the Kingdom of the Two Sicilies), and the Papal States were governed from Rome by the pope in his capacity as a temporal ruler. Already political agitations had begun that would eventually see popular uprisings in the north and the unification of most of modern Italy in 1870, when the Italian army marched on Rome.[72] The politics had no impact on the Ruskins' interests in 1835, and did not prevent them from moving freely to the places they wanted to go. However, they did not venture further south and Ruskin's bond with Italy was formed with the northern parts, where Romanesque and Gothic style flourished. His idiosyncratic education left him without the immersive fluency in ancient languages that a school curriculum would have given him in the nineteenth century. 'Grammar schools' were set up to teach Latin, not English grammar, which was the basis of the curriculum. Ruskin's ancient languages included Hebrew, and he could read them well enough, but the anti-pagan slant of his Bible-based tuition at home meant that he responded warmly to Italian medieval buildings and art, and did not feel the instinctive rapport with the classical past and the Renaissance in the same way as his conventionally educated contemporaries.

The Ruskins returned to Herne Hill and familiar surroundings on 10 December, and the even tenor of domestic life resumed, only to be disturbed in January by the arrival of the four Domecq

girls whom John had met two years before in Paris. He was then the same age as his father had been when he first met Margaret Cox. Within four days, Ruskin later said, he had been reduced to 'a mere heap of white ashes'.[73] He fell in love with Adèle Domecq, but whatever his feelings might have been, she gave him no encouragement and remained completely indifferent to him.

He said it took him four years to recover, and considered himself to have been dealt a heavy blow. In fact it was much longer than that. The thing that seems strange now is how much influence the parents had. Adèle's father was happy to accept the idea that John would marry his daughter, and said that she could convert to Protestantism, but Margaret Ruskin absolutely forbade the marriage because Adèle was a Catholic. Had Ruskin's mother not opposed the match then John and Adèle would have married, as Adèle's indifference would not have been an issue. It is easy to see here a pattern for Ruskin's later infatuations, but really this 'crush' was the most normal experience he had during his teenage years. It was how it was handled that was odd. His infatuation could take a geological turn:

> Blushes bright pass o'er her cheek,
> But pure and pale as is the glow of sunset on a mountain peak,
> Robed in eternal snow.[74]

With no close school friends or siblings to mock him back to an alternate perspective, he was allowed to indulge his feeling of devastation by writing a Venetian tragedy – the heroine a fictionalized Adèle – and some of the poetry found its way into print in *Friendship's Offering*, showing at least that the *Offering*'s sentimental readership could relate to emotions stemming from unrequited obsession. There is no denying that the pain he felt was real, but he seems to have been able to intensify the injury and to sustain its effects when others might have moved on and fallen

for someone else. What he needed was distraction, but instead he nurtured the pain with self-pity.

Ruskin's former schoolmaster, Thomas Dale, became the first professor of English literature at the newly founded King's College in the Strand, and Ruskin started attending his classes there.[75] He also went to meetings and lectures of the Geological Society, then in Somerset House (also the home of the Royal Academy) next door to King's College.[76] He did not put Adèle out of his mind, but continued to obsess about her even after he started at Oxford in 1837. She and her sisters came to England for part of their education and they continued to visit Herne Hill, where John James took on the role of guardian. They were there for the Christmas break of 1838. Their father died in an accident early in 1839, and it somehow happened that Adèle, no doubt numbed by bereavement, passively agreed to marry a man she had never met, the Baron Duquesne.[77] Ruskin was at first shielded from the news, and when he eventually heard he was so devastated that he still felt depressed by the event's anniversary two years later.[78] He was not in a good state of mind and not in good health. He had a tubercular attack, and was depressed. His father conflated the disappointment and the disease when he said later that at this time John had almost died of a broken heart.[79]

Ruskin's idiosyncratic education did not prepare him well for the standard examinations at university. He said that his Latin was the worst there, and although he worked hard and published articles, his achievements were not recognized in the examinations.[80] He won the Newdigate Prize for poetry on his third attempt; but came away with 'a mortal contempt for the whole University system'.[81] He interrupted studies for the sake of his health and eventually graduated in 1843, when he was awarded a fourth-class degree – the barest pass, signalling a low level of achievement. The meaning of such an award is difficult to decode. Maybe the examiners felt that the candidate had not really engaged with the

curriculum, but had nevertheless shown that he had intelligence and deserved a degree. Given how grudging the award looks, it seems almost a satirical gesture on Ruskin's part that when his first book, *Modern Painters*, came out, it was published anonymously and instead of having his name on the title page it was declared to be by 'A Graduate of Oxford University'.

Ruskin's graduation was delayed because he was taken ill early in 1840. He seems to have run himself into the ground with over-work, trying to excel, having started at a disadvantage so far as the standard criteria of the examinations system were concerned.[82] Ruskin's education was highly privileged and in its extraordinary way was exceptionally good. Ruskin himself was passionate about learning, and set himself to do an amazing amount of it. He was received as a Fellow of the Geological Society, and while he was still an undergraduate he published enough articles to be reprinted later as a book.[83] So far as his personal development is concerned, though, the most unexpected detail is that when he went to Oxford, his mother came too, and his father was there at weekends. 'My mother did not come to Oxford,' Ruskin said,

> because she could not part with me, – still less, because she distrusted me. She came simply that she might be at hand in case of accident or sudden illness. She had always been my physician as well as my nurse [. . .] and my day was always happier because I could tell her at tea whatever had pleased or profited me in it.[84]

His college base was Christ Church, where Oxford's cathedral is to be found, and he made friends there, but he was not learning to be independent of his parents. There were definite advantages to the arrangement. John James helped with the research for his son's Newdigate Prize poem, which had to be on a specific topic, deliberately obscure. It also meant that when John started coughing

up blood late one evening, he could walk round to his parents' lodgings for succour. The remedy was prescribed as rest, preferably with the winter spent near the Mediterranean. The Oxford career was suspended. The whole family headed again for Italy, and they were away for ten months from September 1840.[85]

2

Turner and the Picturesque

Samuel Rogers (1763–1855) is not much remembered now, but in
his day he was the doyen of literary London. He had spent his
working life in the family's bank, and retired from it immensely
rich at the age of 40. He wrote poetry, remained unmarried, and
hosted 'breakfasts' and dinners at his house, 22 St James's Place,
which attracted brilliant company. His best friend was Richard
Sharp (1759–1835), known as 'Conversation Sharp', also unmarried,
who was born in Newfoundland, started out as a hatter, made
a great fortune and rose through the ranks of society by being a
wonderfully well-informed raconteur. Wordsworth was a friend
of Rogers; so was Dickens (*The Old Curiosity Shop* is dedicated to
him). He often quietly gave support to those who needed it and
was well known for his practical kindness, as well as for his
waspish remarks. The published collections of his 'table-talk'
are gossipy and give personal insights into the lives of his
contemporaries that are often plausible and rarely verifiable.[1]

Rogers's poems have not worn well, and they were never really
the reason for his celebrity status, though he was taken seriously
as a poet, and was apparently invited to take on the role of Poet
Laureate after Wordsworth's death (1850). He declined because he
felt too old (it went to Tennyson). His best-known poems were *The
Pleasures of Memory* and *Italy*.[2] They are long, urbane efforts that
sound as if they belong to the eighteenth century rather than the
nineteenth. They describe sites and incidents that are full of

drama and pathos, but fail to stir anything deeper than feelings of gentility – which of course was the basis of the poems' appeal to the drawing rooms of Herne Hill and places like it, where gentility is an expression of status. Once the basic necessities of life have been attended to, gentility may be very keenly felt. Rogers represented an ideal of aspiration and accomplishment, the embodiment of good taste and fine sentiment, and more privately of good company. He had travelled across the Alps to Italy, a polite accomplishment in itself, and published an account of his travels in verse: *Italy: A Poem* came out in two volumes (1822 and 1828) that had little impact on the public. Rogers then commissioned 114 illustrations for the poems, which were reissued in a single volume in 1830. The illustrations were mainly from J.M.W. Turner (landscapes, often with architectural elements) and Thomas Stothard (compositions dominated by figures) with a couple of architectural studies by Samuel Prout. This version of the poems did much better. John James's partner Henry Telford, himself an embodiment of gentility, gave John Ruskin, the budding poet, a copy for his thirteenth birthday in 1832 and in doing so introduced him to Turner's work.

Thomas Pringle worked as an editor for Smith, Elder when John's cousin Charles was there. At Charles's suggestion he visited Herne Hill and in 1834 took Ruskin to see 'the polished minstrel of St James's Place'.[3] The prodigy when introduced made the faux pas of telling Rogers how much he liked the pictures in his book without saying anything at all about the poetry, and he appeared distracted during the meal because he let his attention too frequently wander to the paintings on the walls. Rogers had an astonishing collection of paintings, which included Turners and a Titian – *Noli Me Tangere* – that he later bequeathed to the National Gallery.[4] However distracted Ruskin might have been, he did not make a disastrous first impression, and was invited back. 'The old man used to ask me', he said, 'finding me always reverent to him, joyful in his pictures, and sometimes amusing, as an object of curiosity to his guests.'[5]

J.M.W. Turner, *The Shores of Wharfe*, engraving by George Allen, from *Modern Painters*, III (1856).

There was something about Turner's little vignettes that attracted Ruskin from the start. Some of them depict mountain scenery, and give in a very small image an impression of Romantic grandeur. Ruskin came to know Turner's oeuvre better than anyone, and his appreciation of the work was the key motivation for starting work on *Modern Painters*. However, before he started work on that, there was a series of essays that was published by Loudon while Ruskin was still an undergraduate. They were later gathered together and printed as an independent volume under the title *The Poetry of Architecture*. It is of interest because it shows very clearly the position from which Ruskin started out in developing his views about art and architecture. It is completely steeped in the theory of the Picturesque, which belongs more to the world of Samuel Prout and John James Ruskin than to Turner, who had a way of spreading far beyond any pigeonhole into which he might be put, even when he was working in miniature.

The full title makes clear the scope of the work: *The Poetry of Architecture; or, The Architecture of the Nations of Europe Considered in its Association with Natural Scenery and National Character*. It was published under a pseudonym, 'Kata Phusin' (meaning 'according to nature') because Ruskin felt in himself 'a power of judgment . . . which it would not have been becoming in a youth of eighteen to claim'.[6] It certainly reads like the work of an older person. There is a desire to see reform, which might be read as youthful, but that is equally characteristic of Ruskin's much later writing. The idea was to compare and contrast the cottage architecture of England, France, Switzerland and Italy, and then the villa designs around Windermere and Lake Como. The idea might have been taken further, but Loudon's *Architectural Magazine* folded. It is an argument for the establishment and maybe enforcement of a standard of taste in architecture. In painting Ruskin is pleased to note that popular opinion does not make a reputation – that is left to the experts, 'our nobility of taste and

talent'. In architecture, on the other hand, everyone feels that they have the right to do what they like. In Ruskin's view that state of affairs should change, so that good taste can prevail across the national landscape, and not be limited to the estates of people with noble judgement.[7] The problem is not the cottager, who can hardly afford to build anything at all, or the aristocrat, who has breeding and therefore knows how things should be done. Ruskin considers the problem to be the parvenu who has bought a plot of land (30 acres) and as a self-made man thinks he can do what he likes with his money. Ruskin's parents would have belonged to this class, had they not been so concerned with developing the tastes of their social superiors. In Ruskin's text, as might be anticipated, there is some outrageous national stereotyping. Typically there are positive as well as negative aspects to the stereotypes (though Catholic culture was always a problem for him). Here, for example, is an emphatically positive valuation of the Swiss cottage:

when the ornament is not very elaborate, yet enough to preserve the character, and the cottage is old, and not very well kept (suppose in a Catholic canton), and a little rotten, the effect is beautiful: the timber becomes weather-stained, and of a fine warm brown, harmonizing delightfully with the gray stones on the roof, and the dark green of surrounding pines. If it be fortunate enough to be situated in some quiet glen, out of sight of the gigantic features of the scene, and surrounded with cliffs to which it bears some proportion; and if it be partially concealed, not intruding on the eye, but well united with everything around, it becomes altogether perfect; humble, beautiful, and interesting. Perhaps no cottage can then be found to equal it; and none can be more finished in effect, graceful in detail, and characteristic as a whole.[8]

This is a characteristic passage. Ruskin wrote rapidly, using only dashes as punctuation, and his published works always relied on his editors for their commas and full stops. They sound long-winded as the main point is made, perhaps over a long and broken arc, modified and refined by more nuanced touches that interrupt the line. Ruskin's argument is that the reason Swiss chalets are wonderful is that they harmonize so perfectly with the place and the prevailing culture in their location. It would be very wrong indeed to start building them in London. The architect P. F. Robinson (1776–1858) had been doing just that. One of his Swiss cottage designs survives, in St John's Wood at the place now called Swiss Cottage. Another, more prominent in its day, was in Regent's Park.[9] Ruskin points out that these buildings are not remotely like real Swiss cottages and that even if they were they would not belong in London. It is wrong in a way that goes beyond the realm of personal taste.

> An individual has as little right to fulfill his own conceptions by disgusting thousands, as, were his body as impenetrable to steel or poison, as his brain to the effect of the beautiful or true, he would have to decorate his carriage roads with caltrops, or to line his plantations with upas trees.[10]

The external appearance of a building is a matter of social duty, not the expression of personal whim. 'Caltrops', incidentally, are spiky weapons like sharply pointed nails welded together so that when they are scattered, some of the nails are pointing straight up. They would make a road impassable. 'Upas trees' from Java had an exaggerated reputation for deadliness. It is possible to make a poison from their sap, but Dutch travellers to Indonesia turned them into something that could kill the unwary. The trees were supposed to emit vapours that were lethal if breathed, and which were fatal to other plant life. They were mentioned, for

example, in this emblematic way by Erasmus Darwin in one of his natural history poems:

On the blasted heath
Fell Upas sits, the hydra-tree of death.[11]

His footnote for the line states that 'all kinds of vegetables also are destroyed by the effluvia of the noxious tree; so that, in a district of 12 or 14 miles round it, the face of the earth is quite barren and rocky, intermixed only with the skeletons of men and animals; affording a scene of melancholy beyond what poets have described or painters delineated.'

Ruskin's language is emphatic, and his examples colourful, but notice also his use of the word 'disgusting', which to modern ears sounds overstated. Its meaning has shifted since Ruskin's time, but he had been reading the eighteenth-century Picturesque theorists who used it with reference to its Latin root: *gustus*. Translating the eighteenth-century 'disgust' into modern English would give us 'distaste'. So the house which is 'disgusting thousands' of people is not making them retch and vomit; they are merely finding it distasteful. There is another example where Ruskin discusses brick, which he thinks perfectly expresses the English virtues and shortcomings:

Another excellence in brick is its perfect air of English respectability. It is utterly impossible for an edifice altogether of brick to look affected or absurd: it may look rude, it may look vulgar, it may look disgusting, in a wrong place; but it cannot look foolish, for it is incapable of pretension. We may suppose its master a brute, or an ignoramus, but we can never suppose him a coxcomb . . . It is thus that brick is peculiarly English in its effect: for we are brutes in many things, and we are ignoramuses in many things, and we are destitute of feeling in many things, but we are *not* coxcombs.[12]

A person might be a fashion victim in thrall to 'bling', but brick is never going to be the material to express that. Even when the brick is 'disgusting' it has good character. This could not make sense with the modern meaning of the word, but in context it means that even if the brick does not meet the demands of the most fastidious taste it still has good character. 'Rude' and 'vulgar' are both now sometimes used to mean 'obscene', but they did not have that connotation for Ruskin. 'Rude' is 'unsophisticated' or in a more positive way perhaps 'rugged', as in 'rudimentary'. 'Vulgar' means 'of the people', literally 'popular', but that has changed its connotations completely, as in the modern world a thing can be seen to have merit because it is popular, whereas in Ruskin's world it was the 'noble' that was good. 'Coxcomb' was an already-obsolescent word for someone who is conceited and showy, more used in the eighteenth than the nineteenth century. Ruskin later said that he had taken Samuel Johnson (1709–1784) as his literary model (and coxcomb is certainly a word that Johnson used) so the language may initially have been deliberately fogeyish, but it became part of Ruskin's personal vocabulary.[13] His old-fashioned word choices had the effect of making the still very young Ruskin sound more grown-up than he was and therefore more authoritative. This was probably unselfconscious. Most of his social acquaintance was with people of his parents' generation, and he would not be picking up the informal language of his own age group – people who would find their way into print later on. In *The Poetry of Architecture* the influence of Bible reading is not evident, but the language of eighteenth-century 'Picturesque' texts certainly is. It strains for literary effect less ornately than some of his unpublished work, and in later life he remained pleased with the quality of this early writing, but regretted that he had not been encouraged to write in a voice that was more authentically his own.

Had either my father or my tutor said to me, 'Write as it is becoming in a youth to write, – let the reader discover what you know, and be persuaded to what you judge', I perhaps might not now have been ashamed of my youth's essays.[14]

Ruskin's drawing and watercolour technique developed at the same time as his writing. He tried to copy the style of the Turner vignettes in *Italy*, but at first did not know Turner's watercolours. He saw some of his oil paintings at the Royal Academy, but they belonged to a different artistic world from the one he felt he could emulate, so he never tried to copy Turner's oils. His own watercolours owe much more to Samuel Prout and Copley Fielding. John James bought a Copley Fielding watercolour, and paid for John to have some personal lessons with him in 1835.[15] Turner was less approachable.

Anyone who finds their way into print as young as Ruskin did, and then carries on writing, is bound to leave in their writing a trace of the development of their thinking. The thing that is odd in Ruskin's case is that he gave a single title, *Modern Painters*, to five books whose publication was spread across the years between 1843 and 1860, from when Ruskin was 24 until he was 41. The five volumes do not really make a coherent work, as Ruskin's views of things were subject to change. 'All true opinions are living', he said in the preface to the final book, 'and show their life by being capable of nourishment; therefore of change. But their change is that of a tree – not of a cloud.'[16] He was a much more knowledgeable and sophisticated critic in the final volume than he had been in the first. The precision of thought is constant, but the outlook by the end was much more widely informed. At the outset Ruskin was still thoroughly immersed in the values of the Picturesque, and the book's heroes are Henry Prout, Copley Fielding and Turner.

Ruskin's relationship with the Picturesque is complex, because there are times later on when he seems to repudiate it, while carrying

on with some ideas that clearly derived from it as a method. This is compatible with his image of change as developmental growth (like a tree) rather than nomadic drifting and dispersal (like a cloud). In discussing 'modern painters' (as opposed to Old Masters), Ruskin's range was surprisingly limited to British contemporaries – even excluding Turner's earlier, more conventionally Picturesque work.

What did 'Picturesque' mean in the 1830s? Its meaning and connotations had been refined and codified in Britain back in the 1780s and 1790s, when it was first associated mainly with William Gilpin and his 'Picturesque tours' to the Wye Valley and other parts of Britain. This meant travelling in search of views of rural scenery – perhaps including ruins like Tintern Abbey or other buildings that brought out the evocative qualities of a place. The idea was to find real places that looked as composed as pictures. The great thing about the Wye Valley, and the reason why it became a tourist attraction in the late eighteenth century, was that the steeply sloping forested banks and the distant views along the river tended to make satisfyingly 'pictorial', that is, Picturesque, compositions, with foregrounds, middle grounds and distances. Dutch landscape painters were admired, but the most esteemed Old Masters of landscape were Nicolas Poussin and Claude Lorrain, whose images of Italian scenery populated by classical figures could stir the noblest sentiments of the landed gentry.

There was a desire on the part of the people who were in a position to do it to remodel landscape gardens so that they resembled such paintings and evoked the same responses. A well-educated landowner with a finely tuned sensibility might be in the best position to make adjustments to the park around his house, but for a great estate there was professional help at hand. The most prominent of these professionals during the vogue for the Picturesque was Humphry Repton, who styled himself a 'landscape gardener'. During the 1790s he became embroiled in a heated debate with Uvedale Price – an emollient character, who

wrote various essays on the Picturesque – and Richard Payne Knight, who was much more combative. Knight attacked first Repton's practice (in the footnotes of his poem *The Landscape* – far more footnotes in the second edition than in the first) and then Price's theory (in his *Analytical Inquiry into the Principles of Taste*).[17]

Knight pointed out that the word *picturesque* derived from the Italian *pictor* (painter) and meant *after the manner of painters*.[18] His aesthetic theory, derived from Archibald Alison's Associationist ideas, insisted that Picturesque-ness was not exactly in the landscape, but in the mind of the viewer. Someone who was familiar with the work of the great landscape painters would be able to recall them (maybe subliminally) when looking at real scenes, particularly when they took on a harmonious colouration, when gilded by the subdued light at sunrise or sunset, or if there were a fine mist.[19]

Logically speaking, if the word *picturesque* means *after the manner of painters* then the last thing it should be applied to is paintings. They are always done after the manner of painters. Nevertheless it did come to be so applied. The kinds of landscapes and sights that were sought after on Picturesque tours could not in those days be fixed as photographs, but they could be sketched and worked up into paintings. Turner's early career was built up on such topographical work, such as his detailed views of Tintern Abbey (1794) mouldering, with vegetation growing over the ruin in an impeccably Picturesque manner. The directives for how to select landscapes that evoked pictures turned back into records of those scenes in pictures. There is a danger with such reflexivity of the paintings becoming parodic, as pictures start to record the aspects of the world that have been found to look like pictures, and this is rather the state of 'the picturesque' as it was to be found in the hands of the minor artists of Ruskin's youth. For amateurs there is something appealing about learning to paint 'after the manner of painters', because it means that one's efforts look like

the work of established artists. For an amateur it can be a satisfying achievement to be able to reproduce the cliché system of established artworks, but that is never the way to make a name as an artist. The artists whose work stands out as innovative and distinct will emerge from one tradition or another by doing something that is not quite in the manner of the artists who have gone before, and that work would seem by definition less Picturesque. When Ruskin had lessons from Copley Fielding, whose work he continued to admire and praise, he was given lessons in the production of conventional images. He describes his initial excitement when he was shown the technique, but that first reaction subsided as he realized he was just repeating a formula.[20]

The most powerful influence of the Picturesque on Ruskin was in the first instance in its characteristic subject-matter. The landscapes with mountains, lakes, ruins, cottages and trees continued to furnish his imagination throughout his life, sometimes as a focus of attention, sometimes as background. In the second place, but ultimately more importantly, the practice of drawing came to be for him a vital discipline, even when it ceased to be directed towards the making of pictorial compositions. In 1857 Ruskin published a treatise, *The Elements of Drawing*, which gives practical guidance on sketching. He declared himself uninterested in, or incapable of, helping people who wanted to pass time drawing as a polite accomplishment, but could show the reader how to search for truth in drawing, and how to see the world better by drawing.[21] For Ruskin drawing was a way of intensely contemplating a fragment of the world: a form of meditation. It was as much a spiritual discipline as a way of conveying practical information, of tuning in to the manifest part of the universe. The whole point of drawing and painting was to apprehend a truth about appearances – a truth about the world. The concept of truth is at the core of Ruskin's idea of art, and it dominates the opening pages of the first volume of *Modern Painters*.

While Ruskin was working on the book he called it *Turner and the Ancients*,[22] and there is no doubt that Turner is the hero of the work. The title changed after negotiations with the publisher, Smith, Elder (or rather his editor there, W. H. Harrison, by now an established friend). When the first edition came out the title had changed to the evidently more marketable *Modern Painters: their Superiority in the Art of Landscape Painting to all the Ancient Masters proved by Examples of the True, the Beautiful, and the Intellectual, from the Works of Modern Artists, especially from those of J. M. Turner, Esq., R.A.*

Turner came from a modest background – his father was a barber – but the brilliance of his draughtsmanship was recognized at an early age and he had been elected as an academician in his early twenties, the youngest-ever member.[23] By the time Ruskin was given his copy of Rogers's *Italy*, Turner was already 57, and coming to the end of his long period of tenure as the academy's professor of perspective. The work that made his reputation included very detailed topographical and architectural perspectives, which were absolutely assured and superbly skilful. His later paintings became entranced by the effects of light, and involved much less rendering of concrete detail, but they evoked space and elevated sentiment through the use of washes of colour with deftly placed elements here and there that made the paintings surprisingly compelling. The real subject-matter in the paintings is formless, or shifting – clouds and mists, light and the movement of water – effects that are impossible to transcribe directly to the page or the canvas. But in Turner's work one senses the heaving mass of water in a rough sea, the power of a storm in swirling clouds, the vertiginous drop of a depthless chasm or the sheer blissful radiance of the sun. His reputation among the greatest of artists is now absolutely secure, but in his own lifetime things were different. He attracted admirers, but there were detractors too, and during Ruskin's late teens it seemed to him that the detractors might be in the ascendant.

Ruskin was rapturously receptive to Turner's work, and was delighted when his father started to buy it, though John James was at least at first cautious about the prices he would pay. When John reached the age of 21 his father gave him stocks that produced an income of about £200 a year (at a time when a labourer in steady employment would earn less than £8 a year, and be able to get by on it). He spent £70 of the first year's allowance on a Turner water-colour of Harlech Castle.[24] When *Modern Painters* was published in 1843 it took its leave of Turner by describing him as

> sent as a prophet of God to reveal to men the mysteries of
> His universe, standing, like the great angel of the Apocalypse
> clothed with a cloud, and with a rainbow upon his head, and
> with the sun and stars given into his hands.[25]

The reference to the Apocalypse is to the last book of the Bible (The Apocalypse of St John, or the Book of Revelation) and the 'angel standing in the sun' therein.[26] This image was dropped from later editions because of sensitivity about its seeming idolatrous, but there is no doubt that it was sincerely felt. One of Turner's last paintings would be an image of this angel, so it remains associated with him. At the turning of the new year after the publication, John James gave his son a Turner oil painting, *The Slave Ship*, which was excitedly received.[27] He had already written about the painting, having noticed it as 'the chief Academy picture of the Exhibition of 1840'.[28]

When I look at Turner's later paintings I find it impossible to see them without them resonating with more recent work, such as that of the Impressionists, which was partly inspired by Turner's example and which certainly did not develop until it was too late for Ruskin to know about it. I remember my first encounter with the Turners hanging in the Tate Gallery in London when I was a teenager, and how powerful the images were. *Norham Castle*, for

example, did not seem to belong to any historical sequence that I knew or that was evident in the room, but just looked radiant and entrancing. There was hardly anything there – a swirl of mist, the silhouette of a castle and a couple of cows, barely sketched in, but those few hints did enough to establish a sense of depth and space and compelling presence. The painting clearly did not have the same effect on Ruskin, or he would have felt the need to say something about it. For him these late works, including the *Angel Standing in the Sun*, seemed to be evidence of his hero's waning power, and maybe of insanity. Some of them, like *Norham Castle*, were certainly unfinished, and *The Slave Ship* does not seem to be so far removed from its evocative mists. Indistinctness became the characteristic achievement of Turner's late style, giving a sense of atmosphere and evocative depth that stirs profounder feeling than the more geometric precision of his youth.[29]

Ruskin describes *The Slave Ship* while hardly mentioning its ostensible subject. He explains in a footnote that the ship 'is a slaver, throwing her slaves overboard. The near sea is encumbered with corpses'.[30] That is all. The full title – *Slavers Throwing Overboard the Dead and Dying, Typhoon Coming On* – clarifies the content of the image, as did the accompanying poem (one of Turner's own earlier compositions) in the catalogue:

Aloft all hands, strike the top-masts and belay;
Yon angry setting sun and fierce-edged clouds
Declare the Typhon's coming.
Before it sweeps your decks, throw overboard
The dead and dying – ne'er heed their chains
Hope, Hope, fallacious Hope!
Where is thy market now?[31]

The slave trade had been abolished in the British Empire in 1807, and the abolition of slavery itself in 1833. But the subject-matter of

J.M.W. Turner, *Slavers Throwing Overboard the Dead and Dying, Typhoon Coming On* (also known as *The Slave Ship*), 1840, oil on canvas.

the painting remained topical: slavery in the Southern states of the USA continued until the end of the American Civil War (1861–5). In Turner's painting the action demonstrates the callousness of a commercial logic that has become indifferent to the lives and hopes of the humans who are considered mere goods. The dead and dying slaves are in the foreground of the painting, but they are treated vaguely, and the real energy of the painting is in the depiction of the weather. The coming typhoon (or whirlwind) resonates with the biblical proverb, 'For they have sown the wind, and they shall reap the whirlwind'.[32] It has passed into ordinary usage as 'reaping the whirlwind', which suggests that a major calamity has been brought on by its victims. 'Typhon' was also the name of the Greek god of winds, so there is a suggestion of the presence of a divinity in the approaching storm, and retribution or justice. With hindsight one might see the American Civil War as the whirlwind that was sowed in events such as the one depicted,

but Turner was not to know that. He did have a sense, though, that there would be a day of reckoning for this crime, or at least that such a day would be deserved.

Ruskin's commentary does not draw out any of the moral purpose that might be read into the story, but instead reads as if the morality is in concentrated solution in the salty waters of the sea. In this instance it is not that the painting brings to mind noble associations of ideas, but that (in Ruskin's description) it is the sea itself that is noble: 'I think, the noblest sea that Turner has ever painted, and, if so, the noblest certainly ever painted by man, is that of the Slave Ship.' The description continues at some length, laying in a highly coloured impression of the scene: 'the fire of the sunset falls along the trough of the sea, dyeing it with an awful but glorious light, the intense and lurid splendour which burns like gold and bathes like blood.'

It can be difficult to find brief quotations in Ruskin's writing that do justice to his rhetorical effects. This passage builds, phrase by phrase, through convoluted sentences. To contemporary sensibilities it sounds overwrought to the point of absurdity, but Ruskin's writing was admired for its fine style, and he was read as much for that as for his judgements about artworks. If we allow him his ornate adjectives and exotic vocabulary then we too can be carried along through these purple passages:

Purple and blue, the lurid shadows of the hollow breakers are cast upon the mist of the night, which gathers cold and low, advancing like the shadow of death upon the guilty ship as it labours amidst the lightning of the sea, its thin masts written upon the sky in lines of blood, girded with condemnation in that fearful hue which signs the sky with horror, and mixes its flaming flood with the sunlight, – and cast far along the desolate heave of the sepulchral waves, incarnadines the multitudinous sea.

I believe, if I were reduced to rest Turner's immortality upon any single work, I should choose this.[33]

The dominant colours of the sunset in Turner's painting, around which the composition revolves, are red and gold, the colours of blood and money, which are exactly the things that are central to the depicted incident.[34] The image is full of sentiment and associations of ideas, but the scene is presented in Ruskin's tour de force as a completely accurate and truthful rendering of a natural scene. The intensity of Ruskin's language would make no sense without the moral import of the depicted scene, but that moral content is left unremarked. Maybe it seemed too self-evident to need a commentary spelling it out, and his description is certainly a response to it, even though that is not quite explicit. The adjectives regularly invest the things described with properties that they cannot literally have. A ship cannot be 'guilty'; waves cannot be 'wild', 'fitful', 'furious' or 'desolate'.

Ruskin himself coined the term 'pathetic fallacy' for this type of language. He cited Charles Kingsley: 'They rowed her in across the rolling foam—/ The cruel, crawling foam'.[35] 'The foam', says Ruskin, 'is not cruel, neither does it crawl.' 'Pathetic' here means 'relating to feelings' and it is a fallacy because the feelings in question are misattributed to inanimate things that do not have them. He argues that it is not necessarily wrong to use such language, because it can be expressive. In moments of strong feeling one's rationality is temporarily unhinged – the foam seems cruel, the ship seems guilty – and a sense of heightened emotion is conveyed to the reader who notices, perhaps subliminally, that the language has become unhinged. Ruskin's analysis of the 'pathetic fallacy' should be enlisted as part of the history of 'affect theory' as we have come to know it.[36] Ruskin argues that its use should be sparing and classifies writers in the following groups: those who have no use for the

pathetic fallacy because they have no feelings, and therefore feel no need to express them; and others who make too much use of the pathetic fallacy, and in their hands the world seems to be full of feelings, but it can easily turn into whimsy and there is no sense of reason in the writing. Ruskin puts Alexander Pope's verses in this latter category, seeing them as definitely 'minor' in their poetic achievements, however polished they might be as performances in versification. The pathetic fallacy becomes interesting when the poet's reason has been established, and when the power of reasoning is evident in the descriptions of emotionally manageable events. It is only when reason is overcome by emotion that the 'cruel foam' starts to have an appropriate effect, and that effect is to convey the emotional state of the poet, not the emotional state of the foam. Some of the most powerful poetry, says Ruskin, is written without the poet becoming unhinged in this way. Dante, for example, and Homer, convey the emotional states of others (the people depicted within the poems) without the poet's own voice becoming emotionally involved. Their capacity for reason enables them to hold a scene at arm's length, and to convey the passion without being personally embroiled in it.[37]

Ruskin wonders how it is that we can find the pathetic fallacy so appealing, when it is not true, and truth is one of the hallmarks of merit in anything.[38] He concludes, 'The pathetic fallacy is powerful only so far as it is pathetic, feeble so far as it is fallacious, and therefore the dominion of Truth is entire.'[39] Ruskin distanced himself from 'philosophers', and did not intend to write like one.[40]

Turning back to the description of *The Slave Ship*, it is clear that Ruskin was writing in this 'unhinged' register, responding in an appropriate way to the story of a commercial atrocity and the approach of a whirlwind. The subject is overwhelming for Ruskin's limited capacity for rationality. He wants us to know that he is overwhelmed by this subject, because he wants us to know that he passionately feels and cares about the plight of

these slaves and the abolitionist cause. The wind and the waves are not 'noble', but the abolitionist cause is noble. The ship is not actually 'girded with condemnation' by the red sky, the colour of which is not inherently a 'fearful hue'. These are Ruskin's projections onto the scene, and they are entirely appropriate. The title of the painting and Turner's poetic fragments give some hints as to how the scene should be seen, and Ruskin enthusiastically participates in the collaboration.

Turner himself made use of the pathetic fallacy in making the sea and sky match the heightened mood that is appropriate to the mass murder. It would have been possible, perhaps, to have depicted the incident on a calm sea with a clear sky, which might have brought out the coldness and cruelty in the decision on the part of its perpetrators. The violence of the colours and the turbulence of the sea do not depict the mood of the villains, but of the viewers of the canvas. For us the story is upsetting and the picture dramatizes the upset. Its horizon is not horizontal, as if we too are at sea and off balance. The scene is magisterially depicted as if it were a natural occurrence. Turner was better able than anyone to depict the formations of clouds and swells. Ruskin's category of truth-telling is not undermined. Also in Turner's technique there is the kind of sublime detachment that Ruskin attributed to Dante and Homer, but which Ruskin himself apparently could not manage at this moment – his writing is appropriately and deliberately unhinged, but Turner's painting is impeccable. There are very many rapid brushstrokes in overlapping colours, building up an effect of blurring that helps convey the impression of these shifting forms. There is nothing crude about it – no angry lashing out with the brushes, no collapse of technique. The bodies in the foreground can barely be made out, except for a hand and a leg, but there seem to be chains there, and some fish presumably feeding on the corpses, but oddly depicted as if on the surface of the water. They are lost to Ruskin's view, as he dwells on the way in which the colours of the

sky are scattered but reflected in the heaving water – a naturalistic effect, but produced here by meticulous artistry. So the scene conveys to us, and stirs in us, its heightened emotion and unhinging horror through a careful rendering executed rapidly but in a mood of protean calm.

The impeccable artistry could be admired, but for Ruskin that was never enough, and never quite the point.

> Painting, or art generally, as such, with all its technicalities, difficulties, and particular ends, is nothing but a noble and expressive language, invaluable as the vehicle of thought, but by itself nothing.[41]

Failure to attend to the difference between an artist having an impeccable technique and actually having something worthwhile to say lays a critic open to 'every form of coxcombry, and liable to every phase of error'.[42] A brilliant technique is a prerequisite, in

Sir Edwin Landseer, *The Old Shepherd's Chief Mourner*, 1837, oil on canvas.

the way that a poet must be able to turn a phrase, but it has to be harnessed to some worthy subject-matter if it is going to succeed as a work of art. Ruskin makes his point with admirable clarity by giving a description of just such a masterly work. It has prominence because it is the first description of a modern work in *Modern Painters*, so it sets the tone for what is to come.

> Take, for instance, one of the most perfect poems or pictures (I use the words as synonymous) which modern times have seen: – the 'Old Shepherd's Chief-mourner'. Here the exquisite execution of the glossy and crisp hair of the dog, the bright sharp touching of the green bough beside it, the clear painting of the wood of the coffin and the folds of the blanket, are language – language clear and expressive in the highest degree. But the close pressure of the dog's breast against the wood, the convulsive clinging of the paws, which has dragged the blanket off the trestle, the total powerlessness of the head laid, close and motionless, upon its folds, the fixed and tearful fall of the eye in its utter hopelessness, the rigidity of repose which marks that there has been no motion nor change in the trance of agony since the last blow was struck on the coffin-lid, the quietness and gloom of the chamber, the spectacles marking the place where the Bible was last closed, indicating how lonely has been the life – how unwatched the departure of him who is now laid solitary in his sleep; – these are all thoughts – thoughts by which the picture is separated at once from hundreds of equal merit, as far as mere painting goes, by which it ranks as a work of high art, and stamps its author, not as the neat imitator of the texture of a skin, or the fold of a drapery, but as the Man of Mind.[43]

Landseer exhibited this picture at the Royal Academy in 1837 and it was an immediate popular success. An engraving of it sold well, and the image is still in popular circulation as a greetings

card. For art critics, though, it has been a problem. At some point during the twentieth century the image started to look hackneyed and, more than that, trashily sentimental. The technical execution of course is brilliant, but no one would now want to claim that Landseer was a prominent exemplar of the 'Man of Mind'. If his reputation is to be salvaged then it would have to be by persuading us that we should be less squeamish about having sentimental reactions to things, and that investing our dogs with quasi-human emotions is legitimate activity for high-minded folk, as a way of demonstrating to one another our fine sensibilities. So far at least Landseer's reputation as a serious artist (as opposed to a miraculously skilful technician) seems unlikely ever to regain the high position it enjoyed in his heyday, but his images are popular and have had appreciative critical attention.[44]

In 1964 Kenneth Clark compiled a selection of Ruskin's writings (*Ruskin Today*) that made no mention of Landseer, nor of other artists that Ruskin admired, such as David Cox. Copley Fielding is mentioned only as Ruskin's teacher, and Samuel Prout and David Roberts more for their shortcomings than for the moments when they inspired Ruskin.[45] The best strategy for rehabilitating Ruskin's reputation was to concentrate on his enthusiasm for Turner. Ruskin's love of Turner's paintings has redeemed him in the eyes of the critical establishment since the 1960s, but when Ruskin first published *Modern Painters* it was the other way round. Turner was the questionable inclusion in need of defence. The other artists were popular and mainstream. Landseer was being collected by Queen Victoria, who had her portrait painted by him more than once. When we look at Turner's work we are inclined to see it as visionary and 'ahead of its time' because it seems to anticipate the Impressionists and therefore belongs more with the future than its own time. But in order to see Turner as Ruskin saw him, we need to bear in mind that the way of looking was formed by way of the Picturesque and the kinds of painting that

sat comfortably in bourgeois drawing rooms, such as that at Herne Hill. Looking back at Ruskin's enthusiasm for *The Slave Ship* we can see that part of the appreciation is in the skilful technique, but that is to be taken for granted in any work that comes into consideration. The thing that makes *The Slave Ship* the work of a 'Man of Mind' is the fact that it permitted Ruskin to project into the scene the associations of ideas that elevate the subject-matter into something that has moral worth. Feeling sympathy for slaughtered slaves is a nobler kind of sentiment than looking fondly on a mournful dog, but it is sentiment nonetheless. Ruskin saw in Turner the sentimental force that he saw in Landseer. There are paintings by Turner where that sentiment does not seem to be in place, where the whole point of the picture seems to be to arrest an effect of the light. Where such paintings are concerned Ruskin falls silent. He had nothing to say about *Norham Castle*, nor about the *Burning of the Houses of Parliament*, *Rain, Steam and Speed* or *The Angel Standing in the Sun*.

Imagining how the arguments set out in *Modern Painters* would have worked for Ruskin's first readers is now straightforward. He sets out at the beginning of the work the claim that public opinion is not a good judge of new paintings, but that if something sustains a place in public esteem over centuries as fashions come and go, then that work undoubtedly has merit.[46] The best judges of new paintings are experts who have studied art and who know what they are talking about. Ruskin, of course, despite his youth, was setting himself up as such an expert. His arguments now often seem tendentious, but we are inclined to find an argument dubious if it reaches a conclusion that we are unwilling to accept. If the conclusion is that we have to accept a sentimental subject as evidence of Landseer's towering genius, then we demur. However, if we have found Landseer's remarkable painting of the profound bond between a man and his working dog a genuinely moving experience, then we trust Ruskin's judgement a little more for having acknowledged its rare qualities. In fact, throughout, Ruskin's taste could be taken

to be middlebrow and populist, with Turner as the exceptional case. For the non-argumentative reader, the book assured at the outset that it was taking a thoroughly elitist view of art, but then as the judgements about individual modern painters came through, the reader would in all likelihood find those judgements unchallenging. The reader would feel like an expert, so would find that Ruskin had excellent taste, and would then be inclined to acquiesce in the over-the-top enthusiasm for Turner. However, not all of Ruskin's readers would react in that way.

The aspect of *Modern Painters* that makes it lively is not so much its endorsement of some artists as its denigration of others. It is this that establishes a distinct character to Ruskin's taste – and the taste of his generation – and distances it from the enthusiasms of the late eighteenth century that were lingering on among 'the followers' of Sir George Beaumont (1753–1827), an accomplished amateur painter, the champion and patron of John Constable (1776–1837) and a collector of Old Master paintings. It was he who proposed the formation of a national gallery, by donating his own collection of paintings on the condition that John Julius Angerstein's collection be bought for the nation and a suitable building constructed to display the works. In 1838 the National Gallery opened its doors in the still-new Trafalgar Square, with relatively few works to show. It was Beaumont's belief – and not only his – that British art would be improved if artists' tastes were ameliorated by exposure to Old Masters. In the preface to the second edition of *Modern Painters* Ruskin said that Beaumont:

furnishes . . . a melancholy instance of the degradation into which the human mind may fall, when it suffers human works to interfere between it and its Master. The recommending the colour of an old Cremona fiddle for the prevailing tone of everything, and the vapid inquiry of the conventionalist, 'Where do you put your brown tree?' show a prostration of

John Ruskin, 'Leaf Curvature, Magnolia and Laburnum', engraved by R. P. Cuff, from *Modern Painter*s, IV (1856).

John Ruskin, 'Oak-Spray', wood-engraving by H. S. Uhlrich after Ruskin's drawing of 1867, from *The Works of John Ruskin*, XXXVIII (1912).

intellect so laughable and lamentable, that they are at once, on all, and to all, students of the gallery, a satire and a warning.[47]

In Ruskin's writing Beaumont becomes emblematic of false taste, which has lost sight of nature and becomes captivated by the conventions of art. Ruskin, however, exempted 'historical painters' from his denigration of the Old Masters, and made it clear that when

he spoke about them disparagingly he meant the landscape painters, especially Claude, Gaspar Poussin [Dughet], Salvator Rosa, Cuyp, Berghem, Both, Ruysdael, Hobbima, Teniers, (in his landscapes,) P. Potter, Canaletti and the various Van-somethings, and Back-somethings, more especially and malignantly those who have libelled the sea.[48]

In other words, when Ruskin speaks deprecatingly of the Old Masters, he means more or less the collections of Beaumont and

Angerstein on show as the nation's art collection. For Ruskin the established taste of Beaumont's generation was overly conventional, but it was this generation's taste presented in Richard Payne Knight's *Analytical Inquiry into the Principles of Taste* (1805) that is perhaps as close as anything was to being a model for *Modern Painters*. Knight himself (1751–1824) was a combative character and primarily a Greek scholar, but also a great collector of Old Master drawings and ancient coins and bronzes. He was a major early benefactor of the British Museum, which developed a little earlier than the National Gallery but moved into new premises at about the same time.

Knight wrote in support of the Associationist aesthetics of Archibald Alison, which Ruskin would also draw upon; but Ruskin was able to supplement the ideas with reference to Dugald Stewart, a friend of Alison, whose work was published later.[49] The sentimental side of Associationism is evident in Knight's choice of outstanding modern pictures. He cites three: Benjamin West's *Death of Wolfe*, Joseph Wright's *Soldier's Tent* (now known as *The Dead Soldier*) and Richard Westall's *Harvesters Sheltering from a Storm*.[50] They are all touching in their different ways – the death of a military hero; a dead or dying soldier sheltered by a makeshift awning, with a dependent woman suckling an infant doing her best to look after him; peasants watching a storm that might be about to destroy their year's crop – but their reputations have not lasted. Benjamin West had a distinguished career, and was president of the Royal Academy, but now his work is known only to specialists. Wright of Derby remains very well known, but it is his depictions of scientific demonstrations that circulate most widely. His painting of the dead soldier remains on display in the Holburne Museum in Bath, where one easily passes it without notice. Westall had an initially brilliant career, under Knight's patronage.[51] The king commissioned him to paint an altarpiece for the new church that John Nash designed for Langham Place in 1824, but he made some

bad investments in overpriced and under-authenticated Old Master drawings, and was reduced to hack work for illustrated books and teaching the young Princess Victoria to draw. Knight loved Claude's paintings and the Dutch landscape painters' work – repudiated by Ruskin. Turner also loved Claude's work and he painted companion pieces that hang alongside Claudes in the National Gallery (as Turner in his will stipulated they must), showing that he could do just as well, but also paying homage to the Old Master.

Knight did make a strong connection between art and morality, which may have influenced Ruskin as he developed his ideas, but then again Ruskin may not have noticed. Knight's morality was derived from his reading of Lucretius, and to other people it tended to look like self-indulgence, whereas there is no mistaking the moralizing in Ruskin's biblically derived pronouncements. Nevertheless, Knight made links between the state of a society and the work that it was able to produce, contrasting the fine achievements of small, self-governing city-states in ancient Greece with the cruder but more copious work of sculptors working in the Roman Empire. There is an adumbration of the thinking that Ruskin would make central to his later discussion of architecture.[52] Knight's love of rich colouring in paintings rather than the Stradivarius-coloured (Cremona fiddle) landscapes might also have been a point of contact with Ruskin; and they were both in accord in their reverence for nature. The strongest similarities, though, are in the high-handed dismissals of revered works of art. Knight described the Sistine Chapel ceiling as 'vast and turgid'. Ruskin was more appreciative of it, but here he is on Leonardo's *Virgin of the Rocks*:

> Leonardo's landscape has been of unfortunate effect on art, so far as it has had any effect at all. In realization of detail he verges on the ornamental; in his rock outlines he has all the deficiencies and little of the feeling of the earlier men. Behind

the 'Sacrifice for the Friends' of Giotto at Pisa, there is a sweet piece of rock incident; a little fountain breaking out at the mountain foot, and trickling away, its course marked by branches of reeds, the latter formal enough certainly, and always in triplets, but still with a sense of nature pervading the whole which is utterly wanting to the rocks of Leonardo in the Holy Family in the Louvre. The latter are grotesque without being ideal, and extraordinary without being impressive.[53]

That is all he says about the picture. It stands condemned for lack of geology. This insistence on accuracy in the representation of nature is unrelenting, and uncowed by reputation. Ruskin's insistence on truth as a guide is repeated and revisited in his work. The realization of its importance for art seems to have come as a revelation. It arrived in a moment, if his account in his memoir is to be believed, and then never left him:

One day on the road to Norwood, I noticed a bit of ivy round a thorn stem, which seemed, even to my critical judgment, not 'ill-composed', and proceeded to make a light and shade pencil study of it in my grey paper pocketbook, carefully, as if it had been a bit of sculpture, liking it more and more as I drew. When it was done, I saw that I had virtually lost all my time since I was twelve years old, because no one had ever told me to draw what was really there![54]

Ruskin saw Turner as a great truth-teller where nature was concerned, opening himself up to experiences of mountains, sky and sea. He defied the conventions of landscape painting as they had developed and managed to establish a place for himself in the art world of his day that gave him remarkable freedom to do as he chose. Turner's early success gave him the confidence to experiment, and his financial security enabled him to travel. He made repeated

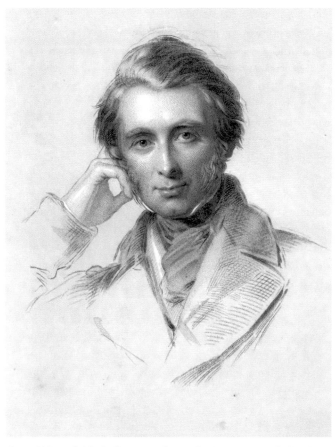

George Richmond, *John Ruskin*, 1843, at the age of 24, in an engraving by Francis Holl after Richmond's drawing in chalks.

visits to Italy. He did not escape criticism, but it does not seem to have influenced him much. He lived austerely, in conditions that looked like poverty, but by keeping his overheads low he amassed a significant fortune and collected his own paintings, which he left to the nation – with young Ruskin as one of his executors. We do not know what Turner made of Ruskin. He apparently preferred

John James's company, but John's public support was clearly good for Turner's prices and he treated him with respect and allowed him to visit.

We know very well what Ruskin made of Turner. He made him a hero and came close to making him a god, but he was left bemused by some of Turner's most extraordinary work. Ruskin had taken offence on Turner's behalf in 1836, before going to Oxford, when a critic poured scorn on the works that Turner exhibited at the Royal Academy.[55] Ruskin's riposte was extravagant. First he replied to the critic, intending to send the letter to be published, but John James forwarded it first to Turner, and he, with a shrug, asked permission to send it on to the person who had bought one of the paintings that was denigrated in the review. Six years later Ruskin's indignation had produced a book, which combined a reasoned appreciation of modern landscape painters, with denigration of Old Masters and passionate unhinged advocacy of Turner. It turned out to be a winning combination. The book was a runaway best-seller and turned Ruskin into the most prominent critic of the age.

3

The Pre-Raphaelites

In March 1842 the Ruskin family moved from 28 Herne Hill to 163 Denmark Hill, eight minutes walk away and actually on the same road, despite its change of name. It was a much larger house, and it made sense to each member of the family in a different way. For John James, then aged 57, it was a better setting for entertaining his clients, but he wondered whether his vanity had too great a role in the decision, and hesitated about it. At 61 Margaret Ruskin thought the move was coming too late in life for her, and she was daunted by the idea of taking on the running of a larger household; but she admitted that she would like a larger garden, and the seven acres of grounds at the Denmark Hill house gave her plenty of potential. John, 23, had misgivings about leaving his childhood home, but came round to the idea when he realized that a field behind the house would be a great place to build the canal about which he had been daydreaming. Looking back on it in his memoir in his sixties, he found it surprising that his thinking was so boyish – 'and very young-boyish, too'.[1]

He was already writing *Modern Painters*, and the first volume was published in 1843 when he was living here. When John James gave him Turner's *Slave Ship*, the painting hung in the hallway at the foot of the stairs, a prominent position where it would be seen by the whole household and by every visitor. In retrospect, though, Ruskin was not so happy with the move. He said that after leaving Herne Hill he never felt at home again, except when travelling and revisiting the places where he had been in his childhood. In his

memoir the garden at Herne Hill is cast as the Garden of Eden (the only differences being that *all* the fruits were forbidden, and there were no companionable beasts).[2] With hindsight the Herne Hill house became a place of ideal happiness – the place where Ruskin had spent his brilliant childhood, sparkling with precocious promise and doted on by the parents whose attention he had in abundance. Wonderful though it seemed at the time, the childhood did not emotionally prepare him for adulthood, and his life became at a personal level problematic. The realization that this would be the case was all in the future when the family moved house, but in retrospect the Denmark Hill house was invested in Ruskin's imagination with a feeling that something was missing – a feeling that pervaded the emotional landscape of his adult life.

The canal project is astonishing for its lack of understanding of practicalities. Ruskin was inspired by a children's story that even he did not find plausible, and he quickly realized that the water the project would have needed would not be available. In some ways he was still very much a child, and the first volume of *Modern Painters* is the culmination of his precocious childhood. The writing is sophisticated and developed, through intense practice and insistent application over the years of his education, but the view of art and the choice of paintings is exactly that of John James and his circle. Young John was at that point still on the same wavelength as his father, and the book is the work of a prodigy, no longer altogether a child. Ruskin's taste transformed, developed and became more idiosyncratically his own by the time the second volume of *Modern Painters* was published in 1846.

The crucial experience that enabled this development was another expedition to Italy, for seven months of 1845. It was the first time that Ruskin, by now 26, had been without his parents' company for more than a few days. The parents worried about their son's health, and tried to talk him out of going. They enlisted Turner's support, thinking that John might listen to him, but

Turner knew how valuable Swiss and Italian experience could be, and his attempted persuasions were not so forceful as to change Ruskin's mind. A family servant, George Hobbs, went on the journey with him, and they met up with Joseph Couttet, a Swiss guide already known to the Ruskins ('the captain of Mont Blanc').[3] They travelled in fine style, in a carriage that had been fitted with a sun-roof and leather frames for the Turner watercolours that went with them.[4] In later years when Ruskin routinely disparaged rail travel, his nostalgia was for this glamorous conveyance. There was a return to the mountains, and earnest searching-out of paintings by early Italian masters, many of them painted on the walls of churches and monasteries, and in a deplorable state of neglect. There are many footnotes in the second volume of *Modern Painters* that detail the shocking mistreatment of major works, and they are sometimes equally stories about the neglect of medieval buildings:

At Pisa – The old Baptistery is at this present time in process of being 'restored,' that is, dashed to pieces, and common stone painted black and varnished, substituted for its black marble. In the Campo Santo, the invaluable frescoes, which might be protected by merely glazing the arcades, are left exposed to wind and weather. While I was there last year I saw a monument put up against the lower part of the wall, to some private person; the bricklayers knocked out a large space of the lower brickwork, with what beneficial effect to the loose and blistered stucco on which the frescoes are painted above, I leave the reader to imagine; inserted the tablet, and then plastered over the marks of the insertion, destroying a portion of the border of one of the paintings. The greater part of Giotto's 'Satan before God,' has been destroyed by the recent insertion of one of the beams of the roof.

The tomb of Antonio Puccinello, which was the last actually put up against the frescoes, and which destroyed the terminal subject of the Giotto series, bears date 1808.[5]

Ruskin's knowledge of the frescoes was acquired not by visiting well-established cultural tourist spots, but by paying people to move stored wood out of the way, or clambering round a carpet factory, so as to be able to see them. After the publication of this volume, Ruskin would suspend his studies of so-called 'modern painters' to write about architecture (in *The Seven Lamps of Architecture* and *The Stones of Venice*). The interest in medieval architecture is already apparent in this second volume, as is the urgent need to raise awareness of it, for the sake of its survival. As yet, though, there is no analysis of the architecture, only observations. It is less clear in this second volume that the subject-matter is 'modern painters' in any sense, as the book is principally about Italian painters who pre-date the High Renaissance, such as Giotto, along with extravagant praise of Tintoretto (whom Ruskin called 'Tintoret'). A handful of the artists who had been praised in the first volume had become familiar with the Ruskins' dining table, but that was not going to happen with the artists in the second.

As in the first volume, the table of contents has a list of analytical chapter headings which sketch an argument that will evidently be substantiated in the text. It is organized as a philosophical work; but again the line of the argument is overwhelmed by the copious detail about a wealth of examples – of paintings and painters – and the book's real impact was made by introducing the public to early Italian painting and Tintoretto. For a modern reader the really startling aspect of the text is its very evident piety.

In discussing aesthetics, Ruskin announces that he prefers to substitute the term 'theoretic'. He suggests that 'aesthetic pleasure' is sensual, and shared with the animal kingdom, but 'the full comprehension and contemplation of the beautiful as a gift of God' is 'the exulting, reverent, and grateful perception of it [that] I call theoria'.[6] So he is making the appreciation of beauty an act of religious devotion. The element of gratitude here is distinctive – the gratitude being directed to God. Section 12 of chapter xv is

entitled 'Theoria the service of Heaven'.[7] Ruskin makes it clear that he sees it as the principal religious duty of humans to be grateful for the wonders of the world – for beauty.

> I believe that the root of almost every schism and heresy from which the Christian church has ever suffered, has been the effort of men to earn, rather than to receive, their salvation; and that the reason that preaching is so commonly ineffectual is, that it calls on men oftener to work for God, than to behold God working for them. If, for every rebuke that we utter of men's vices, we put forth a claim upon their hearts; if for every assertion of God's demands from them, we could substitute a display of his kindness to them; if side by side with every warning of death, we could exhibit proofs and promises of immortality; if, in fine, instead of assuming the being of an awful Deity, which men, though they cannot and dare not deny, are always unwilling, sometimes unable, to conceive, we were to show them a near, visible, inevitable, but all beneficent Deity, whose presence makes the earth itself a heaven, I think there would be fewer deaf children sitting in the market-place.[8]

It is a rapturous view of religion, based on the grateful contemplation of the world's beauties and the gift of life, and that contemplation is Ruskin's Theoria:

> There will come a time when the service of God shall be the beholding of him; and though in these stormy seas, where we are now driven up and down, his Spirit is dimly seen on the face of the waters, and we are left to cast anchors out of the stern, and wish for the day, that day will come, when, with the evangelists on the crystal and stable sea, all the creatures of God shall be full of eyes within, and there shall be 'no more curse, but his servants shall serve him, and shall see his face'.[9]

This is the conclusion to the first section of the book ('Of the Theoretic Faculty') and the concluding quotation is from the last chapter of the last book of the Bible (Revelation 22:3–4) describing the New Jerusalem. The contemplation of beauty is presented as a premonition of Heaven and the afterlife. This makes the pursuit of beauty not only a pleasure but a moral imperative. The beauty of truth is distinguished from the kind of sensuality that can be indulged to excess, and there does not seem to be any danger of surfeit. The problem, rather, is that in our life on Earth there are practical duties that obstruct our ability to contemplate gratefully, but in Heaven all those obstructions have disappeared. This thanksgiving, prayerful attitude is the key to understanding Ruskin, and all his other concerns revolve around it. It is a cult of beauty, but the sense of beauty has a moral and a pious aspect for Ruskin. To accept beauty and to give thanks for it is the basis of piety and the way to find salvation.

The artists whose work Ruskin most valued were those who seemed to be engaged in this contemplative activity. Turner's truthful rendering of the details of topography in his early works and the exalted evanescent atmospheric effects in his later ones stirred Ruskin's appreciation, especially when (as with *The Slave Ship*) they were explicitly tied to a noble moral sentiment. This perception also pushed Ruskin in his own drawings and watercolours away from the Picturesque compositions in which he had been schooled, towards making intense studies of uncomposed details. Sketching passed for him beyond the acquisition of a polite accomplishment to become a kind of prayer, which supplemented (and did not supplant) the more conventional kind of prayer that he practised at Denmark Hill and in continental hotels.

The greatest thing a human soul ever does in this world is to *see* something, and tell what it *saw* in a plain way. Hundreds of people can talk for one who can think, but thousands can think

Fig. 1. Slates of Bull Crag and Maiden Moor. (GEOL? SURVEY

Fig. 2. Pie-Paste. Compression from the right, simple.

Fig. 3. Pie-Paste. Compression modified by elevatory forces.

Drawn by L. Hilliard. Engraved by G. Allen
Fig. 4. Pie-Paste. Compression restricted to the lower Strata
under a rigid upper one

'Lateral Compression of Strata', drawn by L. Hilliard and engraved by
George Allen for Ruskin's *Deucalion: Collected Studies of the Lapse of Waves
and Life of Stones* (1886 edition).

John Ruskin, 'Banded and Brecciated Concretions', engraved by
George Allen, from an article in *The Geological Magazine*, reprinted
in *The Works of John Ruskin*, xxvi (1906).

for one who can see. To see clearly is poetry, prophecy, and religion, – all in one.[10]

When Ruskin's ideas are being rescued for modern students, this prayerful aspect of them tends to be sidelined, but it is at their core.[11] Ruskin's fervour is evident in his writing, and his nineteenth-century readers responded to it, but they also warmed to his moralizing in a way that a mainstream modern audience might not. The claim that beauty, goodness and truth belonged inextricably together was not original to Ruskin, but he did more than anyone to inculcate that idea in nineteenth-century British culture, so that the public art galleries opening up in the industrial towns, supported by benefactions from the prosperous factory owners, were seen as demonstrations not only of civic pride, but as virtuous displays of spiritual awakenings. The public display of artworks was not just a display of taste and status, but a moral good.

Most of Ruskin's favoured artists in this volume belonged to the late medieval or early Renaissance era, crucially before Raphael (1483–1520) and Michelangelo (1475–1564), who were more generally seen as the apogee of Renaissance accomplishment. In Sir Joshua Reynolds's lectures for artists at the Royal Academy, for example, Michelangelo had been the byword for greatness.[12] Ruskin consistently praised Raphael's early work, but saw his later work as formulaic, as was the work of his contemporaries. In Tintoretto (1518–1594) he saw an exception. He was not assimilated into another artist's studio, but set out on his own account, pursuing his own vision. He worked principally in Venice and was immensely successful in securing and completing enviable commissions: he covered huge expanses of the Doge's Palace with paintings on a heroic scale that Ruskin found completely captivating.

'I never was so utterly crushed to the earth before any human intellect as I was today, before Tintoret', he wrote to his father.[13] The comments in the continuation of this letter make it clear that

what excited Ruskin in Tintoretto was the same aptitude that he had found in Landseer: the ability to dramatize states of mind and morality in concrete symbols and actions. It is the skill of the kind of novelist who can describe characters walking and talking, getting involved with one another and with perilous or critical situations; and although we read about actions and events, we intuit states of mind and learn about the characters' morals and values. The technical aspects of representing figures and scenes in painting could be mastered adequately by artists who were not in Ruskin's view of the first rank. What marked out greatness was the ability to find ways of conveying passions and moral and spiritual truths.

> In his massacre of the innocents one of the mothers has hurled herself off a terrace to avoid the executioner & is falling head-foremost & backwards, holding up the child still. And such a resurrection as there is the rocks of the sepulchre crashed to pieces & roaring down upon you, while Christ soars forth into a torrent of angels, whirled up into heaven till you are lost ten times over. And then to see his touch of quiet thought in his awful crucifixion – there is an *ass* in the distance, feeding on the remains of strewed palm leaves. If that isn't a master's stroke, I don't know what is.[14]

The significance of the ass eating palm leaves is that a week before the Crucifixion Jesus rode into Jerusalem on an ass, like a peasant, rather than on a horse like a nobleman, and was received by friendly and excited crowds who covered the way with palm leaves as an expression of honour, commemorated in the Church calendar with Palm Sunday, the week before Easter. The same crowds called for the pardon of Barrabas rather than Jesus in the run-up to the Crucifixion. The presence of the donkey and the palm fronds brings to mind the events of the week before and draws attention to the fickleness of public opinion.

No critic before or since Ruskin has had quite such a high opinion of Tintoretto. He persuaded more people to his point of view with his appreciation of late medieval and early Renaissance works. The point of these works for Ruskin was as sincere and effective expressions of piety. Fra Angelico (1395–1455), a Dominican friar, for example, persuasively conveys genuine sentiment where others would manage only pictorial bombast.

> The same great feeling occurs throughout the works of the serious men, though most intensely in Angelico, and it is well to compare with it the vileness and falseness of all that succeeded, when men had begun to bring to the cross foot their systems instead of their sorrow.[15]

Ruskin goes on to castigate Bronzino (1503–1572) for his treatment of the same subject. Bronzino was a skilled, academically trained painter, and painted rather flashy portraits, which have their appeal, but his technique was much less effective than Fra Angelico's when it came to conveying religious feeling. Bronzino's figures tend to look burnished and glamorous, where Fra Angelico's look quietly thoughtful.

Ruskin's critiques were published in 1846 and introduced the works of the early Italian masters to the mainstream public. He was appreciatively read by the group of friends who went on to style themselves the Pre-Raphaelite Brotherhood. The name and their approach to painting were inspired by Ruskin, or by the artists he recommended in this second volume of *Modern Painters*. The group initially was composed of John Everett Millais and William Holman Hunt, who were students at the Academy, and Dante Gabriel Rossetti. He was the real ringleader of the group, a poet who had turned to painting and taken Ford Madox Brown as his teacher. These painters declared themselves to be the Pre-Raphaelite Brotherhood in 1848 and in Millais' parents' house on Gower Street

drew up a constitution, but kept the existence of the 'brotherhood' secret from the academicians. The following year Millais and Hunt exhibited works at the Royal Academy's summer exhibition, signed with the initials 'P.R.B.'. They used clear bright colours, more reminiscent of medieval paintings than the chiaroscuro effects that had become the norm since the Renaissance. Instead of losing the background to deep shadows, from which the principal subject could emerge as if from twilight – a strategy that could be found in painters as diverse as Leonardo, Caravaggio, Rembrandt and Reynolds – they favoured brightly lit scenes in which every leaf and blade of grass was meticulously painted, every fibre of the fabrics in the foreground. They were guided by nature, and the vitality of things around them, not by the conventions of the Academy, Beaumont and the National Gallery. There was a preoccupation with links between painting and poetry, and with morally uplifting subject-matter. All these elements of their manifesto were drawn from Ruskin, and incorporated into the paintings, which were brilliantly executed. The detailed work was meticulous in comparison to the sketchy backgrounds favoured by the established academicians, which made it laborious work for the artist, but for the viewer there was much to discover in the detail. The brilliance of the colours made the paintings stand out, and the detail kept the viewer's attention. The imagery was fresh, and even when the scenes were historical they were less heroically idealized than was the norm, so it seemed as if real people rather than mythical beings might have enacted the scenes.

The Pre-Raphaelites would have a profound effect on nineteenth-century painting in Britain.[16] The intense colours, minute detail and moralistic imagery came to seem typical of Victorian art, though there were other aspects to that art world. The history paintings of earlier generations started to look hackneyed. Victorian history paintings strive for the effect of a colour photo of the event, colour photography of course being still a practical impossibility. Ruskin

was enthusiastic about photography and its capacity to record the appearances of things. When the first Pre-Raphaelite paintings were encountered they shocked, because they did not follow the academic conventions of the day. The people looked relatively ordinary, the compositions were not formulaic and were sometimes deliberately ungainly, and no one could mistake the intensity and seriousness of the artists' visions – at least no one in the wider public. The people who could miss the paintings' merits were the critics with established educated tastes, and they were on the whole dismissive, seeing the pictures as garish and coarse. That is why Ruskin's voice was so important to the Pre-Raphaelites. He recognized the merit in their works and championed them against their critics, who included Charles Dickens.[17] The official 'brotherhood' disbanded (or decomposed) after a few years, but its influence continued. Ruskin was not responsible for all of this, but the Pre-Raphaelites are an important part of his story, not only because they took inspiration from him, but also because he saw their merits before others did, and in retrospect that has earned him credit as a perceptive critic. At the time his reputation was high, and he did the Pre-Raphaelites a service by endorsing them. Both they and he went out of fashion during the twentieth century, and were subsequently reappraised. The narrative immediacy, which did so much to recommend the pictures to a popular audience, did not recommend them to twentieth-century critics, who had other expectations from high art. The Pre-Raphaelites' merit is no longer in doubt; but in both cases – Ruskin's and the Pre-Raphaelites' – the reputations have been remade by playing down the moral sense and the sentimentality that recommended both the paintings and the critical commentary to the original audience. When critics admire the paintings now, it is most likely to be for the sharpness of the vision or the beauty of the designs. The concern for detail can seem obsessive, but there is no doubting the exquisite skill in the execution of the paintings and their atmosphere, which can be compelling in its immediacy or

sweetly dreamy. The wider public, less concerned with technique, has been more ready to respond to the subject-matter – as Ruskin would have wished – and is still attracted to paintings whose subjects seem to live and breathe, whether or not the art world will indulge the public by staging exhibitions of such work.[18] The prayerful and meticulous contemplation-through-drawing that Ruskin explained in theoria, had its basis in the careful and sustained rereading of the Bible when Ruskin's mother was conducting his education.[19] If the Bible was to be read carefully and scrutinized for its true sense, so too was the natural world, which was God's creation. Parts of it, such as the Alps, had remained in something like their raw state since the creation.[20] Richard Payne Knight had pointed out back in 1805 that the term *picturesque* meant 'after the manner of painters', and he imagined that 'the manner of painters' was to blur forms, so that rather than depicting every leaf on a tree or every hair on a head, the painter would show an indistinct mass of an appropriate hue which would, maybe at a distance from the painting, give an appropriate effect.[21] One might detect the origins of this technique in Leonardo's *sfumato* effects, giving miraculously blended flesh tones and misty distances, and see it in the soft figures in Giorgione's paintings; but in the Pre-Raphaelites' eyes it had become a painterly manner that made it possible to dash off a painting without giving care to the detail. Their nickname for Joshua Reynolds was 'Sir Sloshua', and what others might have admired as bravura brushwork, they denigrated as 'sloshiness'.[22] The painstaking rendering of detail in the Pre-Raphaelite paintings actively resisted 'the manner of painters', so should be seen as deliberately anti-Picturesque.

Ruskin revisited Italy with his father, to show him some of the things he had discovered while researching the second volume of *Modern Painters.* He realized that his taste had developed away from his father's, and he hoped to open his father's eyes to what he had seen. The attempt was not entirely successful. W. H. Harrison wrote

hoping that John might be able to produce a poem or a Picturesque description for a Christmas gift anthology, *Friendship's Offering*, to which he had made contributions in the past. It was John James who replied, rather regretfully, that his son was not only no longer writing poetry, but that he regretted ever having written any. He explained that John was searching for 'real knowledge' in art,

> but to you and me this knowledge is at present a Sealed Book. It will neither take the shape of picture or poetry. It is gathered in scraps hardly wrought for he is drawing perpetually but no drawing such as in former days you or I might compliment in the usual way by saying it deserved a frame – but fragments of everything from a Cupola to a Cartwheel but in such bits that it is to the common eye a mass of Hieroglyphics – all true – truth itself but Truth in mosaic.[23]

Ruskin's main criticism of the Old Masters was that they had not always looked hard enough or steadily enough to see things properly. Even Leonardo, whose extraordinary draughtsmanship in his anatomical drawings as evidence of boundless curiosity might have silenced Ruskin's objections, was, as we have seen, found to be wanting when it came to looking at rocks.[24] For Ruskin this was no trivial matter, but showed a very fundamental error that had far-reaching ramifications:

> The laws of the organization of the earth are in the landscape the foundation of all other truths – the most necessary, therefore, even if they were not in themselves attractive; but they are as beautiful as they are essential, and every abandonment of them by the artist must end in deformity as it begins in falsehood.[25]

In the light of these comments it is clear that it was not by hazard that when Ruskin commissioned Millais to paint his portrait, he

chose a background of rocks and water. The commission came at a time when Millais and Ruskin admired and inspired one another. The biographical circumstances of the painting's production are also significant in Ruskin's life, and we will come back to them, but for now consider the image itself in relation to other images and first in relation to the text of *Modern Painters* 2, in which, as well as the more general principles, there is a passage that seems more specifically to inform its design. Ruskin discusses the idea of 'repose' in art, and finds it to be the distinguishing character of great art. The text is worth reading at length, but here is the start:

Repose, as it is expressed in material things, is either a simple appearance of permanence and quietness, as in the massy forms of a mountain or rock, [. . .] or else it is repose proper, the rest of things in which there is vitality or capability of motion actual or imagined; and with respect to these the expression of repose is greater in proportion to the amount and sublimity of the action which is not taking place, as well as to the intensity of the negation of it. Thus we speak not of repose in a stone, because the motion of a stone has nothing in it of energy nor vitality, neither its repose of stability. But having once seen a great rock come down a mountain side, we have a noble sensation of its rest, now bedded immovably among the under fern, because the power and fearfulness of its motion were great, and its stability and negation of motion are now great in proportion. Hence the imagination, which delights in nothing more than the enhancing of the characters of repose, effects this usually by either attributing to things visibly energetic an ideal stability, or to things visibly stable an ideal activity or vitality.[26]

Striving for unity in a painting, it is necessary to show rock at its liveliest and people at rest. The quality of 'repose' is certainly evident in the portrait, but notice also the means of achieving it across the

whole painting. The human figure, Ruskin, is at ease, with something of the posture of a classical Greek athlete: his weight supported on his left leg, while his right leg is relaxed and stabilizing rather than supporting. The unevenness of the ground makes his right leg bend a little more than those in actual classical examples of this type, but he is readily seen as a figure in repose, looking horizontally into the far distance and not in some artificially arrested motion. The water in the scene is in action, portrayed here with the help of knowledge gleaned from photographs. Leonardo made studies of water in motion, comparing the forms made in its onward rush, twisted by turbulence, with the lines taken up by curling hair. Millais' representation of water is informed by the photograph, and he can depict the lines made by the water drops as they blur their way across the photographic plate during its long exposure to the scene as it gathers its information from the daylight. The rocks on which Ruskin stands are also remarkable. He took Millais to Scotland to paint them. The thing that matters about them is that they are veined in contrasting colours, and the forms of their striations make it clear that the rocks also were once fluid. It may have been many millions of years ago at the first creation, but their veins make it clear that they once flowed in much the same way as the water that now flows over them. Ruskin seems to have talked Millais into doing what he describes Wordsworth as doing in the continuation of the passage quoted above: the human figure is static; the inert matter suggests animation. It is worth making a comparison with Leonardo's *Virgin of the Rocks*, which Ruskin criticized, because the portrait can be seen almost as a 'corrected' version of the scene. The elements of Leonardo's composition by contrast look very synthetic, as if he had designed them himself from first principles; Millais' approach is much less analytic but in giving his full attention to the superficial appearances of nature, he is subordinating his own inferior intelligence to that of nature and the result is wonderfully harmonious.

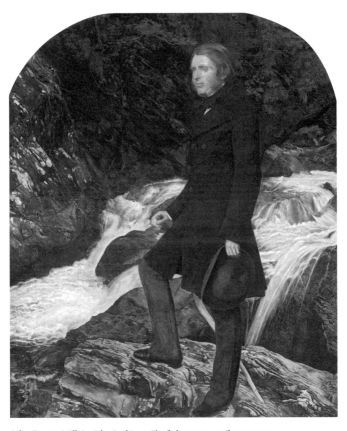

John Everett Millais, *John Ruskin at Glenfinlas*, 1853–4, oil on canvas.

Ruskin's appearance in the image might be a deliberate echo of Wordsworth's in the portrait of him that Benjamin Robert Haydon exhibited in 1842. Haydon (1786–1846) would have been known to Millais by reputation at least, as someone who used to haunt the Royal Academy and its rival organization the British Institution, which lasted from 1805 until 1867. It was set up to promote the views of patrons and critics who thought that the artists of the Royal Academy had come to be overly interested in portrait painting,

which paid reliable money, to the detriment of the nobler art of history painting. Haydon was an indefatigable advocate of history painting and wanted to be the founder of a new school of British history painters.[27] In this enterprise his greatest asset was his conviction of his own genius. The great obstacle was that he could convince few others. He was a friend of Keats, and his portrait of the Duke of Wellington inspired Wordsworth to climb Helvellyn, the Lake District's tallest fell. That in turn inspired Haydon to paint a portrait of Wordsworth on Helvellyn. Haydon's draughtsmanship was often good, but his paintings are mostly terrible. Reproductions do not catch the clogged quality of his paintwork, which did not pass muster at a time when painterly bravura was in vogue. The picture is easily found. It is in the collection of the National Portrait Gallery in London and can be searched on the Internet. Even a small reproduction shows how misjudged is the design of the composition. Wordsworth is supposed to be on top of a mountain, but that is not evident. There are some dark clouds and some cloud-like rocks that have been sloshed in in the background. Wordsworth's gaze is cast down, which is arguably appropriate for someone standing in a high place, but it makes him look somnolent. It is worth making the comparison with Caspar David Friedrich's earlier *Wanderer Above the Sea of Fog* (1818), to see the opportunity that has been missed. Friedrich's reputation was late to arrive in Britain, and Haydon did not know his work. More strangely, neither did Ruskin. Friedrich's painting was smaller than Haydon's, but it gives a sense of the majesty of the high place that is utterly lacking in the portrait of Wordsworth where it would have been very much to the point. In the portrait of Ruskin it is as if Millais is taking Haydon's portrait and making corrections to it point by point. The central figure is identically dressed, conventionally enough in a dark frock-coat with a white shirt and a black neck-tie. Where Wordsworth is given a hunched and brooding posture, Ruskin is made to stand like a classical athlete, and instead of looking

downwards and therefore accidentally drowsy, he looks to infinity at the horizon and so takes on a visionary air. Then the thing that leaves Haydon dead in the water is that Millais' gaze has not been focused solely on the great man, but he has rendered every square centimetre of the canvas with equal intensity, so the whole relation between man and nature seems to be differently conceived. Where Wordsworth is portrayed as an isolated thinker, Ruskin is portrayed as a part of nature along with the once-molten rocks and the ferns and the rushing rivulets: they are all elements of God's creation and all in it together. It is Ruskin's vision as much as it is Millais', and it springs from ideas that were taking shape when Ruskin was travelling in Italy without his parents, learning about the art world before Raphael, seeing the churches on whose neglected walls the images were painted or hung, and experiencing twice more – on the way there, and on the way back – the sublimities of the Alps.

The once-in-a-lifetime grand tourists of the eighteenth century may have travelled with trepidation, but when they arrived in Italy they fell in with others and there was scope for roistering as well as study; but that was not Ruskin's way. His coach was elegant but his manner was studious, and his companions sedate. He did not follow the eighteenth-century example and return as a man of the world, still less forsake a sweetheart and a son in France as Wordsworth had done.[28] Ruskin's progress was accompanied by morning prayers and feverish study. He knew he was on to something.

Now, to backtrack: the portrait was painted when Ruskin and Millais admired one another, and that admiration might have continued on the professional plane, had their personal circumstances not been so violently changed. The circumstances were brought to their catastrophe by the portrait – or rather by the circumstances in which it was painted. The short version of the tale is that the painting of the portrait saw Millais and Ruskin living together in a Scottish cottage, along with Ruskin's wife, Effie. The painting took longer than was expected, and by the end of the stay Effie

and Millais were in love with one another, and Effie went on to leave Ruskin and marry Millais. Millais thought that Ruskin had treated Effie very badly, and Ruskin thought Millais had made it impossible to continue their friendship, so their relations cooled. Here is a more detailed version of that story. Ruskin married Euphemia Gray in 1848, when he was 29 and she was nineteen. The marriage was famously annulled six years later because it had not been and would not be consummated. Legally speaking, the marriage never took place because the contract was never completed. The annulment caused a scandal at the time because Ruskin was a well-known figure, and also because the reason for the annulment was so extraordinary. There have been many accounts of this non-marriage, and a huge amount of speculation has fleshed out the bare outlines.[29] There were few facts in the public domain, but a great deal of gossip. The tendency of gossip is rarely to make the actual facts less sensational, and a scarcity of facts leaves a vacuum that can be filled by speculation. The codes of polite behaviour meant that the people who actually knew what had happened, John and Effie, were unable to speak frankly in public about it. Intellectually the period when John and Effie lived together was very productive for Ruskin and saw the writing of *The Seven Lamps of Architecture* and *The Stones of Venice*, but the domestic life that was going on behind closed doors was not what the world assumed it to be.

For a young man who was as close to his parents as Ruskin, a marriage to anyone at all would have brought problems. He was too closely chaperoned to have had adventures with women, even when he was at university, but it was not only his mother's presence that held him in check. He was also constrained by his own personal moral sense, from which there was no escape. A conventional nineteenth-century bourgeois would have maintained an appearance of proper behaviour but might secretly have been doing things that would not have been compatible with invitations in polite society. For Ruskin there was none of this conventional hypocrisy; nor had

there been for his father, the 'completely honest businessman'. The Ruskins expected high standards of behaviour from themselves.

John's infatuation with Adèle Domecq seemed at first to be a very typical adolescent experience, but he did not move on from it in the way one would expect. He nurtured the rejection and for years afterwards seems to have been able to suffer from it. His extraordinarily sheltered upbringing gave him an often self-directed intellectual development that served him wonderfully well; but socially he remained reticent. He admired men who, like his father, could move with confidence in the social world, but he realized that that was not his own character. He remarked that had he been a woman he would not have been attracted to a man such he.[30] So he could forgive Adèle's indifference to him and that did not make her any the less desirable. Nobody thought that Ruskin was the type to be a sexual predator, and he later had friendships with women and no hints of impropriety clouded them. He did not feel that he was attractive, and the low self-esteem he felt in this aspect of his personality became an established part of his character – quite different from the intellectual confidence on display in his writings.

Effie first visited the Ruskins' house at Herne Hill when she was twelve. Her father was a lawyer, based in Perth in Scotland. He called to consult John James Ruskin on family business and brought his daughter with him. In Perth they lived in the house, Bowerswell, which had once belonged to the Ruskins, where John James's father committed suicide. During the London visit John must have ended up entertaining the girl, probably by telling her a story that he promised he would one day write down. Perhaps unexpectedly he actually did so later that year when he was at Leamington Spa, bored. He had been sent there for the sake of his health. The story was revised and published ten years later, after John and Effie had married, as *The King of the Golden River*. It became Ruskin's most popular book. Clearly the child had made an impression on him, but at first it was not a romantic

impression. At that time Ruskin was wondering whether to enter holy orders and become a priest as some of his closest friends had already done, and as his mother wanted. He and Effie subsequently met a couple of times over the years, without it seeming to mean much, and in 1847 John formed an attachment of some sort to Charlotte Lockhart, a granddaughter of Sir Walter Scott.[31] Their romance seems to have been entirely a work of John's imagination, as he did not manage to say anything of consequence to her when they were together, so he decided to go to the Lake District and from there write to her in London, intending to address more important matters than he had managed face to face. Goodness knows how he thought this would help. He stayed at Ambleside and fell into a depression as he was drawn into reflecting on his futile passion for Adèle Domecq ten years earlier. Had he lived in a later age he would certainly have seen a therapist, but the workings of Ruskin's unconscious had to remain turbulently mysterious, while he found some sort of soothing effect in the 'black water, still as death', and 'dismal moorlands' around Windermere.[32]

When he returned to London in May, Effie was staying with his parents. She was impressed by John's invitations to glamorous events; they went to the opera together and enjoyed the company of visitors. It sounds as though the social whirl was untypical for John, and when Effie left to return to her parents in Scotland he fell back into his depression and seemed to need some time by himself to recuperate. He went back to Leamington Spa, where the treatment seemed to have been good for him the last time, and while he was there he was joined by his friend William Macdonald, who invited him up to his shooting lodge in Scotland. In August Ruskin went up to Perth and met Effie's father at his office and then joined Macdonald's shooting party.[33] He stayed with Macdonald, but did not join in the sport, and arranged to visit the Gray family, turning up there at the beginning of October.

During the intervening weeks there was a flurry of letters between the Ruskins and Mr Gray. Effie was being considered as a possible wife for John, but no one told her about it, so when John visited the family for a few days in October she treated him like a family friend and no more warmly than that. John evidently proposed to her, but was rejected. On 10 October, on his return journey south, he wrote to Effie's mother from Berwick, imploring her to send him a message that would reach him at Leeds, reassuring him that he was a little missed at Bowerswell – by the mother at least.[34] Not one but two letters reached him at Leeds, and they were not from Mrs Gray, but from Effie. They have been lost, as has John's reply, but they indicated a change of heart, prompting him to renew his proposal by letter, and this time it was accepted.[35] We do not know what prompted Effie's change of mind, or how much her father might have tried to influence the decision. Part of the problem was that Effie had already told another young man that she would marry him when he returned from India, and this engagement seems to have been known about in Effie's circle, but not more widely.[36] Effie asked John to keep their engagement secret, and he agreed, not telling even William Macdonald.

Many letters were sent between the Ruskins and the Grays, not all of which survive. John left Bowerswell on 9 October 1847, when his unanticipated proposal had been refused, and did not meet Effie again until mid-March 1848, shortly before the actual marriage on 10 April.[37] By then everything had been decided. The courtship was almost entirely conducted in handwriting. The last time John had actually met Effie she had let it be known that she had no romantic feelings for him, so whatever chemistry there might have been between them was entirely imagined. On the page it sounds passionate enough:

Ah, Effie – you have such sad, wicked ways without knowing it – Such sweet silver under-tones of innocent voice – that when one

hears, one is lost – such slight – short – inevitable – arrowy
glances from under bent eyelashes – such gentle changes of sunny
and shadowy expression about the lovely lips – such desperate
ways of doing the most innocent things – Mercy on us – to hear
you ask anybody 'whether they take sugar with their peaches'?
– don't you recall my being 'temporarily insane' for all the day
afterwards – after hearing you say such a thing . . .[38]

It is unlikely that Effie recalled anything of the sort – the letter
was written fully two months after she had seen him. 'You say you
love her more the oftener you write to her', said Margaret Ruskin.
'May you not be in some degree surrounding her with imaginary
charms? – take care of this.'[39] The mother was right, but how else
could the relationship have prospered? Most of Effie's letters to John
are missing, some of them destroyed by her family.[40] She professed
herself to be 'happy beyond telling in thinking you love me so much',
and said 'Many trials we shall probably have but not from want of
love on either part.'[41] John's way with words is more unhinged and
suggests the heightened state of a real passion, while Effie is sedate.
The older Ruskins were, as ever, concerned with John's health and
may well have hoped that a happy marriage would be the lasting
cure for his lingering neurasthenia; the troughs of his depression
made him vulnerable to his tubercular weakness. There is always
caution and overreaction to the anxieties about John's health.
When John learnt about Adèle's marriage it brought on an episode
to which his parents reacted by taking him away from university
and through the Alps. A setback in the marriage plans would
certainly have made John's parents worry for the effect on his
fragile state of mind and body, so a second courtship developed
alongside the first, involving the two fathers, and probably Mrs
Ruskin knew what was going on.

George Gray's finances were in ruins. He had speculated in
shares in a French railway and lost much more money than he

could afford when the French king, Louis-Philippe, was deposed in February 1848. Part of the arrangement was that when John and Effie married, rather than bringing a dowry, John James Ruskin would hand over £10,000 to Effie.[42] Everything seemed to go swimmingly. John and Effie were married at a small ceremony in the drawing room of the Grays' house, Bowerswell, on 10 April 1848.[43] Ruskin's parents were not present, unable to face the memories the house held for them.[44] The day itself seemed to pass very happily and no one suspected that anything was wrong until much later. Now we know that six years later the couple would separate and the marriage would be annulled, unconsummated, so looking back we are inclined to see from the start that things were not quite right. It seems strange and inauspicious that the parents did not witness their beloved son's wedding. None of John's close friends were there, and Effie's best friend, Lizzie Cockburn, did not attend, despite having been invited to be a bridesmaid.[45] She would have known about the engagement that had been broken, and might have believed that Effie had been coerced into marrying a much less attractive man.

John and Effie were both virgins and sexually naive to a degree that seems scarcely possible today. In the respectable bourgeois culture of nineteenth-century England sex was not often openly discussed, but it was around. Virginity would be expected of a bride, but not necessarily of a groom. Young men were expected to have sexual adventures and to keep quiet about them; prostitutes, servant girls, widows or wives might be involved, but scandal would be avoided if word did not spread and if there were a pregnancy then an unmarried woman would be found a husband. Had Ruskin been less morally fastidious and more energetic, he might have had as much premarital sex as his contemporaries; but then he would not have been Ruskin. What he said in a legal statement six years later, when things were unravelling, was that Effie had been upset by her father's financial problems, and on the wedding night she 'appeared

in a most weak and nervous state in consequence of this distress'.[46]
This certainly makes it sound as though the money was discussed
on the wedding night, and the whole marriage must suddenly have
looked much less romantic than he had until then taken it to be.
This would surely have been enough to check his imagined passion.
He had thought that two kindred spirits were uniting, but found
instead that Effie was upset and could imagine that she had been
more or less sold as a way of keeping her family afloat. A less sensitive
soul might have laughed it off and had his wicked way with her, but
they talked it through and made an arrangement that the marriage
would be consummated six years later, when Effie was 25. This would
have seemed at such a distant remove in the future that it felt like
an indefinite postponement. 'For my part', said John, 'I married
in order to have a companion – not for passion's sake.'[47]

As an arrangement it sounds naive, but they were naive – both
of them. There has been a great deal of lurid speculation about
what happened. Ruskin said of Effie that 'though her face was
beautiful, her person was not formed to excite passion. On the
contrary, there were certain circumstances in her person which
completely checked it.' And Effie said that 'he was disgusted with
my person the first evening April 10th.'[48] These comments have
left people wondering what on earth could have been so disgusting
about Effie. Was he alarmed that she had pubic hair? Most of
the naked women that Ruskin had seen would have been Greek
statues, and they were modelled without it. Was it that Effie was
menstruating at the time? There is in fact no need to try to imagine
what might have revolted Ruskin, because his use of the term
'disgust' was different from ours. He would have been saying
merely that Effie's body was not to his taste.[49] The thing that
sounds very wrong and odd here is the way that Ruskin seems
to be appraising Effie's body as if it were a work of art, for
aesthetic contemplation, as if – were it perfectly beautiful –
he would irresistibly have been drawn in. But people have been

known to make love in the dark, and in 1848 there would have been only subdued candlelight in the room. Far from reaching out to cuddle and reassure Effie that she would be safe with him, he seems to have kept her at a distance, objectified and appraised her; so no wonder the passion was checked. The thing that made Ruskin keep Effie at a distance was 'her person', which has been taken to mean her body, but we should understand it differently. What he meant was that he had problems with Effie as a person, with her personality. The thing that kept his passion in check was that he had just learned that in order to save her family from ruin, she had broken off her earlier engagement and had agreed to marry John. From his point of view, with his ultra-fastidious moral sense, he had been dealt a shocking blow. Effie, he realized, did not feel romantically drawn to him, but had the character of a whore, and married him for the Ruskin family's money. Those were the 'circumstances in her person' that completely checked passion. The resolution to live celibately was a way of avoiding immediate scandal, and there was tact and decency on John's part in not forcing himself on Effie when she clearly was not ready. It is difficult beyond that to guess how much of their life together was naive self-deception, hoping that things might eventually work out, and how much was the result of John having made up his mind about Effie's character, knowing that she was not fit to be his wife, and then giving her enough freedom to compromise her reputation so that a divorce might be possible. We do not know how many celibate marriages there are and have been, but in the nineteenth century abstinence was the most widely practised form of contraception, and Ruskin did not want to have children, fearing they would interfere with his work. There were childless couples among his apparently happily married friends.[50] Misguided ideas about 'purity', naivety, caution, fear of childbirth and general inhibition from talking about these things surely account for the state of affairs. Had Ruskin been more robustly constituted, things

would no doubt have been different. Ruskin's own language does him no favours. He thought he was attracted to women because he saw that they could be beautiful; but he never seems to have understood erotic stimulus as something different from aesthetic appreciation, or even theoria. This might be because he did not have the language to make such distinctions, but so far as we know (but then, how could we know?) his body was never sexually aroused by another. What Ruskin did have was an obsessive imagination, which led him from time to time to form attachments to women, but they were never relationships that involved them having sex together. It is always a matter of Ruskin feeling 'sympathy', but in a way that a psychoanalyst would call 'projection'. He projected his feelings on to the other party, and turned her into an obsession, rather than developing a rapport. However, these obsessive 'romantic' relationships were few and Ruskin had good friends who were women.

The circumstances around the wedding were strange, with few people in attendance and notable absentees – not only John's parents, but also anyone else who was close to him, or from beyond the Gray family. Many seem to have thought it an odd match, and there was gossip about the lack of closeness between the newlyweds, some of it certainly retrospective.[51] Robert Brownell speculates in his recent book about the marriage that the thing that kept John James Ruskin away from the ceremony was his pride. In Perth the Grays' financial problems were known, and John's effete manners made him an unconvincing suitor, when it was known that there were more dashing alternatives who had already caught Effie's attention. He suggests that John James avoided the personal discomfort that would have arisen from attending what was recognized locally as a marriage of convenience. Moreover, had he been in Perth when John realized what was going on (as he evidently had by the wedding night), then perhaps he would want to back out of the ceremony and call the whole thing off. Given the

arrangements with the financial settlement, that would be impossible at a practical level if John James remained in London.[52] There is speculation here, and John James is credited with being able to second-guess his son's behaviour and to plan pre-emptively, but it has more plausibility in it than the more lurid speculations about John's sexual naivety, which can certainly be dismissed.

The dynamics of the relationship were always awkward for Effie. John's writing was the important thing in his life, and it entailed isolation, which left Effie feeling ignored. This neglect gave her a surprising degree of social independence in London, where they settled in a house in Park Street, between Grosvenor Square and Hyde Park. John James Ruskin paid for the house, and John, ever the dutiful son, went to visit his parents at Denmark Hill most days. He went there to work, and never moved his library out of his parents' house. When Effie's views differed from the senior Ruskins', John sided with his parents. So although to the outside world the young married couple seemed to be living a glamorous life in high society, Effie knew that the marriage was not working as it should. She was continually criticized for her extravagance and her taste for gaudy clothes, and John James complained to George Gray about his daughter's extravagance; but then it came to light that it was in fact John's purchases of books and pictures that were unbalancing their domestic economy.[53] He had been given enough to allow him to be financially independent, but lived beyond even those generous means and remained very dependent on his father's goodwill, which he continued to accept as a personal law. Effie was encouraged by the Ruskins when they noticed that she had managed to persuade John to circulate more in society, but most of what came her way from them she felt to be critical, while they endlessly fussed about John's health.[54]

In 1849 Effie seems to have succumbed to a depressive illness, which her mother-in-law thought she had brought on herself, as she had everything a woman could reasonably want.[55] It was

J.M.W. Turner, *The Dogana, and Santa Maria della Salute, Venice*, photogravure by George Allen, from *Modern Painters*, I (1843).

arranged that Effie would go to stay with her parents in Perth, to buck her up, but while she was with them there were bereavements in the family and she did not get better, so the stay was prolonged and she did not join the Ruskins when they went to the Alps. They left in mid-April and were away for five months.[56] They returned, and John, with some reluctance, went to meet Effie in Perth at the end of September.[57] Effie suggested they go to Venice, an idea that had the support of her doctor. John James Ruskin, who would be paying, agreed. Preparations were made, and they were on the road almost immediately, travelling with Charlotte Ker from Perth as a companion for Effie, and George Hobbs, who again assisted John.[58] Effie and John travelled in separate carriages, and sometimes by rail, and stayed a while in the Alps.[59] It was quite insane to go to Venice just then: the place had recently been under siege and there had been an outbreak of cholera. It was hardly the ideal place to go for the sake of one's health, and when they arrived there were no other tourists. The Venetian population spoke Italian, but Italy had

never been any closer to being a nation-state than when the various kingdoms were brought under the same administration under Napoleon. Now Venice was part of the Austro-Hungarian Empire, and it was imperial troops that maintained law and order. There were popular stirrings of the political outlook that would lead to the unification of Italy, but Ruskin's political sympathies were with the Austro-Hungarians, and he and Effie fell into company with the officers more comfortably than with the Venetian nobility. They stayed at the Hotel Danieli, close to the Piazza San Marco, with views across the water to San Giorgio Maggiore, one of Palladio's fine churches. The city was fantastical, John's parents were far away, John was excitedly engaged with his work, and this became for Effie the happiest interlude in her almost-married life. She and Charlotte went to many social gatherings and made friends. There must have been gossip, but there was no actual scandal. Effie grew quite close to one of the Austrians in particular, Charles Paulizza,

John Ruskin, *Moonlight on Venice, from the Lagoon*, photogravure by George Allen, from *The Stones of Venice*, II (1853).

and others may have suspected a developing romance. If Ruskin had any sense of it he did not show any symptoms of jealousy, but encouraged the friendship and wrote warmly about Paulizza himself, saying that he was one of his best friends in Venice:

> I have never known a nobler person. Brave, kind and gay – as playful as a kitten – knightly in courtesy and in all tones of thought – ready at any instant to lay down his life for his country and his emperor.[60]

Paulizza had helped Ruskin to gain access to Venetian buildings under military control, and by the time Ruskin wrote these lines Paulizza was dead, so they have an obituarist's generosity. Ruskin's work in Venice will be discussed in chapter Five. Whether the marriage could have continued indefinitely on such terms is impossible to say, but in these particular circumstances everything seemed to be working well enough for John and Effie. Paulizza might have turned his attentions to another woman in due course, or been the cause of a divorce, but in fact everyone parted on friendly terms.

The Ruskins returned to England in April 1850, and resumed their life at Park Street. It was in 1851 that they first met Millais. John had written to *The Times* to support Pre-Raphaelite works that had met with criticism when they were shown at the Royal Academy. Ruskin considered them to be trying to show things in a naturalistic way, rather than using the rather schematic 'ideal', which had become the accepted academic method of presenting scenes from history. Ruskin was carefully critical and finally appreciative, saying that if the Pre-Raphaelites developed in the way he hoped, they might 'lay the foundations of a school of art nobler than the world has seen for three hundred years'.[61] Holman Hunt and Millais wrote to thank Ruskin, using Millais' parents' respectable address, and the Ruskins called on them. Millais was charming and became a friend. He was a year younger than Effie, ten years younger than Ruskin.

Ruskin invited Millais to accompany him to Switzerland, but that did not happen.[62] In August John and Effie left for another six months in Italy, mainly in Venice, by way of Switzerland.

The older Ruskins continued to criticize Effie's fondness for ballrooms and glittering parties. John was not reclusive, but his preferred social life involved visiting the kind of people with whom he could have serious conversation, and he was easily bored by chit-chat with people he did not know, even if they were famous or important. He decided to give up the house in Park Street when they returned to London, because he felt that the kind of life it drew them into was bad for his health.[63] It suited him to move, but he knew that it would not suit Effie. 'She will be unhappy', he said, 'that is her fault – not mine.'[64] Effie for her part was scandalized by a poem she found, written to John by his mother, addressing him in such affectionate terms that she sounded like 'a lover . . . addressing a Sonnet to his Mistress'.[65]

When they reached Venice for this second stay they rented an apartment at the Casa Wetzler on the Grand Canal, where they could entertain regally.[66] They learned in Venice that Paulizza had died, but Effie certainly spoke to and possibly flirted with other Austrian officers. Two of them fought a duel over her and one of them was killed, suggesting that however innocently she thought she had behaved, she was inflaming passions – and not her husband's.[67] When their visit was drawing to a close some of Effie's jewels went missing, and the departure was delayed while the police investigated and made accusations. Suspicion fell on an English officer in the Austrian army. Incredibly Ruskin himself was challenged to a duel. Inaccurate and sensational retellings of these adventures appeared in the London newspapers, and Ruskin published a repudiation.[68] Nevertheless, the gossip would have tended to hint that something untoward had been going on.

When they returned to London it was not to Park Street, but to a house at Herne Hill that John James had fitted up for them. It was

next door to the house from which John and his parents had moved when they went to Denmark Hill, but neither John nor Effie liked it and it was not good for entertaining. It was not far from the older Ruskins' house and John walked there each day to continue writing in his old study. His mother was worried that his time in Venice had left him over-sympathetic to Catholicism, and she found Effie to be an ally in keeping him away from it. Therefore they grew closer to one another and there was less tension between them, but Effie nevertheless settled into the opinion that she did not like her in-laws. At the end of September 1852 she went to see her parents and stayed at Bowersell for seven weeks while Ruskin remained in London.[69] Soon after she returned, Millais asked her if she would sit for him for his painting *The Order of Release*. The subject-matter was already decided, and Effie liked its sentiment: it would show a Highlands peasant woman delivering a note to an English gaoler, so as to release her husband – injured and captured at the Battle of Culloden in 1746. The woman is the prominent character in the picture, as the two men's faces are turned away from the viewer, as is the face of the infant that the woman is carrying. There is also a prominent dog, excitedly bouncing up to his master and as expressive as Landseer's sheepdog, but in a much happier state. Millais asked Ruskin's permission, and he agreed. Millais came and painted at the Herne Hill house, while Ruskin went off to his parents' house to write.[70]

When the painting was unveiled at the Royal Academy that summer it was a sensation and crowds pressed around to see it. It was meticulously and brilliantly executed, with sentiment a-plenty and some of the detail – such as the weave of the tartans and the toddler's dropped wild flowers – repays close scrutiny, so people wanted to get in close. The rendering of the scene was illusionistically real, with meticulous and virtuosic depiction of the textures of fabrics, muddy feet and delicate flower petals. The figures' postures are expressive. The soldier seems to wilt with despair or relief, while his wife's sturdy stance suggests resolution to deal

John Everett Millais, *The Order of Release 1746*, 1852–3, oil on canvas.

with the difficult situation that faces her. The thing that makes the painting a showstopper is that the figures have such great presence, especially the dog.

Effie was the centre of attention, and loved it. John said nothing in print about the picture. Nor did he buy it, as Millais must surely have hoped he would. However, arrangements were made to tour Scotland, where Millais had never been, despite the Scottish theme of *The Order of Release*. Holman Hunt was invited too, but he instead went to Syria and in the end the party included the Ruskins, a servant, Millais (whom the Ruskins called Everett so as not to cause confusion with two Johns in the party) and his brother William Millais.[71] It was decided while they were travelling that

Everett Millais would paint a portrait of Ruskin. A canvas was ordered and was sent up from London. In the Highlands the party rented a tiny cottage and rooms at a nearby inn. Everett, John and Effie stayed in the cottage, the others at the inn. Over the weeks of August and September the members of the party grew to know one another very well. Progress on the portrait was slow because it was painted outdoors, on the spot, and the weather was not good. John was preparing some lectures, to be delivered in Edinburgh, which would have entailed ignoring Effie, and then John and William exercised by digging a short canal across the bend in a river, while Everett and Effie took long walks together. By the time they all went on to Edinburgh for John to give the lectures, Everett and Effie had fallen in love. The surprising thing in the circumstances is not that it happened, but that Ruskin should have been so oblivious to its happening and so unsuspecting that it might happen. But perhaps it is a mistake to think that he was oblivious. Robert Brownell credits him with a little more insight and a little less naivety than has become the norm. He certainly seemed to encourage Effie's admirers, and he wanted a way out of the marriage. One of Ruskin's closest confidants, Frederick James Furnivall, said that in Venice, 'Ruskin had hoped that she would elope with an Italian Count who had stayed in the house; but it was the Count who eloped, not with Mrs Ruskin, but with all her jewels instead.'[72] If Ruskin were hoping for some such outcome from the Scottish holiday, then his behaviour and the lodging arrangements look manipulative rather than naive, and one draws a different conclusion about Ruskin's character. He was perhaps a little less unworldly than he has sometimes seemed to be, and was certainly by that time aware of his interest in being freed from Effie.

In the event the Ruskin–Gray marriage was annulled – at Effie's instigation – in 1854.[73] As it had never been consummated Effie could insist that technically she had never been married and legally there was no divorce. There was scandal. Nobody comes out of

such things well. Effie had gone into her marriage with conventional expectations and desires, albeit as a sacrifice to her family's fortune. John was shocked to discover that it had not been love for him that had drawn them together, and they delayed the consummation so that they could get to know one another, hoping to fall in love. That was not the way it worked out. John grew to dislike Effie, who did not understand him and seemed to be at odds with his beloved parents. She found him cruel when he was not neglectful, and the company she kept while she was being neglected brought her some pleasure but also scandal. Her subsequent marriage to Millais turned out to be happy and fruitful. She had eight children, but was sometimes treated as a divorcee, which in those days excluded her from social invitations from punctiliously respectable women.

As for Ruskin: he was hardly heartbroken. His work was his preoccupation, and that came first in his eyes. Perhaps anyone who writes has an exaggerated sense of the importance of writing and what can be achieved through it. It entails isolation and concentration, and that can leave casualties, as it did here; but that is rather different from saying that Ruskin was selfish, as Effie said he was. His great gift to us was his body of work, and for us (as for him) that was the point of his life. His marriage was a mistake. It has nevertheless seized the public imagination, and has been dramatized many times over, first in the retellings of gossip, then in a more formal way on film. There was a silent film, *The Love of John Ruskin* (1912), and the most recent is *Effie Gray* (2014). The story continues to fascinate, even now that the general public has little idea of who Ruskin was and what he stood for. Maybe his most enduring legacy will be in acting as a warning to over-protective parents. One would like to think that what would matter more would be the perspectives opened up in his writings, and the ways they have informed how we can see the world through artworks, architecture and the value systems of our working lives.

4

The Seven Lamps of Architecture

Ruskin's enthusiasm for Gothic architecture grew out of his appreciation of the Picturesque and the prints of Samuel Prout that first drew him and his parents to cross the Channel. He loved these buildings as they mouldered into Picturesqueness, but as his knowledge and appreciation developed, and as time passed, he was dismayed to realize that they were threatened. If they did not collapse then they were restored, and either way their charm was lost. He started to make drawings of places so that when they were lost there would be some record of what there had once been.

In England the taste for medieval architecture was already well established. The Palace of Westminster had burned down in 1834 and was being rebuilt in the style that we would now call Gothic. Its medievalizing detail was designed by Augustus Pugin (1812–1852), who called the style 'Christian or Pointed Architecture' and advocated it as a way of promoting his Roman Catholic version of Christianity, which had a new legal status in Britain after 1829 when the Roman Catholic Relief Act allowed Catholics to vote and take parliamentary office.[1] In 1817 Thomas Rickman had published his analysis of English medieval architecture, in which he introduced the names which are still used for the different varieties of English Gothic: Early English, Decorated and Perpendicular.[2] In Rickman's own terminology, however, they were not presented as varieties of 'Gothic', but as varieties of 'English' architecture: Early English, Decorated English and Perpendicular English. This gave the style

a nationalistic aspect, appropriate to the Palace of Westminster, but historically flawed for a style that turned out to have its roots in France. The most important study for informing Ruskin was Robert Willis, *Remarks on the Architecture of the Middle Ages, Especially of Italy* (Cambridge, 1835) which Ruskin said 'taught me all my grammar of central Gothic'.[3]

In France it was already officially recognized that medieval monuments were often in a very poor state of repair, and from 1830 there were efforts at government level to do something about them. A list of important monuments in danger was drawn up in 1840, and Eugène Viollet-le-Duc (1814–1879) was appointed to supervise first the restoration of the basilica at Vézelay.[4] He subsequently went on to restore and creatively adapt some of the prime examples of French medieval architecture, such as Notre Dame in Paris, which already had a certain mystique on account of Victor Hugo's novel, published in 1831, and Viollet's restorations enhanced it. The soaring and delicate Sainte-Chapelle in Paris became a cage of coloured light, with the stonework painted to match the colours of the stained-glass windows. The fortress of Pierrefonds became the very image of a chivalric château, and the bastions of the fortified town of Carcassonne, in military use until the nineteenth century, became a picture-perfect embodiment of feudal glamour.[5] Ruskin disapproved of his approach, which he saw as destroying the buildings' original mouldering and Picturesque characters. He was drawn into studying the buildings by way of his sketches of details and configurations – 'a mass of Hieroglyphs' – little unconnected, note-like sketches.[6] They developed into an obsession and were the basis of *The Seven Lamps of Architecture*, published in 1849. This was the book that he was working on when he courted and married Effie. The political instability in France in 1848 made it imprudent to travel there for the honeymoon as had been intended, and instead the newlyweds went to Salisbury to gather information on the cathedral there.[7] In retrospect one sees that the problems of the

William Downey, photograph of John Ruskin in 1863, aged 44, flanked by the artists William Bell Scott on the left and Dante Gabriel Rossetti on the right.

marriage were rehearsed right there. It might not have been such a disaster if the older Ruskins had not decided to join them in Salisbury, and once there all the Ruskins imagined themselves to be ill, so Effie was the only one who felt well enough to take walks around the town. The visit was cut short.[8]

John and Effie did travel to France in August, with John James, by which time things seemed safe enough. General Louis Eugène Cavaignac (1802–1857), the third French president since the king had been deposed in February that year, had stabilized things, slaughtering thousands of Parisians in the process.[9] Louis-Napoleon would take over in December. The couple went to Normandy, and found work in progress, destroying old buildings, sometimes in the name of restoration. John pursued his studies with mania, and Effie did her best to tag along; but without a travelling companion she could not wander independently, and was reduced to tears by exhaustion, boredom and anxiety that John simply did not comprehend.[10]

None of this can be guessed from reading the book. It is unlike any other book on architecture that there had ever been. It purports to be a general discussion of architectural principles, but the principles are found embodied only in medieval buildings, as if they were the only buildings that were designed on good principles. In that Ruskin was following Pugin's lead, and ignoring every other treatise on architectural principles, which had tried to adduce principles from classical buildings. Ruskin's book is not presented as a systematically historical study, which might imply some attempt at chronology or typology. The 'lamps' are guiding principles: sacrifice, truth, power, beauty, life, memory and obedience. Ruskin infers that all good buildings at all times are shaped by these principles through the agency of their designers and builders. As a way of discussing ethics, the idea of the 'lamps' is brilliant. Each of the principles is a good thing that one should aim for, but the different lamps may draw one in different directions and may shine with different levels of brilliance in different epochs or for different designers. The outcomes in particular buildings are therefore the result of the weighting given to each of the values – or to continue with Ruskin's image, they will depend on the brightness with which each light is shining. In practice the weighing of one value against

another is a matter of intuition and unconscious judgement, and as Ruskin did not have the language of psychoanalysis available to him, he was unable to speak about the unconscious and instead reached for ideas such as the spiritual. The diatribes against Catholicism today seem barbaric and bizarre. They made sense to Ruskin because they allayed the fears felt by those like his mother, who thought that if he embraced the stylistic precepts of people like Pugin he might also end up adopting their faith. In context Ruskin's anti-Catholic asides made the Gothic Revival more palatable to a mainstream Protestant audience, and it might have remained a cult for zealots if it had remained associated too strongly with Catholicism.

Ruskin's text is an extended meditation on the aesthetic, moral and spiritual effects of buildings and is quite unlike the more practical books written by architects. Viollet-le-Duc, for example, tried to understand Gothic architecture as a constructional and structural system, with the various elements balancing one another and making possible the great vaults.[11] There is none of this pragmatic rationalism in Ruskin, even when their ideas come into alignment. For Ruskin old buildings have a charm that is destroyed by restoration, and Viollet's free and easy way with enhancing the buildings that came under his influence was a long way from anything Ruskin would endorse.

Ruskin's book is a mixture of careful research, penetrating insight, idiosyncratic opinion and bizarre outbursts. His writing, as ever, is carefully balanced and rich with phrases that resonate with Bible and prayer book. The lamps themselves are securely biblical: Ruskin cites 'The Law is light' (Proverbs 6:23) and 'The Word is a lamp unto my feet' (Psalms 119:105).[12] He is inclined to prefer old things, but will be enraptured by something new that is as good. The machine, though, is unlikely to produce anything humane, and so there is a strangely dismissive attitude to railway architecture. Looking back, the great terminus stations seem to be

some of the most impressive achievements of Ruskin's age, but he told architects not to waste their time on them:

> Another of the strange and evil tendencies of the present day is to the decoration of the railroad station. Now, if there be any place in the world in which people are deprived of that portion of temper and discretion which is necessary to the contemplation of beauty, it is there. It is the very temple of discomfort, and the only charity that the builder can extend to us is to show us, as plainly as may be, how soonest to escape from it. The whole system of railroad travelling is addressed to people who, being in a hurry, are therefore, for the time being, miserable.[13]

This passage goes on at some considerable length, with a negative tone, but comes round at its close to a position that sounds like a principled functionalism: 'Railroad architecture has, or would have, a dignity of its own if it were only left to its work. You would not put rings on the fingers of a smith at his anvil.'[14] So there is a background idea of unpretentious building that does not aspire to the condition of being beautiful but which nonetheless has a certain validity and dignity, like a labourer who does honest work. Isambard Kingdom Brunel built Paddington station as the London terminus of the Great Western lines, evoking the form of a cathedral (with a transept). It opened in 1854, and did not make Ruskin change his mind.

This passage comes in the section on the lamp of beauty, though it might equally have belonged to the lamp of truth. There Ruskin's position is stern. There should be no violation of truth in any art, and in architecture the most contemptible and most frequently found violations are making one material look like another, or making it look as if it has been painstakingly wrought, when in fact it has just been put through a machine. Such things are matters of conscience.[15] This aspect of Ruskin's teaching about architecture

has had the longest-lasting influence. Before Ruskin the issue for a designer was whether or not the choice of materials and form would make a good effect. To that end there would be no moral problem involved in painting a column to look as if it had been made from a rare and costly marble, or painting common timber with a grained effect that made it look like a fine hardwood. For Ruskin, however, making one thing look like another was a deception, and therefore was to be condemned as a lie as reprehensible as any other falsehood.

Where structure is concerned, it should be evident how a building supports itself. The structure of Hagia Sophia in Istanbul is condemned, because the arrangement of the masonry is such that the vault is supported by huge masses of stone that are not apparent from inside, so the vast vault appears to float miraculously over the central space. Ruskin acknowledges that the effect is sublime, but sees the means of achieving it as wrong; and the same goes for the vault of the chapel of King's College, Cambridge – a spectacular fan-vault – which is 'a piece of architectural juggling, if possible still more to be condemned, because less sublime'.[16] There is no point in the building making a good effect if it does so by telling lies, or even by being evasive about the truth.

The mechanical reproduction of ornament was a moral problem for Ruskin, because it was deceitful about the amount of effort that had been put into a building. It could make an unimportant building look as if it were significant. 'All cast and machine work is bad, as work' and therefore wrong.[17] This was an exacting position to take, given how much cast decoration there was around, whether plaster cornices, decorative cast-iron work (which could range from fireplace surrounds to park benches, fountains and even, later, Gothic church structures), or off-the-shelf statuary and architectural detail cast in Coade stone.

Ruskin also condemned structural ironwork, on rather different grounds. Here there might not be deception, but there

Ruskin's pencil sketch of a detail of the cathedral of St Lô, Normandy, engraved by R. P. Cuff for *The Seven Lamps of Architecture* (1849). Ruskin said, 'It was meant to show the greater beauty of the natural weeds than of the carved crockets, and the tender harmony of both.'

is disappointment of established conventions, which he described as a kind of corruption:

> Perhaps the most fruitful source of these kinds of corruption which we have to guard against in recent times, is one which, nevertheless, comes in a 'questionable shape', and of which it is not easy to determine the proper laws and limits; I mean the use of iron.[18]

The 'questionable shape' is an allusion to the first appearance of the ghost of Hamlet's father, where the meaning of 'questionable' is different – meaning that Hamlet can ask questions of it; but Ruskin's allusion freights the cast iron with properties that might be diabolical:

> Angels and ministers of grace defend us!
> Be thou a spirit of health or goblin damn'd,
> Bring with thee airs from heaven or blasts from hell,
> Be thy intents wicked or charitable,
> Thou comest in such a questionable shape
> That I will speak to thee.[19]

The problem with cast iron is not presented as practical but as cultural. 'Abstractedly there appears no reason why iron should not be used as well as wood; and the time is probably near when a new system of architectural laws will be developed, adapted entirely to metallic construction.'[20] However, the ingrained habits surrounding issues of sizing and proportion are undermined by the capacities of the material, which is novel for architecture, and therefore Ruskin feels that it is impossible for it to have the dignity that the work would merit. Therefore, Ruskin says, if it is built in iron it is not architecture:

True architecture does not admit iron as a constructive material, and [. . .] such works as the cast-iron central spire of Rouen Cathedral, or the iron roofs and pillars of our railway stations, and of some of our churches, are not architecture at all.[21]

Ruskin's position here is not based on his reasoning. He sees the possibility of architecture in iron, but turns away from it in favour of traditional masonry. In his elaboration of his position he allows for metals to be used in building construction for fixings and for tension members, holding roofs together so that they do not spread apart – tie-rods, chains in the base of a dome and so on. In compression he thought that masonry or timber would be better, so there would be no cast-iron columns or steel frames. Viollet-le-Duc speculated about the possibility of a new architecture deriving from the constructional properties of the new building materials such as cast iron, but Ruskin discouraged such speculation.[22]

Ruskin's conception of architecture is of form that is steeped in culture that resonates with earlier forms. The genuineness of the production is part of the goodness in a built form, but there is also the question of whether or not it feels appropriate and right. This aspect of buildings is related to tradition and habit, and does not easily change, so Ruskin is wary of anything like conscious novelty. He is also very particular about which historical architecture is appropriate as a guide for contemporary use. 'I cannot conceive any architect insane enough to project the vulgarization of Greek architecture', he said.[23]

He commends four styles for contemporary use:

1. The Pisan Romanesque;
2. The early Gothic of the Western Italian Republics, advanced as far and as fast as our art would enable us to the Gothic of Giotto;

Gothic mouldings drawn by Ruskin, engraved by R. P. Cuff for *The Seven Lamps of Architecture* (1849), showing an 'exact correspondence . . . to the structure of involved crystals'.

3. The Venetian Gothic in its purest developement;
4. The English earliest decorated.[24]

The last would be the safest choice. So Ruskin's taste and advocacy in *The Seven Lamps of Architecture* was in line with the established Gothic Revivalist taste of the day, which was given additional authority by Ruskin's writings. It was not merely the taste for the forms that mattered, but also the means of production, which should avoid the stiffness of design of later Gothic work (the Perpendicular) as well as the falsifications of machine production.

One of the modern era's defining monuments was the Crystal Palace, which was designed to house the first great international exhibition in 1851. It was organized by the people involved with the Royal Society for the Encouragement of Arts, Manufactures and Commerce (now usually known as the Royal Society of Arts), including Prince Albert, Queen Victoria's husband. The building, an enormous glasshouse designed by Joseph Paxton, was built with amazing speed and the construction was thought about in the mechanistic ways that had developed in industry. It was a staggering achievement, and the exhibition and the building it was in caused a sensation, attracting attention from all over the world.[25] It was built in Hyde Park, a short walk from the Ruskins' house at Park Street. Effie went to the opening, but John did not.[26] They were preparing to leave for Venice, and the exhibition ran its course while they were away. When it was over the building was taken down, redesigned and rebuilt as a permanent structure in Sydenham, not far from Denmark Hill. It was not until that version of the building was in place that Ruskin wrote about it, from Switzerland. He contrasted the modest dwellings on the Swiss mountain slopes with the glittering palace commanding the hill at Sydenham. Various commentators, including the exhibition's chairman Samuel Laing at the opening ceremony, saw the Crystal Palace as embodying a new kind of architecture, but Ruskin did

not see it as architecture at all. Nor did he see it as necessary or desirable that anyone would be trying to create a new architecture. All that was necessary was to do architecture properly: in his view novelty did not improve it.[27]

The exhibits for the most part would not have commended themselves to him. One of the shocks faced by the organizers was that the exhibits that displayed progress in their methods of manufacture were often so lacking in aesthetic merit. There were all manner of cast-iron decorative works, often of great technical sophistication, but lamentable as objects. Today we would describe them as kitsch, but that word had not been coined at the time. The South Kensington Museum (which later became the Victoria and Albert Museum) was founded as a didactic display in order to educate designers. The first room, through which everyone passed, was a 'chamber of horrors' which displayed examples of faults to avoid: overly heavy or inappropriate ornament, patterns that disguised the shape of the object that they were supposed to adorn and suchlike. Ruskin would have approved of many of the principles that were put forward here by Henry Cole, but not the initial premise that industrial manufacture could produce fine work.[28] In retrospect the Crystal Palace has been seen to have been as remarkable as its advocates claimed at the time. It looks like a twentieth-century building that was built unaccountably early, in the middle of the nineteenth century. That perspective was not available to Ruskin and his contemporaries. There were those who made great claims for it, but architects of the time did not in fact take it as an inspirational model for permanent buildings. They agreed with Ruskin. The buildings that did seem to be inspired by the Crystal Palace were the great train sheds that covered the platforms of the terminal stations – especially Paddington, which seems like a calculated challenge: how dare one suggest that this is not architecture. And yet in a note that Ruskin added in 1880, when Paddington (1854) and St Pancras (1868) were well established, he specifically

excluded from the realm of architecture 'a wasp's nest, a rat hole, or a railway station'.[29]

It is doubtful whether any building designed primarily to turn a profit would find its way into the category of architecture as Ruskin defined it. The key idea for him was that architecture must involve sacrifice, and the lamp of sacrifice was the first on his list. The main text opens with the statements:

> Architecture is the art which so disposes and adorns the edifices raised by man for whatsoever uses, that the sight of them contributes to his mental health, power and pleasure. It is very necessary, in the outset of all inquiry, to distinguish carefully between Architecture and Building.[30]

A wasp's nest, rat hole or railway station would be merely useful, and therefore would be built without aiming for the sight of them to contribute to mental health, power and pleasure. Ruskin defines architecture as building that has some aspect of the non-utilitarian about it:

> Let us, therefore, at once confine the name [Architecture] to that art which, taking up and admitting, as conditions of its working, the necessities and common uses of the building, impresses on its form certain characters venerable or beautiful, but otherwise unnecessary. Thus, I suppose, no one would call the laws architectural which determine the height of a breastwork or the position of a bastion. But if to the stone facing of that bastion be added an unnecessary feature, as a cable moulding, that is Architecture.[31]

The work must go beyond the utilitarian: the point need not be that 'unnecessary' features are added to the building, but that 'unnecessary' effort has been expended on it. The cable moulding

– a simple but decorative projecting line of stone – in Ruskin's example could be added in a nonsensical way that would do nothing to make 'architecture' of the building; but used in the right place it could give an air of finesse and refinement to a structure that might otherwise appear rudimentary. The difference between a rudimentary utilitarian structure and architectural building, according to Ruskin, is sacrifice. Something of value is incorporated into the building simply because it is valuable. This valuable supplement might be extra effort going into the work, making it better considered or more finely decorated, or it might be the use of a better stone than strictly necessary.

> Now, first, to define this Lamp, or Spirit of Sacrifice, clearly. I have said that it prompts us to the offering of precious things merely because they are precious, not because they are useful or necessary. It is a spirit, for instance, which of two marbles, equally beautiful, applicable and durable, would choose the more costly because it was so, and of two kinds of decoration, equally effective, would choose the more elaborate because it was so, in order that it might in the same compass present more cost and more thought. It is therefore most unreasoning and enthusiastic, and perhaps best negatively defined, as the opposite of the prevalent feeling of modern times, which desires to produce the largest results at the least cost.[32]

In a sacrifice economy, therefore, it makes no sense to substitute a fake or a machine-produced alternative. If the cost is reduced then the sacrifice and the value is diminished. In this aspect of things there is no striving for effect: the point is not to make a good show, but to make a significant sacrifice. It is a matter of conscience and piety. There is no point in cheating. It is absolutely against the common sense of the marketplace, but is framed by Ruskin as

A Byzantine capital at the Doge's Palace, Venice, drawn by Ruskin and engraved by R. P. Cuff for *The Seven Lamps of Architecture* (1849).

one's duty to God, and the point is not how splendid the outcome might be, but how high the cost has been:

> It is not the church we want, but the sacrifice; not the emotion of admiration, but the act of adoration: not the gift, but the giving. And see how much more charity the full understanding of this might admit, among classes of men of naturally opposite feelings; and how much more nobleness in the work. There is no need to offend by importunate, self-proclaimant splendour.[33]

This passage turns into a condemnation of the modern Roman Catholic Church and its fondness for 'tinsel and glitter', which would coincide with the mercantile common sense of producing maximum effect for minimum outlay, and thereby failing as sacrifice. Already here in the opening section of the book, Ruskin has shifted the frame of reference from where one might have expected it to be. He is not trying to analyse good building form as a thing in itself, but trying to describe good practices, which – it is to be hoped – would produce architecture in which the goodness would be embodied and from which it might be inferred. The principal point here is that such a building is certainly good for the person making the sacrifice. It may also do others some good later on, but from the point of view of the sacrifice economy, that is beside the point.

This shift of attention from the built form to the moral character of the life that produced the form is characteristic of Ruskin, and finds its fullest development in the chapter on the lamp of life. Objects, especially buildings, 'become noble or ignoble in proportion to the amount of the energy of that mind which has visibly been employed upon them'.[34] A person's life, he says, is compromised and deadened by being trapped into conventions and habits that do not serve their own interests and inclinations, but only (presumably) those of a wider society. Life is diminished as it becomes routine and mechanical:

It is that life of custom and accident in which many of us pass much of our time in the world; that life in which we do what we have not purposed, and speak what we do not mean, and assent to what we do not understand; that life which is overlaid by the weight of things external to it, and is moulded by them, instead of assimilating them; that, which instead of growing and blossoming under any wholesome dew, is crystallised over with it, as with hoar frost, and becomes to the true life what an arborescence is to a tree, a candied agglomeration of thoughts and habits foreign to it, brittle, obstinate, and icy, which can neither bend nor grow, but must be crushed and broken to bits, if it stand in our way.[35]

Ruskin himself was free from having to deal with the more basic human needs, as he could readily pay the bills without compromising his time. He personally need not have found his life deadened by drudgery, though he was aware of it affecting the lives of others. His own life in London was circumscribed by social convention, and by his parents' sense of priorities, from which his travels offered some sense of escape. He was keen to hold onto the liveliness of childhood, but could see the people around him growing more rigid as they aged.

The life of a nation is usually, like the flow of a lava stream, first bright and fierce, then languid and covered, at last advancing only by the tumbling over and over of its frozen blocks. And that last condition is a sad one to look upon. All the steps are marked most clearly in the arts, and in Architecture more than in any other; for it, being especially dependent, as we have just said, on the warmth of the true life, is also peculiarly sensible of the hemlock cold of the false; and I do not know anything more oppressive, when the mind is once awakened to its characteristics, than the aspect of a dead architecture.[36]

Ruskin's drawing of a window in the Ca' Foscari, Venice, engraved by R. P. Cuff for *The Seven Lamps of Architecture* (1849).

For architecture to retain its hold in life it had to engage the creativity and liveliness of the craftsman. The styles of architecture that Ruskin preferred were those that allowed a degree of individuality, inventiveness and imperfection in the detail without that being problematic for the whole. It is in this connection that the use of machine-made ornament comes to be seen as so very wrong, as too would be the classical styles that demanded the regular and accurate repetition of canonic orders of architecture.

Nobler and surer signs of vitality must be sought, – signs independent alike of the decorative or original character of the style, and constant in every style that is determinedly progressive.

Of these, one of the most important I believe to be a certain neglect or contempt of refinement in execution, or, at all events, a visible subordination of execution to conception, commonly involuntary, but not unfrequently intentional.[37]

The workers who produce this kind of work have not been coerced by an employer looking for an over-refined finish, but give their ideas an appropriate expression. There can be variation and adjustment, and in the end everything looks lively and harmonious without the hard inflexibility of steam-driven precision. It is a humane vision of what architecture could and should be. The employer is expected to avoid cutting corners to achieve a general effect of splendour that would be devoid of life and moral worth. The craftsman is employed on work that has some creative freedom in it, that allows the expression of vigour and personal engagement, so it is rewarding work for him to do.

The expression of anxieties about machine production and its effects on people's lives did not begin with Ruskin but is very characteristic of the nineteenth century. Mary Shelley's *Frankenstein* of 1818 was a nightmare that began with high hopes in scientific

progress. Victor Frankenstein succeeds in creating life, but instead of becoming the new Prometheus, worshipped as a god by a new race of creatures, his creation turns on him and those whom he holds dear. The same anxiety was played out at a more practical level by the Luddites, who between 1811 and 1817 smashed industrial machinery that they feared was destroying their livelihoods.[38] William Morris would be inspired by this aspect of Ruskin's thinking, and the Arts and Crafts movement, in which he was a prime mover, became a significant aspect of Late Victorian culture.[39] Samuel Butler's novel *Erewhon*, which would be published in 1872, imagined a society which had taken a deliberate decision to abandon machines because the Erewhonians found that they had become enslaved by them. Similar themes are still explored in films, imagining humans supplanted by computers or robots. The anxieties have not gone away, but the nineteenth-century machines that Ruskin knew now look robust and characterful, and the machine-cut timber and cast-iron decorations of his day look livelier than the extruded laminated and anodized products that took their place a century later.

There is no missing the elevated moral tone of Ruskin's writing. It attaches to the lives of the people who come into contact with buildings, rather than to the buildings in themselves, and there is no simplistic conflation of the use of a particular architectural style with virtue. There is a more certain link between ethics and the production of the building than there is in the use of the building; but ideally the finished building would put one in mind of the principles that brought it into being and which were therefore in a sense embodied in it. Ruskin imagined the process of building from various different points of view – those of the craftman, the architect, the person commissioning and building and the person using the finished result. To these acts of intuitive empathy he added the moralistic view that was all his own. He was far from the first person to make connections between aesthetics and morals, but when it had been done earlier the language of polite accomplishment

had set the discussion in reference to classical literature and ancient philosophers. Alberti, the Earl of Shaftesbury and Winckelmann had ethical positions that linked with their view of art and architectural judgement, but these were less central to their outlook than Ruskin's. The preacherly tone and biblical allusions gave the work authority, and its literary style was widely admired, even by people who did not follow the arguments.[40]

The arguments themselves are not always convincing now, in the way they were to a public that was already taking to the Gothic Revival, and which then felt comfortable with the idea that the best architecture in one way or another was old-fashioned. This is still the way the general public feels, even though architects often feel more enthusiasm for the modern, or are convinced that it must of necessity be embraced. The reading public was pleased with Ruskin's book and its views, which did something to enlighten and inform, while confirming many intuitive prejudices. Also one can imagine people with less money than the Ruskins seeing the principles as admirable but unachievable, and buying mass-produced artefacts nonetheless. The people with whom he was at odds were the progressive types, whose focus of activity would be the Society for the Encouragement of Arts, Manufactures and Commerce – the Crystal Palace set – who embraced the idea of industrial manufacture while recognizing that the products should be better.

The remarkable thing that Ruskin did in this book was to assimilate a vast amount of empirical knowledge, much of it from personal scrutiny of the places involved – in England, France, Switzerland and Italy – and to infer from the careful observation of the fragments the processes and aspirations that had informed their formation. As a method it is profoundly different from the usual typologies and chronologies that had constituted architectural history up until then. The method seems to have been transferred intuitively from geology, where one would study fragments – here

a mountain could be a fragment, and so could a fossil or a portable stone – and from them geologists gradually pieced together an idea of how continents and mountain ranges were torn apart, scraped away and pushed into position, flooding, becoming molten, crystallizing and sedimenting along the way. There are many geological metaphors and analogies in *The Seven Lamps of Architecture*, which show us what we already knew: that geology was part of the stock of Ruskin's mind. It is also highly characteristic that he would make connections between one field of knowledge and another.

There is a similar transfer of principles, sustained at some length, in one of his slighter publications, *The Ethics of the Dust: Ten Lectures to Little Housewives on the Elements of Crystallization* of 1865.[41] It was never a popular work, and there are all sorts of problems with it, some of them painfully evident in the subtitle. It is an attempt to present lessons in womanly virtue alongside lessons about geology and crystals to a group of schoolgirls. The 'dust' of the title is an attempt to find an Anglo-Saxon word for atoms, or 'primary molecules'. The Old Lecturer has the girls running around pretending to be atoms, then crystallizing as a compact group. The first and most important virtue exemplified in crystals, says the Old Lecturer, is purity. While purity is something we might certainly value in a crystal, it is less often promoted as a personal virtue in the twenty-first century. It was the defining virtue that Ruskin attributed to his mother on her gravestone when she died in 1871, but now a desire for purity in people can smack of eugenics or ethnic cleansing. That is certainly not what Ruskin had in mind. He is talking about conduct, not breeding, and it is more likely that he was hoping that, by awakening a love of drawing and geology, the girls' desire for purity might in later life mean that they would not nag their husbands for sex and babies.

In *The Seven Lamps of Architecture* Ruskin's achievement was a moralizing reconceptualization of architecture, developed by way of geological thinking. There is a wealth of detailed and fresh

Details of Gothic ornament at the cathedrals of Rouen and Salisbury, drawn by
Ruskin and engraved by R. P. Cuff for *The Seven Lamps of Architecture* (1849).

observation of medieval buildings, and arguments in support of traditional effort and craft. It endorsed the values that the general reading public liked to think it had, and was hostile to the mercantile values that were dominant in the world of manufacture and commerce and which played a greater role in the lives of the readers than they quite liked to admit. It is a book that appealed to the readers' church-going side, and worked as reading for 'Sunday best', rather than as a guide to anything that would be useful during the working week. The barbed remarks about Roman Catholicism meant that Ruskin promoted Gothic architecture as an outcome of Protestant Christian morality, which made it feel non-threatening for his mainstream audience. It was something that his readers might find appealing, but beyond that it was something they had a duty to value and admire, for the good of humanity in general and also for the sake of holding onto their own humanity when it might be crushed by the power of machines or the social expectations of others.

5

Lapping Waves, Living Stones

'And blood shall drop out of wood, and the stone shall give
his voice, and the people shall be troubled', said the prophet
Esdras. In his apocalyptic visions the natural order seems to be
breaking down and there is a long list of extraordinary things
that will happen: signs of the times to come.[1]

Ruskin quoted him in the introduction to his collected
geological papers: *Deucalion: Collected Studies of the Lapse
of Waves and the Life of Stones,* published in 1875.[2] Deucalion
was one of the sons of Prometheus, who made the first humans
and gave them fire, for which he was punished by the gods. The
humans seem to have thrived, but they sacrificed a child to
Zeus, which he thought was barbaric, so he flooded the world.
Deucalion escaped by floating in a box, and after the waters had
subsided he started a new race of humans, by throwing rocks over
his shoulder. The rocks came to life. Ruskin does not elucidate this
story, but dwells on Esdras.

He said that Esdras foresaw a time that might have been our
own, or if not then a time exactly like our own; a time when

> the deadness of men to all noble things shall be so great, that
> the sap of trees shall be more truly blood, in God's sight, than
> their heart's blood; and the silence of men, in praise of all noble
> things, so great, that the stones shall cry out, in God's hearing,
> instead of their tongues; and the rattling of the shingle on the

beach, and the roar of the rocks driven by the torrent, be truer
Te Deum than the thunder of all their choirs.[3]

Ruskin may or may not have been correct in this interpretation,
but he certainly picked up the prophet's tone. The language is
intensified by bringing in another image: the noise of the seashore.
'The rattling of the shingle on the beach, and the roar of the rocks
driven by the torrent' is not from Esdras. It is an allusion to the
'melancholy, long, withdrawing roar' of the sea as it runs down from
the 'naked shingles of the world'. This sea is 'the sea of faith', from
Matthew Arnold's poem 'Dover Beach' (published in 1867). The
theme of the poem exactly matches Ruskin's sense (even if Esdras'
own sense remains elusive) as Arnold finds in the heaving and
seething of the retreating tide an image of the ebb of religious faith,
and the despair that it leaves as it goes, but Ruskin finds vitality in
the rocks where Arnold finds only desolation. The stones cry out
their melancholy long withdrawing roar as the sea leaves us behind.

If we do not recognize the allusion to 'the sea of faith', then 'the
lapse of waves' in *Deucalion*'s subtitle makes little sense. It sounds
rather like 'the lapping of waves', so it does not immediately sound
incongruous, but try to pin the sense down more precisely and it
slips away. The 'lapse of waves' is the retreat of the waters after
Deucalion's flood, and the modern 'sea of faith', as the waters fall
from a higher to a lower level; and if it equates with 'the lapse of
faith' then the sense is fully congruent with Ruskin's gloss on
Esdras: it is the absolute nullity of the faithless that brings relative
animation to the stones. Of course stones have lives, and of course
they have a story to tell: it is the discipline of geology that tries to
articulate their stories.

The stones of Venice also have a story to tell, and one aspect of
it is a story about the loss of faith. The culture that made Venice
powerful had ebbed away long before Napoleon arrived and
brought the Venetian republic into his empire. The place remains

as an after-effect, lingering as a fabulous mirage lapped by waves that threaten to engulf it. It is easy to be entranced by the apparent weightlessness of the place, as the traffic is by boat and the palaces along the Grand Canal seem to float insubstantially. During the summer months they are lit sometimes flickeringly by the sun that dazzles and glitters as its reflection is broken by waves. Turner authoritatively caught this aspect of Venice. Ruskin was after the facts that informed the dream, and he found them in short supply. It was as though everyone was so convinced that Venice was a collective hallucination that no practical steps were being taken to prevent its solid substance from crumbling away and being claimed by the waves.

The geology of Venice, which arranged the stones so fantastically, had a high level of human agency in it. Ruskin was enraptured by the place, but his feelings about it were complex, as he saw the building forms as being produced by processes that first accumulated power and then dissipated it in decadence. Above all, though, he was scandalized by the lack of knowledge about the place. 'To my consternation', he said,

> I found that the Venetian antiquaries were not agreed within a century as to the date of the building of the façade of the Ducal Palace, and that nothing was known of any other civil edifice of the early city, except that at some time or other it had been fitted up for somebody's reception, and had been thereupon fresh painted. Every date in question was determinable only by internal evidence; and it became necessary for me to examine not only every one of the older palaces, stone by stone, but every fragment throughout the city which afforded any clue to the formation of its styles.[4]

His work was painstaking and original. There were previous accounts of the place, which he found helpful, but he was able to

make corrections. 'I believe few people have any idea of the cost of truth in these things', he said:

> There is not a building in Venice, raised prior to the sixteenth century, which has not sustained essential change in one or more of its most important features. By far the greater number present examples of three or four different styles, it may be successive, it may be accidentally associated; and, in many instances, the restorations or additions have gradually replaced the entire structure of the ancient fabric, of which nothing but the name remains, together with a kind of identity, exhibited in the anomalous association of the modernized portions: the Will of the old building asserted through them all, stubbornly, though vainly, expressive; superseded by codicils, and falsified by misinterpretation; yet animating what would otherwise be a mere group of fantastic masque, as embarrassing to the antiquary, as to the mineralogist, the epigene crystal, formed by materials of one substance modelled on the perished crystals of another.[5]

This is all in the preamble, making clear his geologically inspired method. There is a lengthy geological peroration at the beginning of the second volume, where the historical presentation really begins. Ruskin explains how Venice's architectural character is exquisitely linked with the particularities of land formation. Silt, washed down from the Alps and the Apennines into the pastures of Lombardy and through them in suspension in its muddy rivers, arrives in the Adriatic, where it settles in mudbanks a few miles out from the coast.[6] There are marshes on the shore, which is imprecisely defined, and the mudbanks are sometimes above water level, often below, so the water is never very deep. There is not a great height difference between high and low tide, but with land as gently sloping as this, large areas are covered and

John Ruskin, *St George of the Seaweed* (S. Giorgio in Alga, Venice), photogravure by
Thomas Lupton after Ruskin's watercolour of 1849.

uncovered by the water. Ruskin evokes the islands of Venice in
their primitive state as a place of utter desolation, which would
have been the refuge of desperate people.[7] He also makes the point
that with no tide (as in other parts of the Mediterranean) the
waters would have become foul, but if the range of the tide had
been greater then in later ages the dignity of the republic's nobles
would have been at stake: it would not have been possible to arrive
by water so decorously. The palaces' main entrances face the canals,
and at low tide the lower steps would be covered in slime.[8] If the
canal entrances had been inconvenient or awkward for the nobility
then they would have rearranged things. Streets would have been
widened and the main thoroughfares would have been roads on
reclaimed land instead of canals. The defence of the place was also
aided by the mud. Had the water been deeper, then it would have
been navigable by foreign navies and pirates, and the republic

would have been much more vulnerable to plunder.[9] Ruskin's history therefore begins by stressing the physicality of the place and its practical reality. That is at the beginning of volume 2. Volume 1 begins by evoking the myth and magic of the place, with Ruskin taking the role of a prophet:

> Since the first dominion of men was asserted over the ocean, three thrones, of mark beyond all others, have been set upon its sands: the thrones of Tyre, Venice, and England. Of the First of these great powers only the memory remains; of the Second, the ruin; the Third, which inherits their greatness, if it forget their example, may be led through prouder eminence to less pitied destruction.
>
> The exaltation, the sin, and the punishment of Tyre have been recorded for us, in perhaps the most touching words ever uttered by the Prophets of Israel against the cities of the stranger. But we read them as a lovely song; and close our ears to the sternness of their warning: for the very depth of the Fall of Tyre has blinded us to its reality, and we forget, as we watch the bleaching of the rocks between the sunshine and the sea, that they were once 'as in Eden, the garden of God'.[10]
>
> Her successor, like her in perfection of beauty, though less in endurance of dominion, is still left for our beholding in the final period of her decline: a ghost upon the sands of the sea, so weak – so quiet, – so bereft of all but her loveliness, that we might well doubt, as we watched her faint reflection in the mirage of the lagoon, which was the City, and which the Shadow.
>
> I would endeavour to trace the lines of this image before it be for ever lost, and to record, as far as I may, the warning which seems to me to be uttered by every one of the fast-gaining waves, that beat, like passing bells, against the STONES OF VENICE.[11]

It was a startling message to announce in London, in 1851, when imperial ambition was still in the ascendant. In 1877 Queen Victoria would be declared Empress of India, and the British Empire continued to grow until 1914. Ruskin was not contemplating the decline of the Tyrian and Venetian empires and drawing the conclusion that decline and fall were inevitable, but on the contrary saw that the imperial ambition was what gave these places their greatness, and wanted to ensure that their lessons were learned by the British so that a comparable fate could be avoided. So although in dealing with the ruins of Venetian power Ruskin's tone is elegiac, his underlying argument is that we should be paying attention to the Venetian values that made the city a great imperial power in its day. He argued that the state of Venice lasted for 1,376 years, and for the first 900 years it seemed to be healthy, with a form of elected government. Things started to go wrong, he thought, when the nobility took control of government and effectively excluded the influence of both the common people and the doge. Decline set in in the fifteenth century, after which 'Venice reaped the fruits of her former energies, consumed them, – and expired.'[12] Ruskin attributed to the Venetians an instinct for piety in their private lives, which was not carried over into the workings of the state. In his analysis the character of the citizens served the state well, but the state's interests were seen as purely mercantile, and it resisted being influenced by the then-considerable temporal influence of the Papal States. Ruskin thereby makes the Venetians seem like instinctive Protestants:

> We find, on the one hand, a deep and constant tone of individual religion characterising the lives of the citizens of Venice in her greatness; [. . .] And we find as the natural consequence of all this, a healthy serenity of mind and energy of will expressed in all their actions, and a habit of heroism which never fails them, even when the immediate motive of action ceases to be praiseworthy. With the fulness of this spirit the prosperity of the state is exactly

correspondent, and with its failure her decline, and that with a closeness and precision which it will be one of the collateral objects of the following essay to demonstrate from such accidental evidence as the field of its inquiry presents.[13]

Ruskin here is addressing one of the themes of Edward Gibbon's *History of the Decline and Fall of the Roman Empire*.[14] It was one of the great landmarks of eighteenth-century scholarship, and its main ideas were known to every well-educated Englishman, except perhaps those educated at home by pious mothers. John James Ruskin bought a twelve-volume edition of it in 1840 to help with John's preparation for writing one of his unsuccessful competition poems for the Newdigate Prize at Oxford.[15] This edition had been annotated by its editor, the Very Revd Henry Hart Millman (an Oxford Professor of Poetry). One of Gibbon's themes was the role of religion in the Romans' sense of civic virtue, and he suggested that one of the reasons for the Empire's decline was the softening

John Ruskin, *The Grand Canal, Venice*, photogravure by Allen & Co., from *The Works of John Ruskin*, IX (1903).

effect of the adoption of Christianity as an official religion early
in the fourth century. It is the role of religion in this civic virtue
that Ruskin picks up when he points out that before the fifteenth
century first elected monarchs, and then private citizens, were pre-
pared to die for the Venetian Republic, but later, when private
religion was less strong, public heroism vanished from the scene,
and eventually the Venetians let all their power slip away. So
Ruskin is repudiating Gibbon's idea that Christianity would be a
cause of imperial decline. In fact Ruskin is much more inclined to
think that explains what made Venice great. Where Gibbon brought
his narrative to a close in 1590, long after the Fall of Rome (*c.* 480)
and even after the Fall of Constantinople in 1453, Ruskin lost interest
in Venice in its period of decline and discusses nothing later than the
Renaissance: 'Early Renaissance, consisting of the first corruptions
introduced into the Gothic schools; Central or Roman Renaissance,
which is the perfectly formed style; and Grotesque Renaissance,
which is the corruption of the Renaissance itself'.[16] He later said
that in *The Stones of Venice* he had no other aim than

> to show that the Gothic architecture of Venice had arisen out
> of, and indicated in all its features, a state of pure national
> faith, and of domestic virtue; and that its Renaissance
> architecture had arisen out of, and in all its features indicated,
> a state of concealed national infidelity, and of domestic
> corruption.[17]

Venice's greatest glory, in Ruskin's eyes, was its architecture of
the fourteenth century. His story explains how the architecture
gradually developed from its desperate primitive and then
Byzantine origins. The mudbanks have no quarry among them,
so the stones have all been brought from elsewhere by human
agency. The mudbanks were stabilized and buildings supported
on timber piles, which do not last for ever. They can be renewed,

but the stonework here seems to be precariously propped, and never has the innate stability of a well-founded building on the mainland. There are so few remains from the earlier periods that there are times when Ruskin seems determined to present each and every stone in turn. There are many detailed presentations of individual buildings, but the work's high point is his analysis of the Gothic style and the virtues that he thought it embodied, a chapter entitled 'The Nature of Gothic':

> I believe [. . .] that the characteristic or moral elements of Gothic are the following, placed in the order of their importance:
>
> 1. Savageness.
> 2. Changefulness.
> 3. Naturalism.
> 4. Grotesqueness.
> 5. Rigidity.
> 6. Redundance.
>
> These characters are here expressed as belonging to the building; as belonging to the builder, they would be expressed thus: –
> 1. Savageness, or Rudeness. 2. Love of Change. 3. Love of Nature. 4. Disturbed Imagination. 5. Obstinacy. 6. Generosity. And I repeat, that the withdrawal of any one, or any two, will not at once destroy the Gothic character of a building, but the removal of a majority of them will.

Ruskin contrasts the character of the plants and animal life to be found in the south – around the Mediterranean – with those of the north: the Arab horse as compared with the Shetland; the bird of paradise compared with the osprey. The northern origins of Gothic architecture find appropriate expression in its wildness, but more importantly than that there is an expression of political relations. In Ruskin's analysis the architectural ornament of the

ancient Greeks, Assyrians and Egyptians expressed in its mechanical repetition the slave condition of the craftsmen. The Christian ornament is different because of the different valuation of the human soul. In Gothic work the detail need not be so perfect, because the conception is grander:

Now, in the make and nature of every man, however rude or simple, whom we employ in manual labour, there are some powers for better things: some tardy imagination, torpid capacity of emotion, tottering steps of thought, there are, even at the worst; and in most cases it is all our own fault that they *are* tardy or torpid. But they cannot be strengthened, unless we are content to take them in their feebleness, and unless we prize and honour them in their imperfection above the best and most perfect manual skill. And this is what we have to do with all our labourers; to look for the *thoughtful* part of them, and get that out of them, whatever we lose for it, whatever faults and errors we are obliged to take with it. For the best that is in them cannot manifest itself, but in company with much error. Understand this clearly: You can teach a man to draw a straight line, and to cut one; to strike a curved line, and to carve it; and to copy and carve any number of given lines or forms, with admirable speed and perfect precision; and you find his work perfect of its kind: but if you ask him to think about any of those forms, to consider if he cannot find any better in his own head, he stops; his execution becomes hesitating; he thinks, and ten to one he thinks wrong; ten to one he makes a mistake in the first touch he gives to his work as a thinking being. But you have made a man of him for all that. He was only a machine before, an animated tool.

And observe, you are put to stern choice in this matter. You must either make a tool of the creature, or a man of him. You cannot make both. Men were not intended to work with the accuracy of tools, to be precise and perfect in all their

actions. If you will have that precision out of them, and make their fingers measure degrees like cog-wheels, and their arms strike curves like compasses, you must unhumanize them. All the energy of their spirits must be given to make cogs and compasses of themselves. All their attention and strength must go to the accomplishment of the mean act.[18]

This is the heart of Ruskin's conception of what matters in building. 'You must either make a tool of the creature, or a man of him.' It is not just a matter of the way things look, but the fact that one can infer from the finished appearance the quality of the life that produced the appearance. One responds warmly when one can sense that it was a decent, free-spirited life, and it is this sense that animated Ruskin and drove him on as he urgently tried to make others see it too. He was aware that there had been injustice and cruelty during the Middle Ages, when the Gothic architecture was produced, but he thought that modern factory conditions were a worse slavery, because they crushed men's souls:

There might be more freedom in England, though her feudal lords' lightest words were worth men's lives, and though the blood of the vexed husbandman dropped in the furrows of her fields, than there is while the animation of her multitudes is sent like fuel to feed the factory smoke, and the strength of them is given daily to be wasted into the fineness of a web, or racked into the exactness of a line.[19]

Thinking back to the Crystal Palace now, one understands why Ruskin had so little sympathy for it. Its means of production, using smelted metals, repetitive factory-formed elements and cylinder-blown sheet glass, entailed sending multitudes to the factory smoke, and in Ruskin's system of judgement they might as well have been human sacrifices. It is less immediately evident that Ruskin would

have problems with the Palace of Westminster, which was in a Gothic style. The decorative detail was by Pugin, who stood for Roman Catholicism, which Ruskin detested, but that was not the main problem. It lacked this quality of savageness – the imperfections that showed that the craftsman was in charge of himself and had the freedom to improvise. Ruskin saw Charles Barry as one of the chief exemplars of the slave-driver architect who coerced his workmen into the machine-like following of a template – he wanted to put him in a black hole of all that was bad.[20] The repeated bays of the facades of the Palace of Westminster are finely decorated, but each bay is identical to the next, and the precision with which they are executed, which is admirable in its way, ends up being expressive of something deadened. It is a masonry building produced by handwork, but it is driven by the spirit of the machine. The freedom and inventiveness is all in Pugin's drawings, and in his mind, while the craftsmen are treated like machines, required to reproduce the design, not to engage with it and think creatively about it. By contrast, here is Ruskin's description of the cathedral of San Marco in Venice. It is approached on foot by way of dark narrow irregular alley-like streets, which bring one into the Piazza San Marco, where there is space and order,

> the countless arches prolong themselves into ranged symmetry, as if the rugged and irregular houses that pressed together above us in the dark alley had been struck back into sudden obedience and lovely order, and all their rude casements and broken walls had been transformed into arches charged with goodly sculpture, and fluted shafts of delicate stone.[21]

Beyond them in the distance:

> a multitude of pillars and white domes, clustered into a long low pyramid of coloured light; a treasure-heap, it seems, partly

John Ruskin, *Studies for 'The Stones of Venice'*, photogravure by George Allen.

of gold, and partly of opal and mother-of-pearl, hollowed
beneath into five great vaulted porches, ceiled with fair mosaic,
and beset with sculpture of alabaster, clear as amber and
delicate as ivory – sculpture fantastic and involved, of palm
leaves and lilies, and grapes and pomegranates, and birds

clinging and fluttering among the branches, all twined together
into an endless network of buds and plumes; and, in the midst
of it, the solemn forms of angels, sceptred, and robed to the
feet, and leaning to each other across the gates, their figures
indistinct among the gleaming of the golden ground through
the leaves beside them, interrupted and dim, like the morning
light as it faded back among the branches of Eden, when first
its gates were angel-guarded long ago. And round the walls of
the porches there are set pillars of variegated stones, jasper
and porphyry, and deep-green serpentine spotted with flakes
of snow, and marbles, that half refuse and half yield to the
sunshine . . .[22]

Only about half the sentence is quoted here. It continues with its
gradual build-up of accumulated detail, an allusion to Shakespeare's
Cleopatra, and evocations of the Biblical Tyre, with the mention of
precious stones in the building's facades, but above all giving the
impression that no one has looked at this building before with
so much rapt attention. The writing is over the top because the
occasion demands it. It is informed by sustained and meticulous
observation, but Ruskin is not only conveying facts and information
about the forms. He is also conveying an impression of his feelings,
and he persuades us that we could feel those things too if we opened
ourselves up to the experience of what was before our eyes at this
spot. Ruskin's book is a complex mix of prophecy, historical and
topographical information, a campaign for the preservation of
ancient fabrics, not restoration, and an impassioned plea for the
improved condition of the craftsman, who should be commissioned
to do work that will not only be practical, useful and beautiful, but
which will actually save his soul which might otherwise be destroyed
in the living death entailed by operating a machine. Some of the
writing is detailed technical observation, with analysis of the forms
of arches and mouldings, and some of it is superlatively evocative.

While Ruskin was writing such stuff as this, Effie was amusing herself as best she could. What was she doing? Deciding what to wear? Flirting with Austrian soldiers? Why would John care? He was working out a way of saving men's souls and feeling a bond of sympathy across centuries with the wild and free craftsmen who had laboured to conjure this place into being a reality that nevertheless felt like a dream. It seems odd that Ruskin should have been thinking such thoughts of sympathy for the plight of the slave worker while he was staying somewhere as luxurious as the Hotel Danieli, or the Casa Wetzler, but there we are. In the fine, good-hearted fragments of old Venice, themselves often standing in need of salvage, Ruskin was, he thought, seeing the salvation for the modern working world.

This theme became an important part of Ruskin's reputation, and the chapter in which it was explained most fully, 'The Nature of Gothic', would become the most-read part of *The Stones of Venice*. In the 1890s William Morris, the leading propagandist for the Arts and Crafts movement, and for socialism, published this chapter as a book in itself. In his preface he said that in future days it would be seen as 'one of the very few necessary and inevitable utterances of the century'.[23] It is not clear how this concern was awakened in Ruskin, but the attitude seems already to have been in place in *The Seven Lamps of Architecture*, and was prominently there in the opening sentence of a pamphlet, *Pre-Raphaelitism* of 1851, which said that Ruskin was certain that God 'intends every man to be happy in his work'.[24] This was certainly in the background when Ruskin published the fourth volume of *Modern Painters* in 1856 – *Of Mountain Beauty*. It might be expected, given the relatively recent development of the science, that Ruskin would see a study of geology as being as important for the modern landscape artist as the study of anatomy had been for academic figure painters. Ruskin saw precisely that analogy, but he had reservations about both fields of study:

I observed that all our young figure-painters were rendered, to all intents and purposes, *blind* by their knowledge of anatomy. They saw only certain muscles and bones, of which they had learned the positions by rote, but could not, on account of the very prominence in their minds of these bits of fragmentary knowledge, see the real movement, colour, rounding, or any other subtle quality of the human form. And I was quite sure that if I examined the mountain anatomy scientifically, I should go wrong, in like manner, touching the external aspects. Therefore in beginning the inquiries of which the results are given in the preceding pages, I closed all geological books, and set myself, as far as I could, to see the Alps in a simple, thoughtless, and untheorizing manner; but to *see* them, if it might be, thoroughly.[25]

In making this observation Ruskin was returning to a theme, of being blinded by rather than informed by theory. His work is steeped in the theory of the Picturesque, which in this volume he partially repudiates on moral grounds, while elsewhere commending the Picturesque quality of mountains, which represent the 'higher' picturesque, conducive to noble sentiment. The Picturesque's approbation of quaintness, however, was a problem:

the lower picturesque ideal is eminently a *heartless* one: the lover of it seems to go forth into the world in a temper as merciless as its rocks. All other men feel some regret at the sight of disorder and ruin. He alone delights in both; it matters not of what. Fallen cottage – desolate villa – deserted village – blasted heath – mouldering castle – to him, so that they do but show jagged angles of stone and timber, all are sights equally joyful. Poverty, and darkness, and guilt, bring in their several contributions to his treasury of pleasant thoughts.[26]

Ruskin wants us not to be made blind to the poverty and suffering by an aesthetic theory that enables us to relish their incidental effects. It is better in Ruskin's judgement to alleviate the poverty than to paint it.[27] The insight that lies behind this position dawned on him when he visited Switzerland with Effie and Charlotte on the way to Venice. Ruskin had been there before and had been entranced. It was they, not he, who were in the first place appalled by the poverty and deformity of the Swiss peasants. He was looking at the geology and the Picturesque effects. Once his eyes had been opened, however, Ruskin was keen that we too should know that the splendid scenery of the Alps is not matched by the conditions of life for their inhabitants:

For them, there is neither hope nor passion of spirit; for them neither advance nor exultation. Black bread, rude roof, dark night, laborious day, weary arm at sunset; and life ebbs away. No books, no thoughts, no attainments, no rest; except only sometimes a little sitting in the sun under the church wall, as the bell tolls thin and far in the mountain air; a pattering of a few prayers, not understood, by the altar rails of the dimly gilded chapel, and so back to the sombre home, with the cloud upon them still unbroken – that cloud of rocky gloom, born out of the wild torrents and ruinous stones, and unlightened, even in their religion, except by the vague promise of some better thing unknown, mingled with threatening, and obscured by an unspeakable horror, – a smoke, as it were, of martyrdom, coiling up with the incense, and, amidst the images of tortured bodies and lamenting spirits in hurtling flames, the very cross, for them, dashed more deeply than for others, with gouts of blood.

Do not let this be thought a darkened picture of the life of these mountaineers. It is literal fact.[28]

Elsewhere in the book, the mountains are presented as a necessary precondition for life. They are instrumental in the circulation of air and in the cycle of water, which sees the salt water of the oceans purified. The streams and rivers that nurture human life would not be in place without the gradients generated by mountains.[29] Ruskin's account of mountains folds a rich variety of ingredients into the mix, including ideas of development and growth in their formation, along with aesthetics, morality and vitality. Despite his announcement that he has closed his books about geology before sitting down to write, there is a sustained discussion of geology that can only count as intuition and direct observation if one has already digested the principal ideas.

In discussing the Matterhorn, Ruskin refers directly to the work of 'Professor Forbes' – James Forbes (1809–1868) of Edinburgh University, an explorer of the Alps, whose image of the Matterhorn published in 1843 did much to establish it as a destination for travellers.[30] Ruskin, travelling with his parents when he was fifteen, met Forbes at Simplon in Switzerland in 1844. Young Ruskin had sketched a mountain peak, mistakenly thinking it was the Matterhorn. Forbes set him right, and Ruskin eventually visited the real Matterhorn in 1849, making meticulous sketches of it and taking the first photograph – 'sun-portrait' – of it, or (so far as he knew) of any Swiss mountain.[31] In *Modern Painters* he gives a critique of Forbes's image, and implicitly on the limitations of images in general, pointing out that the apparent pointed peak of the mountain (which Forbes characterized as 'an obelisk') is in fact a horizontal ridge that appears to slope steeply because of the effect of perspective.[32] The Matterhorn is at the end of a prolonged ridge and is much less 'pyramidal' than it appears in the well-known views. Ruskin's engagement with the peaks and cliffs is presented as a discipline, based on drawing, that involves sustained contemplation and openness to the actuality of what is before one's eyes. This involves effort and patience, and the

rewards are a sense of profound understanding rather than of bravura posturing.

> Therefore in this chapter I have endeavoured to direct the reader to a severe mathematical estimate of precipice outline, and to make him dwell, not on the immediately pathetic or impressive aspect of cliffs, which all men feel readily enough, but on their internal structure. For he may rest assured that, as the Matterhorn is built of mica flakes, so every great pictorial impression in scenery of this kind is to be reached by little and little; the cliff must be built in the picture as it was probably in reality – inch by inch; and the work will, in the end, have most power which was begun with most patience. No man is fit to paint Swiss scenery until he can place himself front to front with one of those mighty crags, in broad daylight, with no 'effect' to aid him, and work it out, boss by boss, only with such conventionality as its infinitude renders unavoidable. We have seen that a literal facsimile is impossible, just as a literal facsimile of the carving of an entire cathedral front is impossible. But it is as vain to endeavour to give any conception of an Alpine cliff without minuteness of detail, and by mere breadth of effect, as it would be to give a conception of the façades of Rouen or Rheims, without indicating any statues or foliation. When the statues and foliation are once got, add as much blue mist and thundercloud as you choose, but not before.[33]

Ruskin is advocating the use of a technique of the Picturesque tourist – going out with a sketchbook – but is turning it into a spiritual discipline. The aim is not to produce appealing pictures, but to comprehend the visible aspect of nature. The emphasis on geology (and patience) that is evident in Ruskin's text is in effect a close scrutiny of the visible surfaces of mountains in an attempt to infer what is going on beneath the surface. It is the action of matter

beneath the surface that causes the superficial effects that we can see, and which are the only clues we have about what is going on (unless we have other resources of information like mineshafts or books about geology, which Ruskin claims to have closed).

Ruskin's chapter headings include four on 'the materials of mountains', about the composition of different types of rock, followed by two on 'the sculpture of mountains', about how the rocks are shaped. Then there are five chapters on 'resulting forms'. Together they make up the bulk of the book, which on balance is more about geology than about the modern painters in the book's title. It is less about the depiction of mountain scenery than the production of mountains. There is an awareness of the mountains' role in the global economy of precipitation, and the role of glaciers in sculpting the rock is described as part of the process – again an effect of water on the surfaces of the rock. So the cumulative effect of the analysis is not quite what might be anticipated from the chapter headings, where first the matter is made by unknowable natural processes, then sculpted as if by some act of will. On the

John Ruskin, *Fondaco de' Turchi, Venice*, engraved by McLagan and Cumming, from *The Stones of Venice*, II (1853 edition).

contrary, the dynamic relations of rock, air and water are presented as interacting on one another, and causing one another, so as to modify the eventual forms in ways that were not altogether anticipated at the outset. Although Ruskin personally enjoys the Picturesque effects of mountain scenery, his account of what is important about them dwells on what the surface effects reveal about what went on beneath the surface in order to create them. Furthermore they make human life possible, by purifying water and circulating air, even though the human lives that are lived on their slopes are less exalted than one would imagine them to be, given their inspiring location. Nevertheless the rocks, air, water and life are all caught up together in a process of formation that continues indefinitely into the future, albeit changing at a pace so slowly that change is hardly visible across the span of human history. The mountain peaks can outlast the evolution of a species, but they are subject to change in their own time. The geology of the Alps and the life of the Earth are caught up in processes of upheaval and erosion as surely as the rise and fall of civilizations and empires. The moral character of the people of Venice or the remote parts of Switzerland is drawn into the discussions and is seen as part of the mutable character of the place, formed by the upheavals of earth and the ebb and flow of the air and water that sustains and challenges them with the lapse of waves and the lives of stones.

6

Reform

Ruskin's sympathy with stones and craftsmen was entirely a projection from his own imagination. Of course he had not spoken with any fourteenth-century Venetian masons, and all his inferences about their state of mind were his own imaginative work. The craftsmen had left no documents other than the stones themselves to give clues as to their states of mind, but for Ruskin the geologist that was evidence enough.

Ruskin did start to meet living craftsmen. The three volumes of *The Stones of Venice* were published in 1851 (volume 1) and 1853 (volumes 2 and 3). The marriage was annulled in 1854. Effie had been with Ruskin through a very productive part of his career, but that productivity involved isolating himself from her so that he could write. In 1855 he started teaching at the Working Men's College. This was surprising, given the Christian Socialist outlook of the college's founders, and Ruskin's Toryism, but one of Ruskin's most loyal friends, Frederick James Furnivall (1825–1910) was involved with founding the establishment, and had promoted discussion at meetings by circulating 'The Nature of Gothic' from *The Stones of Venice*. So the Working Men's College was in part inspired by Ruskin's romantic idea of what the craftsman could and should be. Ruskin taught drawing at the college, and brought Rossetti in to help him.[1] Before he began he imagined that he might awaken great talents, but he soon adjusted his expectations so that instead of teaching people to become fine draughtsmen he

concentrated on advocating drawing as a spiritual exercise that makes one look intensely and attentively at the world. It enables us to see. This outlook was expounded in print in *The Elements of Drawing* of 1857, based on his work at the college. By then Ruskin was back with his parents, living at Denmark Hill, and he gathered round him a group of working men whom he employed as servants while thinking of them as a 'protestant convent' – evidently a model that might be replicated, with groups of art-workers making copies of medieval manuscripts and artworks.[2] One of them, George Butterworth, gave Ruskin woodworking lessons.[3] Another, William Ward, sometimes gave drawing lessons at the college on Ruskin's behalf.[4] There were others who were taught mezzotint and engraving techniques and who became part of a team that produced the plates for Ruskin's books. Among them was George Allen, who married Ruskin's mother's maid. When Ruskin decided that he would do better to publish his own work than to have Smith, Elder continue to publish it for him, George Allen was put in charge of the project. While they certainly remained as servants there was a social bond in the group, which meant that most of them remained in Ruskin's service for the rest of their lives. That bond may have been more feudal in character than the 'fraternal' relations of a convent, but it was important for Ruskin's sense of well-being. With his parents he remained deferential: in their eyes he was always a child. He could summon up the persona of an Old Testament prophet to redirect the attention of the art world, but at home Margaret Ruskin could overrule him. His circle of craftsmen was more biddable.

One of Ruskin's contemporaries at Oxford was Henry Acland (1815–1900) – a medical student when their friendship first formed. He stayed on in Oxford and had a distinguished academic career, being made Regius Professor of Medicine in 1858. He is credited with introducing the study of natural history to the university, and to that end he successfully campaigned for the building of a natural

history museum in Oxford. In late 1854 there was a competition for a building design, and it was won by an Irish firm, Deane and Woodward. They proposed a Gothic building. Acland had lobbied for it, and Ruskin wanted it to win but did not think that Gothic would be commissioned in Oxford. However, it did win. Ruskin was excited and at that point started to take a serious interest in the building.

> I hope to be able to get Millais and Rossetti to design flower and beast borders – crocodiles and various vermin [. . .].
> I will pay for a good deal myself, and I doubt not to have funds. *Such* capitals as we will have![5]

It did not quite work out like that. Millais married Effie at about this time, and it is worth noticing that Ruskin did not think that commissioning him was out of the question.[6] Rather than behaving like a wronged husband, he was perhaps relieved that Millais had taken Effie off his hands. Millais, however, would have been hearing Effie's version of events and of Ruskin's character, and he accepted no further commissions from Ruskin after the portrait. He and Rossetti came and visited Oxford, but did not get drawn into the museum project. Rosetti did some work on the Oxford Union – one of Woodward's designs – with William Morris and Edward Burne-Jones, who were inspired by Ruskin's writings, but Ruskin was not personally involved.[7] At the museum Ruskin contributed £300 towards the carving of naturalistic ornament, and had many meetings with Benjamin Woodward (1816–1861), whom he regarded as a friend.[8] The design was Woodward's, not Ruskin's, as has sometimes been supposed, but Ruskin certainly inspired the approach to the design and discussed and approved many details. It was due to Ruskin's influence that the workmen on the building attended religious services in the morning and went to lectures in the evening. The capitals were partly designed by the men who

carved them, bringing 'wit and alacrity from the Emerald Isle to their cheerful task'.[9] The cost of decorating the building with flowers inside and animals outside was great and problematic.[10] A design of monkeys in a window-surround that might mischievously have alluded to evolutionary theory seems to have been turned into cats, to avoid controversy. There was also a start on a frieze with alternating parrots and owls, which was abandoned.[11] Overall Ruskin was disappointed with the results. He described the principal carver, James O'Shea, as a 'poor Irish workman', who was

> a man of truest genius, and of the kindest nature. Not only the best, but the only person, who could have done anything of what we wanted to do here. But he could only have done anything of it after many years of honest learning; and he too easily thought in the pleasure of his first essays, that he had nothing to learn. The delight of the freedom and power which would have been the elements of all health to a trained work-man were destruction to him, and the more that if he would have studied, there was nobody to teach him, and there were hundreds to despise. I could not teach him – nothing but the master's constant presence would do that – and I dared not discourage him. I hoped he would find his way in time, but hoped, as so often in vain.[12]

Ruskin realized that it was not enough to find the most promising individual and give the best possible conditions. The craftsman had to belong to a culture and a tradition where the right skills would be in place along with the right attitudes to work and the right sensibility in order to make fine judgements. Work that embodied the grace and freedom of fourteenth-century Venetian masonry was not going to be achievable in the nineteenth century. The freedom could be put in place, but without the

fourteenth-century experience and devotional attitudes, the results were disappointing.

Volumes 3 and 4 of *Modern Painters* appeared in 1855, when work on the museum was just beginning. It opened in 1861, soon after Woodward's death. During that time Ruskin's main preoccupation, as he explains in the preface to *Modern Painters* volume 5, was the cataloguing of Turner's drawings from his bequest to the nation. Ruskin not only admired the work, but he was better placed than anyone to recognize the locations that were depicted. It is often said that Ruskin prudishly destroyed Turner's erotic drawings, but that is untrue. The drawings survive, 'lost' among the other drawings and protected from Victorian censure by not being mentioned in the catalogue. They are incidental to Turner's output and his reputation, but the myth of their destruction has unjustly perpetuated an idea of Ruskin's naivety and prudishness. The work on Turner meant that Ruskin was once again immersed in the world of Turner's sensibility, which he found more satisfying than the productions of the artists who were still living. For example, he admired John Brett's landscapes and bought his spectacular view of the Val d'Aosta,[13] but then came to have reservations about it. It was not really a 'noble' picture:

It seems to me wholly emotionless. I cannot find that the painter loved, or feared, anything in all that wonderful piece of the world . . . I never saw the mirror so held up to nature; but it is Mirror's work, not Man's.[14]

By contrast Turner's works are less 'mechanical'. He normally stretched the vertical element of the proportions in a landscape, so that mountains seem to tower and precipices seem vertiginous. Photographs of the same spots can disappoint. It was Ruskin's conviction that Turner conveyed the human truth of the experience of the place, while others like Brett could only manage, however

painstakingly, a proficient mechanical transcription of the scene. With a Turner to look at, one feels as one would in the place. The fifth volume of *Modern Painters* gave Ruskin some trouble, not only because of the other projects mentioned in the preface – including 'upwards of nineteen thousand pieces of paper drawn upon by Turner'[15] – but also because if it were convincingly to conclude the multi-volume work, it would have to give the impression that there had been a design to the whole. That was a tall order, given the way the project had developed so discursively as Ruskin discovered unanticipated enthusiasms (such as early Italian paintings) along the way. It is in volume 3, *Of Many Things*, where the idea of an over-arching design seems to have been altogether abandoned, but volume 5 concludes with new raptures extolling Turner's virtues, and we seem to have come back to the home territory from which the journey of adventure and discovery had set out seventeen years earlier. Ruskin celebrates Turner's brilliance in conveying the sense of place and of sunlight, but more than anything he returns to praise Turner's moral sense, often conveyed through the use of Greek mythological themes allied with brilliant evocations of atmospheric effects. Ruskin's father pressed his son to finish this book, as he was feeling his age, and said that he wanted to be able to read it – he was 75 when it was published. It ends with Turner continuing as a benign presence despite being ignored by nearly everyone and misunderstood by the rest, including the young Ruskin. The conclusion is a meditation on peace, hope and death, which is absolutely in the territory of piety rather than aesthetics, though Turner, so much identified with light in the preceding pages, is certainly caught up in the symbolism of Ruskin's words. The received wisdom is that 'Christ is the light of the world', but most people do not seem to be living in the world that is illuminated by Christ, but in a darkness that has not yet heard God's command, 'Let there be':[16]

Which is, therefore, in truth, as yet no world; but chaos, on the face of which, moving, the Spirit of God yet causes men to hope that a world will come. The better one, they call it: perhaps they might, more wisely, call it the real one.

[. . .]

This kingdom it is not in our power to bring; but it is, to receive. Nay, it is come already, in part; but not received, because men love chaos best; and the Night, with her daughters. That is still the only question for us.[17]

To choose 'the way of the world' is to choose avarice, darkness and death, whereas to choose Christ and the light is to bring peace and eternal life. Ruskin sees Turner's greatness as lying in his having chosen light – which is to say the symbolic and true light that he attempted to convey through his depictions of light in the literal world. Ruskin's appreciation of Turner's work was as intense as it had always been, but it had deepened into an understanding of a pervasive symbolism of light that enriched its naturalistic rendering. The theme of death and eternal life would have been an issue at home with his ageing parents, but the opposition between worldly wisdom and Christian principle that is introduced here is important. In the prayers that England dictates to her children, says Ruskin, 'she tells them to fight against the world, the flesh, and the devil'. But 'What is the world which they are to "fight with", and how does it differ from the world they are to "get on in"?'[18] This question lies at the heart of Ruskin's next book, a set of essays on political economy, *Unto this Last*. Ruskin was a Tory, but emphatically not a capitalist. In these essays he tried to set out a basis for economics developed on really Christian principles. It did not go down well.

In Ruskin's view of the world, political economy was 'the science of darkness'.[19] He sought to put it on a new footing. His title 'unto this last' refers to one of his key principles. In the New Testament, Matthew retells a story told by Jesus. A man hired labourers to

work in his vineyard. Several times during the day he went to the marketplace to find people who were looking for work, and brought them back to the vineyard. At the end of the day he paid each of them a penny. The people who had worked in the vineyard all day complained that this was unfair, but the man said that he was paying them what had been agreed (in those days a penny must have been a fair wage for a day's work) and it was doing those conscientious workers no disservice if he chose to pay the same even 'unto this last', who had arrived only for the final hour of work. That is what the kingdom of Heaven is like, according to Jesus.[20] How does one make such an insight the basis of political economy? Well, not without changing everything from its established patterns.

Ruskin argued that conventional economics treated people as if they were covetous machines.[21] If they were treated differently, they would behave differently. The motive force that drives things along is human will; there are souls in this machine, and it is most productive not when it is administered oppressively, but when people are in love with the thing they are doing and when they have proper respect for and from those around them. So Ruskin makes the principle of 'affection' the basis of his way of thinking about economic relations.[22] He commends Dickens's *Hard Times* as an exaggerated but essentially truthful illustration of how things go wrong when we think of humans as utilitarian commodities.[23] Ruskin's parable to show that the love of money is deadly involves a rich man who drowns because he cannot let go of his gold. His conclusion, in capital letters, is that 'THERE IS NO WEALTH BUT LIFE'.[24]

Ruskin believed that craftsmen should be paid enough to live on, but that the wage should not be dependent on the quality of their work. He did not want to see their employers competing on price, undercutting one another, as that could only lead to the lowering of standards. The market should deal with bad workmanship by declining to employ the bad workmen, not by persuading them to work for less. Similarly he thought that workmen should

be encouraged towards steady employment: 'The men prefer three days of violent labour, and three days of drunkenness, to six days of moderate work and wise rest.'[25]

It has been suggested that these essays on political economy were an attack on John James Ruskin's principles as a commercial operator, as he continued to work in the conventional economy that is criticized in them. There was not a straightforward Oedipal confrontation of father and son. They quarrelled and annoyed one another, but John remained in his father's house and deferred to him in practical matters, while maintaining his independent outlook in his writing. The essays were written in Switzerland, and John sent them to his father, so that John James could read them and take them to the publisher (the popular *Cornhill Magazine*). Ruskin did not want to see them published if they would embarrass his father, who, far from being embarrassed, seems to have been their most enthusiastic early reader. The analysis of the merchant's role in society is very appreciative, but it is mixed in with a discussion of death. Ruskin presents a list of five great intellectual professions: soldier, pastor, physician, lawyer, merchant. Society has a role for them all. The merchant's role is to provide the things that society needs. The money-making side of the role is incidental, and Ruskin describes the merchant as having a paternal role in relation to the people who must be brought together in order to make the enterprise work. He is 'invested with a distinctly paternal authority and responsibility'.[26] Each of these professions brings with it, says Ruskin, a duty to die if the circumstances arise that demand it. The role of the soldier, for example, is to defend the nation, and it is his duty to die for it rather than leave his post in battle. For the merchant the duty is less clear:

The Merchant – what is *his* 'due occasion' of death?
It is the main question for the merchant, as for all of us.
For, truly, the man who does not know when to die, does
not know how to live.[27]

It is an extraordinary way to couch the discussion, to be read by his 75-year-old father who was still working in the city, going in each day to look after his business family:

> In most cases, a youth entering a commercial establishment is withdrawn altogether from home influence; his master must become his father, else he has, for practical and constant help, no father at hand: in all cases the master's authority, together with the general tone and atmosphere of his business, and the character of the men with whom the youth is compelled in the course of it to associate, have more immediate and pressing weight than the home influence, and will usually neutralize it either for good or evil; so that the only means which the master has of doing justice to the men employed by him is to ask himself sternly whether he is dealing with such subordinates as he would with his own son, if compelled by circumstances to take such a position.[28]

This section is not as clear as it might be, but it seems to be saying that the merchant gives up his life a little at a time, by going into work and being the moral guardian and surrogate father of his enterprise, meanwhile – the implication might be – neglecting his wife and his actual son. There was another strange episode at about this time, when Ruskin decided to divest himself of his Turners. He gave them away to the universities at Oxford and Cambridge, although they had not asked for them and had no particular use for them.[29] The motive had nothing to do with external pressures, but came entirely from within the household. The works, 73 of them, had been acquired painstakingly and with loving care over the course of many years by father and son together. They had formed John's taste and he had written about them. As a group they were not only the household's greatest treasure, they were an important part of its intellectual and cultural fabric. The

decision to remove them must have been painful, and it certainly pained John James, who had paid for the pictures. He and John seem to have had an argument.

> He began emptying his cases of Turners & slightly pillaging the walls carrying off my property without scruple or remorse to present to his College & he has an equally felonious design on some Turners just bought, in favour of Cambridge. Seriously however I am not sorry for this – I had indeed told him that his costly decorated Walls & large accumulation of undivided Luxury did not accord with his Doctrines. I am now paying for my speech.[30]

John James knew better than his son did how the household was sustained by commerce. He knew how to deal in the world and how to make his way in it, and protected his son from having to do the same. His overriding aim in life was not so much the accumulation of money as social advancement, and the money was accumulated as a by-product of the responsibly managed business – selling a fine product honestly – and social elevation was enabled by having the money. Of course John the author and celebrity had a higher social status than his father, but domestically it was the father who was in charge. When John was invited to Lord Palmerston's country seat for a weekend in March 1861, he was not feeling well and did not want to go. John James wanted him to go, and eventually he agreed, on the condition that his father buy him four Turner drawings – one for each of the days he would lose.[31]

In these matters Ruskin was behaving in a strangely childish way, the more so as his main reason for not wanting to go to the Palmerstons was so that he could play with the children at Winnington, where he was. It does not come close to the Oedipal relation of making oneself independent of one's father (in Freud's sense by 'killing' him). On the contrary, the father's authority is

accepted and survives unchallenged; but he is made to pay. The removal of the Turners from the walls seems to be calculated to pain John James, but it nevertheless follows his argument that their cost makes them decoration that is incompatible with Ruskin's arguments. Ruskin felt the need to give them away to prove to himself that he was not as attached to them as the drowned merchant was to his gold. It was a spiritual exercise, and it hurt; and it was designed also to hurt John James for pointing out that the pictures were things with a market value, as well as being the morally edifying and aesthetically wonderful objects that had made John want them in the first place. The money-cost meant nothing to him. John James, meanwhile, behaved as if he were waiting for a toddler's tantrum to quieten down, in the first case, and bribing good behaviour from a manipulative child in the second. The tokens in the exchanges – masterly artworks and a stay at the prime minister's house – are dazzlingly sophisticated, but the emotional content is unedifying. John's unconscious was producing childish moods, as perhaps the unconscious does, but he had not developed the social skill to mask them, nor taken the steps towards adulthood that would have made them go away.

Maria La Touche was the half-sister of one of Ruskin's friends at Oxford (John Otway O'Conner Cuffe, Earl of Desart). She grew up in Ireland and married John La Touche, a Protestant landowner, whose family had banking interests. They divided their time between Mayfair and their 11,000-acre estate at Harristown in Ireland.[32] The father was intensely religious – he had become a fanatical Calvinist – but Maria had a more common-sense religious outlook and a sparkling personality. She had published novels and had three children. She thought her daughters should have drawing lessons, and could think of no one better than Ruskin to teach them. Ruskin sent one of the members of his 'convent', William Ward, to see them on his behalf.[33] Maria and her daughter Rose came to visit

John Ruskin,
Rose La Touche,
c. 1861–2,
watercolour drawing.

Denmark Hill, where Ruskin charmed them, and he was invited back. A pattern of regular visiting was established, and Ruskin became a friend of the family, and especially a friend of Rose. This could all have been completely and conventionally benign, and was assumed to be so, until Ruskin proposed that he and Rose should be married. That was on 2 February 1866, when Rose was just eighteen. John's forty-seventh birthday would be the following week. Rose thought she should wait until she was 21 before making up her mind. Her parents were shocked and insisted that she must not write to him.[34] Ruskin's conviction that the match would work did not waver, and he started counting down the days until Rose's coming-of-age.

There had been changes at Denmark Hill. John James Ruskin died on 3 March 1864, and his widow Margaret (then 83) looked to her son as head of the household. She took a liking to one of her cousins, the seventeen-year-old Joan Agnew, visiting from

Scotland, whom she seems to have first met after the funeral and taken in as a companion. The arrangement was exactly like the one that had taken young Margaret Cock the publican's daughter up to Edinburgh 63 years earlier. John acted as Joan's legal guardian, so it was he whose permission was asked when Rose's brother, Percy La Touche, proposed marriage to Joan in 1867, writing from Bologna.[35] Ruskin did not forbid it, but Joan broke off the engagement in 1871 after Percy's misbehaviour at his twenty-first birthday party.[36] She remained on good terms with his sister, and was able to pass messages between her and John when official communication was forbidden. She remained very close to John and took over the running of the household at Herne Hill. They exchanged letters every day when they were not under the same roof. From 1867 onwards these notes are often written in baby-talk.

> Oos poo wee Donnie – so – ired – and so – tick – and so eerie – and so fightened – and so – only – dat if he hadn't his wee mamie to [illegible – comfort?] him – he don't know what he oud do.[37]

In isolation this is fairly amusing, but cumulatively – there are thousands of such notes – the effect is disturbing. This note would be typical of John's (Donnie) communications to Joan (Doanie) in his dotage, but here it was when he was 50. Of course the tone is playful, if depressive, but role-playing the child came easily and became a refuge and a comfort as much as a game. This is an aspect of Ruskin's personality, but not the only one, and it was not seen in public when it would have been inappropriate. Ruskin always had a rapport with young girls, and the childish playfulness was undoubtedly part of his creativity. The playfulness could attach to serious ideas in his lectures, but he could just be enjoyably silly when it amused children. He was in touch with his inner child; that was part of his strength. It becomes worrying when that inner

child starts to be the dominant part of Ruskin's personality. When Margaret Ruskin died in 1871 Joan was the person closest to him in the world, and she seems by degrees to have become Ruskin's substitute for his mother, at first playfully but later in a way that was quite dependent. He shared unguarded thoughts with her and let her manage the household as she saw best. 'Now. – I have no hope – no future – no Father – no mother – no Rose – and only the third part of a Joan.'[38]

During the period when Rose was incommunicado, any sign from her was rapturously received. By way of Joan she would sometimes send a pressed flower, which Ruskin would over-interpret as a coded message. The infatuation with Adèle Domecq set the pattern that was again followed here, of Ruskin able to feed his anxieties and hopes on the basis of the flimsiest evidence. In Adèle's case he had had no encouragement at all, but he could still feel injured by the agony of it all 40 years later. With Rose it was different because she did have some friendly feelings for him, though it is not altogether clear what those feelings were. Where Ruskin was concerned the feelings were not conspicuously erotic or predatory, but they were obsessive. Somehow he had convinced himself that Rose was a living saint, and he wanted her approval for the things he did. He made her his authority figure, apparently putting her where his father had been, not so much where practical matters were concerned, but when he was looking for moral guidance. He emphatically disagreed with some of her religious views, for which he blamed her parents, and presumably thought she would grow out of them. Later, after her death, he started to identify her with St Ursula, and believed that Carpaccio had painted her; also Botticelli, who seemed to have used her as the model for Zipporah (Moses' wife) in the Sistine Chapel.[39] He wanted to have contact with her in the spirit world, and in periods when he lost his sanity, he had hallucinatory messages that he could clearly see.[40] When Ruskin brought up the idea of marriage to Rose, her mother contacted

Effie, now Effie Millais and a mother many times over, and Effie replied. The letter is lost, but it confirmed to Rose's parents that a marriage to Ruskin was in their eyes absolutely out of the question. It is less clear how it looked to Rose. There may have been a time in her late teens when she might have wanted to marry him, and she gave him crumbs of encouragement without realizing the power of the obsession she was feeding. She did not resolutely break off with him, but there was a discouraging moment on 7 January 1870 at the Royal Academy, when they chanced on one another on the stairs – a rather public place. Rose was 21 by then, certainly no longer a child. She tried to pretend not to have seen Ruskin, which made it a devastating day for him. He challenged her, taking out of his pocket the red silk wallet lined with gold plates in which he kept next to his heart some of the letters that she had written to him.[41] She declined to acknowledge it. Had he been less infatuated, he would surely have seen that whatever she had said a few years earlier, she had moved on now and it was all over. Somehow, though, Ruskin was able to sustain his hopes. He projected on to her a numinous authority that he found irresistible, but which others could not see.

His relations with both Rose and Adèle were very odd, very private and very much one-sided. In 1871 Joan married Arthur Severn, an undistinguished painter, and as Joan Severn she was one of Ruskin's executors and saw to it that all the correspondence with Rose was destroyed for the sake of Ruskin's reputation. There is not much to go on, but the modern consensus is that Rose suffered from anorexia, at about the time that Sir William Gull first coined the term (1873).[42] Whether that would be brought on by religious mania or by authority figures in her life being in conflict with one another is open to speculation, but Rose never flourished as an adult. She gradually wasted away and died in 1875 when she was 27. Ruskin went to see her when she was close to the end, and they parted on peaceable terms. Joan arranged for the parents to visit

Ruskin in old age, and they passed the time in the Lake District agreeably and politely. But in private Ruskin remained devoted to Rose in an obsessional way, imagining that they would be together again when he died. He wrote to her in his books, sometimes including passages that he thought only she would understand; and he wanted to be haunted by her, welcoming any way of feeling himself to be in her company, which now would only be in hallucinations or dreams.

Ruskin's travels continued, but they rarely took him further afield than the places he had visited in his youth with his parents. He made a tour of Germany to improve his knowledge of the artworks held there, but never crossed the Atlantic, and nearly all his journeys took him through northern France to Switzerland, and then sometimes on to Italy. The Alps remained the focus of his affections, and he would go there for months on end, to write, walk and geologize, with a servant as travelling companion. He would often meet artists or other friends while he was there, and maintained a daily correspondence with Denmark Hill. The railways speeded the long-haul parts of the journeys, but he regretted their effect on the scenery.

As he felt more at home among the mountains than he did anywhere else, he decided it would be a good idea to settle there, and in 1861, when his parents were still alive, he found a place where he thought it would be ideal to build. The site was on an Alp, the Brezon, near Bonneville, in Savoy, which had very recently changed hands from the kingdom of Sardinia to France, but it was close to Lake Geneva and one might have thought oneself in Switzerland. The site was spectacularly romantic, and would no doubt have been conducive to great thoughts. In 1869 in Bavaria, in very similar scenery on the northern edge of the Alps, Ludwig II would start construction work on Neuschwanstein. The romantic sensibility was no longer avant-garde, but it was not exactly mainstream, and Ludwig's castle was seen by some as evidence of his insanity. Ruskin's idea for a chalet would have been more modest,

but the costs would have escalated as the project advanced. Access would have been a problem; he would have had to build tracks if not roads; and the size of the house would have grown when Ruskin realized that he would need servants; the costs of taking building materials and workmen to the site would have been extravagant. In short, he would have had a modest dwelling at exorbitant cost. It was doubtful whether the site had an owner from whom it could be bought, but Ruskin tried to buy it. In the eyes of the local people it was so obviously unsuited to dwelling that they deduced that Ruskin with his interest in geology had made a find of gold there, so they refused to sell. When he raised his offer it confirmed the rumours. Ruskin's friends thought they would never see him again if he settled there, and they tried to talk him out of it. John James sent John's tutor from Oxford, Osborne Gordon, across to talk him out of it. He told Ruskin not to be such a fool, and the idea was dropped.[43]

Ruskin's purchase of Brantwood, a cottage by Coniston Water in the Lake District, was the practical version of the same impulse. The site feels remote, but is relatively accessible, and the place had happy childhood memories associated with it, as well as more recent visits. Ruskin made the purchase of 16 acres of land without seeing the site. It was the location, not the building, that was important to him. The cottage could be, and was, rebuilt and extended. The place is glorious, with extensive views across the water to the fells beyond. Ruskin described his purchase as 'a bit of steep hillside, facing West — commanding from the brow of it, all Coniston lake and the mass of hills of south Cumberland'.[44] The house even with its extensions is not grandiose, but has the character of a well-appointed gentleman's farm house. It is a comfortable place to be in spectacular scenery, but it does not attempt to attract attention to itself. It was designed to be a useful facility rather than an impressive monument. Ruskin bought the land when he was feeling depressed. He did not feel well enough to

leave the country that summer; his mother was ill and, he thought – rightly – in terminal decline. After her death he made Brantwood his base, and for as long as he travelled, he travelled from there, though he was very often away. He added a well-proportioned dining room with a view of the lake and a run of Venetian-looking Gothic windows, but most of the building was not stylistically anything much, other than 'traditional', and the dining room's furniture had been his parents' at Denmark Hill and was there for sentimental rather than stylistic reasons. The scale of the room suited the furniture and was no grander than the room from which it had been moved. The house's central room was a not-too-large study, and there were only two spare bedrooms, so visitors often stayed in Coniston village.[45] The model at the back of Ruskin's mind was Abbotsford, Sir Walter Scott's house in Roxburghshire, but divested of its social pretension and Scott's theatrical sense of baronial style. It is a writer's house, based around the library. It housed some Scott manuscripts, which Joan secretly tried to sell.[46]

John Ruskin, *Bonneville, Savoy* (now Rhône-Alpes, France), photogravure by George Allen after Ruskin's drawing of 1856. The mountain beyond the town is Mont Brezon, where Ruskin wanted to live.

Cousin Joan married Arthur Severn in 1871 and Ruskin gave them the remainder of the lease on the house at 28 Herne Hill where he had lived with his parents before they moved to Denmark Hill. The Ruskins had evidently sublet the house for some years, but then when the tenants moved out Ruskin started to make use of the house himself, for example keeping geological samples there. After 1871, with Joan and Arthur living there, and the Denmark Hill house sold, this was where Ruskin would stay when he was visiting London. Joan kept his old nursery as his room, so it was there, with the safety bars that had been put across the window to stop him falling out of it as a toddler, that he would go to sleep.

After much imploring and cajoling from Ruskin, Joan and Arthur Severn and their three children moved to Brantwood in 1887.

Can't you sell evy ting off at once – and come and live oos di pa comfy and nevy go to that wicked London no mo? [. . .] I am doing a good deal – but theer is really <u>no</u> happy time in living alone – and me's getting so cows and woes and sulk and walk – there's no speakin to me.[47]

Joan took over Brantwood's management and the house was further extended to accommodate the additional people, and to make it better suited to the social rank that the Severns felt they should have. As Ruskin's physical and mental health declined, Joan tried to protect him and his reputation by keeping him out of the public eye. There are times when it sounds as if Ruskin was being kept in circumstances that seem disrespectful of the great man, but that is probably not what he felt. Far from being pompous and asserting his authority at Brantwood, only to be overruled, he seems to have been determined to regress. There were times when he misbehaved and Joan was sensible. The thing that is strange about Ruskin's circumstances is the gulf that grew between his public persona and the infantile regression in which he found security and comfort

when he was at home. He could not be properly childish by himself, but needed an adult figure with him so that he could be directed like a child. He described himself as 'a child of the Lakes', and settled back into that role in the years of his decline, and in a place of great geological interest and breathtaking beauty.

At some point in middle age Ruskin's psychology became in some sense paedophilic, as one modern biographer, Tim Hilton, has unequivocally asserted, although another, John Batchelor, demurs.[48] If the use of the term seems to imply that he would want to have sex with underage girls, it would be wide of the mark. Rather he was drawn to them because he felt himself to be a child, and wanted a relationship or friendship where sex was out of the question. His infatuations were with young women in their late teens or older, which looked normal enough when he was that age himself, but improper when he was older. His childish regression is troubling, and points to problems that developed because his parents were so close to him for so long. He did not find a route into the adult development of that side of his character – which was surely his responsibility as much as it was his parents', had anyone been aware of it. The closeness of the ties, and the continuing dependence on the father's money, seem to have kept John perpetually in mind of his father's views, even if on occasion even in middle age he petulantly defied them, thinking of them as 'the fondest – faithfullest – most devoted – most mistaken parents that ever child was blest with – or ruined by'.[49]

So, while this regression was going on out of the public eye, Ruskin the public figure was looking ever more like a prophet from the Sistine Chapel ceiling. He grew his beard extravagantly long and issued proclamations to the general public about how they should live their lives. In the seclusion of Brantwood he reviewed his own life, trying to make sense of it in the memoir that was published as *Praeterita*. It breaks off before his marriage, so really it is an account of his childhood and adolescence, giving

beguiling insights into his imaginative development and how he experienced his upbringing. There is a wistfulness about it – the title means 'of past things' – and there is a sense of an idyllic childhood that passed without properly preparing him to be the kind of man he would have wished to be. The memoir petered out, and did not deal with his adult concerns. Ruskin's writing had always been digressive in character, but his mind started to wander uncontrollably and the memoir was abandoned after the publication of its third volume in 1889. It was during the two preceding decades that Ruskin enjoyed the height of public recognition, which in fact continued after he stopped writing and appearing in public. Indeed, his reputation remained intact after his death, until the 1914–18 war changed everyone's attitudes to the Victorian era of which he was so conspicuous a part.

In 1869 he was made the first Slade Professor of Art at Oxford, and he was scheduled to give his inaugural address at the Oxford Museum, with which he had been involved. His celebrity was such that 2,000 people turned up to hear him. The lecture theatre could not cope and new arrangements were hastily made. The event moved to the Sheldonian Theatre, and the audience walked there from the advertised venue as a straggling informal procession.[50]

In 1871 Ruskin stopped publishing with Smith, Elder, who had been with him through his whole career. He put his servant George Allen in charge of making the practical arrangements, but although the works were beautifully printed under Ruskin's direct guidance, the distribution was not well organized, Ruskin refused to advertise and the enterprise lost money.[51] It was not until 1882, when Allen started to issue cheaper, small-format versions of Ruskin's earlier and more famous works, that the publishing business began to flourish. It produced a good income, and by that time Ruskin needed it. Incredibly, given the size of the fortune that had been left to him, Ruskin ran into financial difficulties. This was partly because of the number of people who depended on him – not only Joan and her

family, but the servants and a host of his parents' servants who were supported in their retirement. He continued to collect. His gift of Turners to the universities was not a signal that he would stop buying Turners. Joan and Arthur sold paintings and manuscripts from Brantwood to generate income.[52] It pained Ruskin, but he acquiesced – at least in notes that were not destroyed. There is a sense of barbarism about the way Joan, who was practical but had no appreciation of fine culture, took apart the elevated domestic ambience that Ruskin had put in place. She died in 1924; her husband, who moved to London and neglected Brantwood, died in 1931. By then the house was in poor condition and the collections completely dispersed, uncatalogued.[53] They had been one of the cultural high points of the age, housed in a cottage; but by the time the Severns left it was a large rambling house with nothing special to recommend it. The house is now open to the public, as Ruskin wanted it to be, and with a collection that has been pieced together through the devotion and generosity of Ruskin's twentieth- and twenty-first-century admirers. If only Joan and Arthur Severn had been more appreciative, much more could have been saved, but the shape of Ruskin's life is of a glowing childhood of brilliant promise that was realized as a young adult, and then burned out and enfeebled. He could look like a prophet, and so long as he remained silent and let his publications do the talking, his reputation seemed secure; but at a personal level he was progressively ruined.

There may be a sympathetic way to tell Arthur Severn's story, but it would not be from a Ruskinian point of view. He showed enough promise as an artist to decide to make that his métier, but not enough to make many sales, and he certainly never managed to support himself but was always completely dependent on Ruskin's largesse, by way of Joan. His paintings are competent, and with more energy and application he might have managed to establish a reputation, but he lived as a gentleman amateur. Some people

must have found him good company, as he was on friendly terms with James Abbott McNeill Whistler and Walter Crane. Ruskin could not have serious conversations with him, but they went to the theatre together and they did not irk one another when they were both light-hearted. Ruskin never said anything about him in print, which might, to Severn, have seemed disobliging. He tried to introduce Ruskin to Whistler, but the meeting never took place. However, in 1877 Ruskin published a review of Whistler's painting, *Nocturne in Black and Gold – The Falling Rocket*, which was exhibited at the Grosvenor Gallery.

The gallery had been set up by Sir Coutts Lindsay in Bond Street, a short distance from the Royal Academy, which it was seen to rival. It was a place where artists who were not academicians could exhibit their work to a very wealthy clientele who could pay good prices. Whistler was financially dependent on making sales to such people, and Ruskin's comments about his work went beyond being unappreciative of the particular painting, threatening Whistler's livelihood. 'For Whistler's own sake', said Ruskin,

> no less than for the protection of the purchaser, Sir Coutts Lindsay ought not to have admitted works into the gallery in which the ill-educated conceit of the artist so nearly approached the aspect of wilful imposture. I have seen, and heard, much of Cockney impudence before now; but never expected to hear a coxcomb ask two hundred guineas for flinging a pot of paint in the public's face.[54]

A 'coxcomb' again. The word was still part of Ruskin's vocabulary, but by this time surely of no one else's. Whistler decided to sue Ruskin for libel. The details of the subsequent trial have been well documented, and will not be discussed here.[55] Whistler treated the court as a stage and expounded his ideas with a wit that delighted reporters and drew rounds of applause in the courtroom, while

Ruskin excused himself with a doctor's note and stayed away. Ruskin's letters to his doctor from this time have resurfaced and show him, at 59, craving the opium-based 'tonic' that seemed to revive his spirits while he was taking it but left him listless and apathetic.[56] There were also hallucinations, including an episode where the wallpaper in Ruskin's bedroom filled him with such a feeling of overwhelming dread that he never slept in that room again. Most of the time he was not absolutely ill, but he would have cut a sorry confused figure in court if Whistler had been allowed to question him.

Why had Ruskin found Whistler's painting so objectionable? There is the matter of detail and finish. Ruskin admired the paintings by Edward Burne Jones that were on display in the gallery at the same time as the finest that the age could produce. He praised Tissot's technique, but lamented his subject-matter, and even praised Millais, while lamenting the loss of his youthful zeal with the execution of detail. The painterly films of colour on Whistler's canvas were without detail, and the execution looked spontaneous rather than painstaking. Ruskin, however, was quite capable of admiring rapidly executed sketchy paintings if he felt that they had accurately caught whatever it was that it seemed essential to capture.[57] Turner's later work can have much in common with Whistler's. The attempt to capture the transient and vaporous effects of *Rain, Steam and Speed*, first exhibited at the Royal Academy in 1844, for example, stands in comparison to Whistler's attempt at capturing the arresting but fleeting impression made by the falling rocket. The reputation of both artists is now secure, and both paintings are in public collections, the Whistler in Detroit, the Turner in London – one of the few of his works to be on display at the National Gallery rather than with the huge collection of his work at Tate Britain. *Rain, Steam and Speed* is now seen not only as a good example of Turner's work, but as among his greatest achievements, and its exceptional quality was recognized early.

The novelist William Makepeace Thackeray (1811–1863) said, 'The world has never seen anything like this picture.'[58] Ruskin said nothing about it.

When we look at Turner's work from a later age, we can hardly help but see in his later paintings premonitions of things to come. For me *Rain, Steam and Speed* seems to have more in common with Monet's 'impressions' than anything by Turner's contemporaries – and I daresay I am not alone in that. The first exhibition of works that came to be known as 'Impressionist' was held in Paris in 1874, and their significance would not be realized for years to come, so Ruskin and Turner could not have seen *Rain, Steam and Speed* as a precursor of Impressionism. It is easy enough for us to look at Turner's work anachronistically, and admire it in ways that would have been alien to Turner himself and to his patrons. Ruskin saw Turner as a great moralist, who found a way to express important truths through symbolic language naturalistically rendered as landscape showing the fleeting effects of weather and light. Ruskin was able to attribute moral sentiment to Turner's landscapes, and when that moral sentiment was not identifiable then he had nothing to say about the paintings. He knew that some late works in the Turner Bequest were unfinished, and he could suppose that the moral content might become evident only later when the painting was more developed, but Ruskin clung to the idea that it was supposed to be there.

This moralizing was an aspect of art that Whistler entirely repudiated. He gave his pictures titles that give priority to the dominant pigments rather than their subject-matter. Perhaps the closest he came to the expression of sentiment in his paintings was in his portrait of his mother (1871), but he gave it the title *Arrangement in Grey and Black*. *Nocturne in Black and Gold* had no discernible moral content. It depicted a firework – not a natural atmospheric occurrence that might be seen as God's handiwork – burning itself out over Cremorne Gardens, a popular pleasure

garden in Chelsea, where a fashionable crowd went to make merry with dance, music, food, drink and sometimes fireworks. In Ruskin's terms it was worthless, and the sketchiness of the execution, which one might admire as painterly bravura, looked to him to be slapdash, and outrageous given the high price that was attached to it, with no conscientious craftsmanship in the work.

Of course we have learnt to look admiringly at Whistler's work, and now I have greater problems with the sentimentality that is so evident in the work of his Ruskin and Royal Academy-approved contemporaries. The aim to make non-referential artworks that were things of beauty was mainstream in the art world during the twentieth century and is a well-established position, but for Ruskin it signalled the abnegation of what art should be trying to do. Whistler had his day in court and won the case. Ruskin had indeed libelled him, but the judge assessed the damage to his reputation as worth one farthing (one quarter of a penny, the smallest coin in circulation). Whistler had the farthing mounted on a gold chain and wore it round his neck as an act of bravado, but he was not awarded costs and was ruined by the trial. Ruskin's costs were paid by a subscription of his supporters, but he did not appear in court. He was too ill and confused, suffering from a bout of the insanity that at this period of his life came and went.

The trial was a disaster for Whistler's finances, and no great triumph for Ruskin. It now acts as a landmark, showing an ambitious artist of a different cast of mind, and a younger generation, making his mark by provoking a confrontation; and given that Whistler would prove to be one of the important artists of the time, Ruskin shows a lack of perception in failing to recognize his merits. It would not look so bad if it were not for the fact that Ruskin was at the time so very appreciative of Kate Greenaway's work, which is charming and brilliantly executed, but it does not pass muster as belonging in the greatest of company, whereas Whistler evidently does. The trial marks an end to Ruskin's reign

as the unchallenged arbiter of taste in the art world, and he was no longer someone whose opinion commanded the respect of ambitious young artists, as the Pre-Raphaelites had been when Ruskin took up their cause. In the wider world, however, away from the avant-garde, his reputation continued to ride high. During the twentieth century the doctrine of 'art for art's sake' ('l'art pour l'art'), which Whistler had brought over from Paris, became the accepted norm and the avant-garde adopted it and pushed in the direction of abstraction – sometimes appreciating pure colour and form in a way that seems to be foreshadowed by Whistler's attitudes. Whistler repudiated the idea that art should have moral content at all, and his paintings were demonstrations of that position, which of course was anathema to Ruskin. Attitudes did not change overnight, but the generation that was educated in Ruskin's tastes was replaced by the next which listened to people who had paid heed to Whistler. It was only when Abstract Expressionism was no longer the latest thing, at some point in the 1960s, that Ruskin's reputation began to recover. The Whistler trial was not a great event in Ruskin's life (he was not even there) but in retrospect it was the catastrophe that signals the art world's break from Victorian tastes.

Ruskin was an avid user of social media, such as they were in his day. He has had a reputation for reclusiveness, but that has been exaggerated. He needed time by himself to think and write, and he felt that his time was wasted by the sort of social occasion when only small talk is appropriate. But until he started to feel insecure about his faculties he regularly dined with intellectuals. In his later years Joan Severn would turn people away, meaning well, but sometimes depriving Ruskin of company that he would have enjoyed. He regularly wrote letters to *The Times*, and maintained exchanges of letters with a wide variety of people. In 1871 he began *Fors Clavigera*, which was in effect a blog. He styled it 'letters to the workmen and labourers of Great Britain', and

published a letter a month, year after year, discussing whatever seemed important to him at the time, and often digressing. The title means 'force bearing a club, key or nail', and he explained the symbolism as meaning that he hoped these letters would strike home and bring about social change. He sometimes reached a conclusion, sometimes dropped a topic and then picked it up again months or years later. He recognized that the workmen and labourers who were around at that time would not necessarily be able to understand what he was saying to them, given that they were so ill-educated (on utilitarian principles) but he saw no reason why in the future the writings would be out of reach. Incidentally, although Ruskin was using the gender-specific language of the day, he certainly believed in educating women. He was a regular visiting teacher at Winnington School, not only because he enjoyed the company of the schoolgirls, and his lectures on geology that were published as *Ethics of the Dust* were directed to a female readership. Rose La Touche started learning Greek to oblige Ruskin, and the intellectual overexertion involved was seen by others as a possible cause of her illness. Greek was usually studied only by young men at the time, because it was thought that women had more limited intellectual capacities, which might be over-taxed. Some of the letters to the workmen of Great Britain were in fact addressed to Rose. These letters sometimes responded to topical events – for example in the review of an exhibition at the Grosvenor Gallery – but they were designed to be reread in an improved future.[59]

The letters were part of a great project to save the souls of the workmen of Great Britain from being annihilated by the machine and the utilitarian thinking of their employers. To that end Ruskin set up a trust, the St George's Fund, which would buy land that could be used for traditional agriculture and the building of modest properties that could be let for fair rent. He pledged one-tenth of his capital and future income to it, and invited others to do likewise. People were less forthcoming than he had hoped, but he did find

Charles Dodgson
(Lewis Carroll),
photograph of John
Ruskin, 1874 (aged 54).

supporters, and in 1878 the fund was incorporated as the Guild
of St George. The guild still exists, and owns property, though
its significance is eclipsed by that of the National Trust, now the
nation's largest landowner, founded in 1891 by Octavia Hill
(1838–1912) along with Sir Robert Hunter and Canon Hardwicke
Rawnsley. Hill was a housing reformer whom Ruskin had employed
to manage his Marylebone properties, where the retired servants
lived, but she criticized the management of St George's Fund, and
Ruskin fell out with her over it. The National Trust's vision was
entirely compatible with that of the Guild of St George, but

the National Trust was certainly better managed, and had Ruskin not fallen out with her, Octavia Hill might have been able to see the guild grow as much as the National Trust did. 'My own gifts', said Ruskin, 'lie more in the way of cataloguing minerals than of managing men.'[60]

Ruskin made several catalogues of minerals, including one of silica samples at the British Museum. He made gifts of stones to various museums, including the Coniston Institute and St David's School, Reigate.[61] The most important was that given to St George's Museum in Sheffield. There the minerals were part of a collection of objects designed to delight and instruct. The museum was established first in Walkley, north of the city centre, where there is now a Ruskin Park, and then in larger premises at Meersbrook Park to the south. The collection included casts, paintings and drawings, many of them by Ruskin himself, or commissioned from other artists, copying Old Master paintings so that their subject-matter and manner of composition would be accessible. There are also some Old Master prints and an original oil painting by Verrocchi – to whom Leonardo da Vinci was apprenticed – as well as books that were beautiful, rare and old, and others that had instructive content. The wonderful thing about the museum is not so much the monetary value of its collection as the use to which it was to be put. The first curator, Henry Swan, had studied with Ruskin at the Working Men's College.[62] Swan was a convinced disciple and did his best to use the collection to inspire visitors. Ruskin made visits there, chatted with the workmen and lectured. In 1879 Prince Leopold came to visit. He was the eighth of Queen Victoria's children, and because he was a haemophiliac he could not join the armed forces as would have been traditional for a royal prince. Instead he acted as his mother's secretary and took up the cause of social reform, which brought him into contact with Ruskin, whose advice he followed. They became friends until his death (from internal bleeding after a fall) in 1884, when he was 30.

A local vicar, the Revd T. W. Holmes, gave an account of one of Ruskin's visits:

There were about a dozen of us waiting the arrival of a man whom the wisest hold in reverence, and of whom all Englishmen are proud. Presently Mr Ruskin entered. He greeted us all with that exquisite courtesy which is characteristic of him. Mr Swan's face beamed with rare delight. Among those who were introduced to Mr Ruskin the majority were working men who had learnt to honour him from the words of his disciple, then at the summit of satisfaction.

The master chose a seat by the window, and after a few questions in regard to the subject on which we wished to have his counsel, began at once one of those monologues to which his hearers listened with breathless attention. . . . The master's speech flowed on like a mountain stream. . . . The voice we heard was a perfect medium for every vagrant fancy that struck across the current of his thought, and for the deeper speech in which the heart and not the fancy spoke.

The subject of Mr Ruskin's talk was largely that of the noblest treatise on the ethics of business in the English tongue, Unto this Last. It was full of prophetic intimations of what the world will be when the toil of men is not for hurtful things, when the beauty of the earth and sky is no longer defiled with the smoke of men tormented with an inappeasable desire to make money without any conception of its worthy use.[63]

After the lecture he told Ruskin about an encounter with a coachman. The vicar had sat next to him on a journey in Derbyshire, which took the coach across a steep-sided valley. 'I wish', said the coachman, 'Mr Ruskin would bring his young men from Oxford and fill up that hollow; they'd be doing a kindness to these horses.'[64] The 'young men from Oxford' were 'the Hinksey diggers', undergraduates

who had been enlisted by Ruskin to help repair a road near Oxford. The group included a number of people who went on to have notable careers: one of them was Oscar Wilde. The vicar's and coachman's remarks make it clear how far Ruskin's reputation had spread. He was not only someone who had written perceptive books about art, architecture and social reform; he was a popular emblem of high culture, and someone who crossed the usual cultural divisions. He could have conversations with princes or labourers, and helped them to understand one another. His conception of aesthetic value was crucial to making this possible. It was not just works of art, but also mineral samples that could be contemplated for their beauty and lessons in morality. The minerals that had awakened his curiosity and made him want to catalogue them when he was a child in his Garden of Eden at Herne Hill might awaken the spirit of a labourer who was living in the smoke of an industrial city. The beauty of a crystal or of an Early Renaissance painting could move him and he felt sure it would move others if they were exposed to it. Without that exposure they stood no chance and would never wake up to see the beauty of the world around them, or see that the world deserved to be respected and cared for, rather than have all the goodness pounded out of it by machines.

The museum's pioneering role becomes evident when the dates are considered. It was being set up in 1875, and though it was small it was the first institution in the city of Sheffield to put artworks on free public display. Other galleries and museums were founded soon afterwards: the Mappin Art Gallery opened in 1887, in a significantly more middle-class part of the city; Manchester's Art Gallery was established in 1882, taking over and expanding the old Royal Manchester Institution of 1824; the Birmingham Museum and Art Gallery opened in 1885; Leeds Art Gallery in 1888; the Harris Museum in Preston opened in 1893. The industrial wealth that had been produced in these fast-developing

places found an outlet for prestigious display in important civic monuments. They were accessible to all, but they had a very different character from St George's Museum, which was not designed to impress, but to make available the tools for awakening a love of beauty. It was an unassuming little building, with the atmosphere of Ruskin's domestic library and drawing room – a personal study-collection open to the public, not the proud display of a collector's loot.

Through all Ruskin's thought there is an awareness of processes at work: processes of creation and destruction, creative growth and waning power, formation and erosion. No one before him had made such ideas so central to their thinking, and with Ruskin it seems to be something that he learned first from geology, then saw in creative and social processes, in education and building. Everything is to be understood as a process of becoming, of growth and change, and because the processes are what matters, rather than particular ideal forms, the values that inform those processes are critically important. The ethos of a culture and of a craftsman have to be habitual and ingrained so as to be, as it were, instinctive when quick intuitive judgements need to be made. Ruskin's judgements were not always right, but he knew that he had to go with them. There is painstaking scholarship in the work, and whenever he could Ruskin would look for evidence to support the attributions of works, or dating of edifices. The state of knowledge about his topics was better after he took his leave of them than it had been on his arrival. However, that aspect of his work might have been managed equally well by other assiduous scholars. His writings' more characteristic way of thinking is not scholarly but empathetic. He looked long and hard at the details of things, with the help of his pencil and later photographic apparatus, and scrutinized them, searching for the feelings that had gone into their creation. He was well habituated in putting his feelings into words, so they find a marvellously nuanced expression

on the page. Through the writing he could guide his readers to recognize their own feelings in his. They might look at a painting like *The Slave Ship* and admire it, but Ruskin could coax a reader into feeling that it was the most wonderful and noble painting, and that he (Ruskin) could see things in it that the reader could not. In this way Ruskin is a persuasive writer, who awakens feelings in his attentive readers that they take away as their own.

When he was contemplating and interrogating stones to make them give up their secrets, his work could be scientific, as it was with geology, but when it came to the stones of Venice, the method is more clearly an act of imaginative sympathy. The imaginative aspect is undeniable and admirable, but while these projected feelings animate the stones and paintings, there is no independent way to verify their correctness. There are no living fourteenth-century masons, and they left no record of how they thought and felt, except the stones they shaped, and that evidence is highly ambiguous, so it is unscientific history. The writing remains evocative; it can be admired for the way it stirs our sympathy, and is better read for that purpose than for its information content, as the scholarship has often been superseded by later, more detailed study. But when Ruskin was dealing with real, living people rather than stones, he used the same method of empathetic thinking and it could be dangerous. With the craftsmen at the Oxford Museum it was merely disappointing when they failed to live up to the mythic role he had projected for them, but with Adèle Domecq and Rose La Touche the results were catastrophic. These relationships were imaginative projections onto women who were in different ways remote and who did not suspect how obsessional things had become. With Effie, who was much less remote and much more forthright, the obsession never developed and she seems to have been forgotten. The episode of Ruskin's marriage, or non-marriage, damaged his reputation, but did no psychological damage to him. By contrast the almost

John Ruskin, *Self-portrait in Blue Neckcloth*, 1873, watercolour drawing made at the age of 54. Ruskin made a point of wearing blue at his neck when he was in public, in order to bring out the blue of his eyes.

entirely imaginary relationships with Adèle and Rose did significant damage to his mental and physical health.

Ruskin was never ennobled, unlike Effie, who became Lady Millais of Palace Gate in Kensington in the County of Middlesex and of St Ouen in Jersey, when her husband was made a baronet in 1885. Ruskin surely did more for the public good than Millais ever did, and had good connections in the high ranks of society, but he was not part of the establishment and was not at home in the corridors of power. His economic views were accepted by some people, but the captains of industry would have seen them as eccentric, if not mad and dangerous, and they would not have been seen as suitable views in a lawmaker. The mental health problems and sex scandals would not have helped. It is amazing that someone who remained celibate throughout his life should have had such a compromised reputation.

Ruskin functioned best, and his greatest writings were achieved, when he had the help of his parents, providing a stable base and intelligent company, or bailing him out of what would have been financial difficulties. They were not always in the same building, but even when there were extended separations, letters passed between them, and Ruskin and his father especially discussed his work, while his mother gave emotional support and worried about his health. John Ruskin's accomplishments were on a public stage, and he is the one on whom the attention is focused, but in many ways it is the parents who had more successful and remarkable lives. The daughter of a single-mother publican and the son of a bankrupt grocer made a life together that saw them from middle age living in great comfort, keeping company with artists and gentlefolk, amassing a great fortune and bringing up (and bankrolling) one of the great cultural figures of the age. The son, brought up in an atmosphere of high expectations, did more or less what was expected of him, and ruefully wished he had pursued geology more seriously instead of allowing himself to

be distracted by the studies in art and architecture that gratified his parents. The three of them deserve to be recognized together as a team that accomplished great things. Of course there was collateral damage.

7

Influence

There is a strange essay, 'The Storm-Cloud of the Nineteenth Century', in which Ruskin suggested that the climate was changing because of man's activities and greed.[1] The train of reasoning is none too clear, but it has practical and moral dimensions, and the piece builds a sense of foreboding. He seems to be persuading us that natural retribution is on the way. We will reap the whirlwind, or a biblical flood. It is not scientific enough to count as an early diagnosis of global warming, but there is an intuition that all is not well. The power of the piece comes from the way the writing is handled, which is almost like a ghost story, as the everyday storm-cloud that might blow over is gradually turned into a menacing thing that has been sent to punish us for our wrongdoing.[2]

Maybe it is like *Moby-Dick*, where Captain Ahab is obsessed with hunting a white whale, and becomes deranged to the point that he is convinced that the white whale is stalking him.[3] A cloud can act as a screen for psychological projections as effectively as a white whale. Ruskin was a close observer of natural phenomena, and his rhetoric is grounded on his perceptions, so he is persuasive; but it is impossible to say whether there is extraordinary perception here, or just a charismatic speaker, drawing the reader into his mania, being menaced by a dark cloud. However as the links between the industrial exploitation of the Earth's minerals and climate change become ever better substantiated by scientific methods, Ruskin's foresight now seems extraordinary and

Cassandra-like. He is an unheeded prophet of a disaster that he could intuit without being able to articulate the physical logic of cause and effect. He was unable to articulate a persuasive argument, but it would have been good if this moment in his thought had been more influential than it proved to be. He noticed a change in the clouds, which probably was real, if slight, but there were no measured data to check. He could see that the exploitative attitudes of the industrial city were unethical and had the feeling that no good could come of it. His thinking follows the idea of retributive natural justice in Turner's *Slave Ship*; his conclusions were not wrong, but the penalty is still in abeyance – maybe the planet will become inhospitable for human life.

Ruskin's upbringing and way of life were highly privileged, but he was also a strangely isolated figure who did not flourish in the social whirl of power and influence where his father wanted to place him, bribing him with Turners where necessary. He moved confidently in the worlds of books, painting, rocks and ideas, and was comfortable in his dealings with friends and children, but less assured in the sphere of men of the world. His health was always a worry, and in middle age his not always indulged addiction to opium-based 'tonic' could leave him confused, paranoid and listless. He withdrew into a secluded realm, supervised by Joan, based at Brantwood, and was rarely seen beyond the local community. At too late a stage in his life he proposed marriage to Kathleen Olander, an art student, but by then his mental deterioration and Joan's intervention prevented it.[4] His last great project was the composition of *Praeterita*, his memoir, which was never really finished, but it drifted to its irresolute close by 1889, fading out as the mention of Rose became unavoidable. He managed to gloss over Effie, but Rose was too important to him, and Joan could see that the writing would run into trouble, not least because Ruskin thought he was in communication with Rose in Heaven. It could have ruined his reputation as a serious thinker. *Praeterita* is the best introduction

to Ruskin as a person, and one sees what made him the way he was. It is a revealing confession, but it avoids the difficulties of his adult life. In writing *Praeterita* he was basking again in the company of his parents, albeit in his imagination, and was reflecting on ways in which he had been overly protected and too much loved. He was finding it difficult to concentrate, or remember what material he was trying to organize. His writing had always meandered, but as *Praeterita* progressed there were times when it was difficult to salvage any coherence. Joan tried to help. There were times when his handwriting became too shaky to be legible, and then Joan would write the words that John dictated. She looked after him and protected him from the world, and sometimes from visitors whose company he might have enjoyed, including Kathleen Olander. Ruskin himself was no longer interested in trying to impress anyone with his writing, or with anything else. He was offered a burial place at Westminster Abbey, but chose Coniston's parish church. When he died in 1900, at the age of 82, it was influenza that finished him, so he faded away unsensationally. The world paid its respects, but it did not know the confused and timid man who had died, apparently disappointed with himself after the numinous promise of his youth had faded, but kept out of sight by Joan so that his reputation would remain intact. The world remembered a more vigorous Ruskin, who thundered prophetically on the page, and with his books established a reputation and an influence on public opinion about art and architecture that has never been matched.

Ruskin's views about cultural matters were always trenchant, but they were not really a great challenge to mainstream taste. He championed the Pre-Raphaelites before their reputation was established, but their work and the work of others who painted like them is now seen for good or ill as the mainstream of Victorian taste: thrillingly immediate for its admirers, gaudy and sentimental for those who go for other things. But it was Ruskin who talked

educated taste round to seeing the merits in this popular work, when it had been blinded by the cliché systems of the Old Master landscapes and grand-manner history paintings that were being displayed in the National Gallery.

Ruskin's writing style now often seems overly ornate. It is difficult to find quotations that succinctly make a key point, and the sentences often go on for half a page at a time, adding in little touches of detail and digression, evocations and nuances. To read Ruskin appreciatively it is important not to be in a hurry. When the earlier writings were new they were admired for the beauty of their style. It was that beauty that moved Marcel Proust to translate *The Bible of Amiens* into French.[5] Ruskin's later style was deliberately plainer, so that people would pay more attention to his arguments. *Unto This Last* may have seemed bizarre to the London business world, but Mahatma Gandhi said he was over-whelmed by his reading of it, and saw it as one of the three modern works that had most influenced his thinking.[6] Tolstoy was also impressed by the way Ruskin honoured physical labour as the core of a good life. 'I don't know why you English make such a fuss about Gladstone', said Tolstoy, 'You have a much greater man in Ruskin.'[7] Much of Tolstoy's own thought about art accords with Ruskin's, but he demurred from its religiosity.[8] The Pre-Raphaelites, most enduringly Rossetti, were impressed by the passion and acuity of Ruskin's writing, and they cultivated him not only for the advantage of having a prominent critic on their side, but also because they learned from him and enjoyed his conversation. William Morris and Edward Burne-Jones were inspired by Ruskin's sense of the importance of the craftsman and turned that perception into the Arts and Crafts movement. Morris's artworks are furnish-ings – chairs and tables, fabrics and wallpapers – and Burne-Jones painted furniture as well as canvases, designed tapestries and stained glass. Their art was designed to enhance the activities of living. Morris developed and propagated socialist ideas, but his

socialism was not derived from Ruskin. There are moments when Ruskin calls himself a communist, but he did not think in modern categories, and his version of politics – some sort of Red Toryism – was paternalistic: more like a revived feudalism with a strong monarch and benign masters making sure everyone flourished.[9] His addresses to working men are always admiring of honest work well done, but he never doubts that he must assume the role of the leader in their company, and any other arrangement would be a manifest absurdity. But then he could put himself on the same level by asking, for example, to be taught carpentry.

The thing that makes Ruskin most endearing is the complete absence of hypocrisy in his writings. He can gush with enthusiasm, but there is no doubting that it is real enthusiasm. His praise of one painter over another can seem eccentric, but there is no doubt that it is sincere – at least at that moment. He could feel something different on another occasion and would report on that different feeling with equal conviction. He was a workaholic who pushed himself at times too hard, writing a vast corpus of work, sometimes

Ruskin's studies of twisted columns at Ferrara Cathedral, engraved by R. P. Cuff for *The Seven Lamps of Architecture* (1849).

studying feverishly when what he really needed was rest; and his love for his fellow workers was such that he dissipated his fortune in their interests, trying to awaken them to beauty as the way to save the world. There are times when his privilege and remoteness from the kinds of pressures that ordinary workers cannot escape set a limit on the empathy and understanding he could manage, but he more than anyone was aware of that, and his own conscience was a more punishing judge than any other. He found it easier to forgive others their shortcomings than to forgive himself.

The general drift of his teachings as his career concluded was with increasing clarity to see mechanized greed as the main threat to humanity. Salvation lay in sacrifice, beauty and thoughtfulness. Ruskin's writings were the mainspring of his influence on the world, but his more personal appearances at lectures, regularly at Oxford but also at working-men's institutes and in public halls, meant that many people from all walks of life felt they had been in his presence. His influence is therefore impossible to document in a clear and exhaustive way, in the way that it would be today if he were expounding his thoughts by way of broadcasting. Once George Allen had produced the cheap, small-format versions of Ruskin's principal writings in the 1880s, Ruskin's influence was everywhere.

Where buildings were concerned, Ruskin's most architecturally significant project was his involvement with Deane and Woodward at the Oxford Museum, but socially the Guild of St George's attempts at affordable housing also made a strong impact. The most important part of Ruskin's influence involved noticing that buildings not only housed humans but were also constructed by humans, and their humanity was under threat when they were considered part of the great machine of industrial production, whether that involved the use of machinery in construction work, or just thinking about people as machines, in terms of abstract and inhumane ideas of efficiency and productivity. Awakening

the sense of beauty and encouraging people to treat one another humanely went hand in hand with bringing art to the working person and making the craftsman's life a rewarding vocation. Designers could specify machine-like perfection from craftsmanship, but that would dehumanize the expectation and would see the vagaries of handwork as failings compared with the accuracy of the machine. Indeed, the precision with which Victorian buildings were made is a quality that sets them apart from the older masonry buildings where they survive in a contemporary city: the decoration might have been cast from moulds, or fed through a proofing machine. Even when the decoration had to be carved by hand, the level of finish demanded could give the carving a repetitive mechanical quality. Ruskin's ethical approach to architecture was not driven by the idea of style, but he thought that the practices of the Middle Ages were to be preferred to those before and since. Medieval masons had some freedom to vary the ornament within an established pattern, whereas classical ornament demanded machine-like repetition of the canonic forms. Ruskin was not a pioneer of the Gothic Revival, and said only dismissive things about Pugin – which is surprising, given how close their tastes seem to have been. For Ruskin, Pugin's Catholicism was a worry, and Pugin's advocacy of 'pointed' architecture was made on rather different grounds from Ruskin's; for Pugin it was the forms of the buildings that seemed to be admirable, whereas for Ruskin the buildings' forms were emergent properties that resulted from an admirable set of conditions – the craftsmen's training and understanding, their piety, their way of life, and the types of work that they were commissioned to do. The decoration at Oxford was a brave attempt to do the right thing, but it showed Ruskin that it was not enough to put a modern craftsman in position and ask him to design detail; he had to have been shaped by a living tradition that was no longer in place in nineteenth-century Britain. What the nineteenth-century craftsman could do was meticulously

John Ruskin, *Gothic Capitals*, engraved by R. P. Cuff, from *The Stones of Venice*, III (1853).

follow a designer's instructions, which is what Sir Charles Barry, for example, asked his craftsmen to do in the repetitive bays of the New Palace of Westminster, following the design provided by Pugin. In medieval buildings there is often an impression of repetition, but it is not exact: the detail is varied. On occasion in medieval work there is a squashed bay at the end of a sequence, as if the setting-out of the work had been sabotaged, but the masons decided to follow the error and build as perfectly as they could on that initial error. A good example is the west front of Bourges Cathedral, where the five similar elaborately decorated doorways are all of different sizes, so the impression is of organic growth, rather than additive assembly of factory-made parts. 'The architect of Bourges Cathedral liked hawthorns', said Ruskin, 'so he has covered his porch with hawthorn.'[10] The effects of weathering over the centuries also tend to soften the appearance of a building, and Ruskin was a pioneer of the conservation movement, arguing for the preservation of old stones rather than the restoration of old buildings with modern and mechanically precise work. Again one could imagine the influence of geology, in his wanting to preserve the actual stones as products and relics of a process of formation. If they are replaced, even by good copies, then they cease to be genuine evidence of the past and are only simulacra, carrying the traces of formation only of the later time when these new stones were worked and placed.

This attitude came to inform the attitudes of the Society of the Protection of Ancient Buildings. William Morris wrote its manifesto in 1877, and Philip Webb and Edward Burne-Jones were founding members. It remains an effective campaigning organization, which took Ruskin's perceptions and anxieties about old buildings and turned them into practical action.[11] By this time Ruskin the man was on the wane, but the ideas he had formulated decades earlier were gathering momentum, and have continued to inform British ideas about building conservation.

Pugin died when Ruskin was 33, after the publication of
The Seven Lamps of Architecture, and before the second volume of
The Stones of Venice. The Gothic Revival had already begun without
Ruskin's support. His fixation on Venice was unprecedented in the
architecture world, and if we are looking for Victorian buildings
in British city centres that carry recognizable traces of Ruskin's
influence then the presence of Venetian motifs is the surest sign
– and they are there to be found.[12] Examples include: in Manchester
the Memorial Hall in Albert Square, by Thomas Worthington
(1863), and the Reform Club in Spring Gardens, by Edward Salomon
(1870); in Bristol there was the City Museum and Library on Queens
Road, by Foster and Archibald Ponton (1867), now in use as a
restaurant; in the City of London there is a former bank building
at 7 Lothbury, by George Somers Clarke (1868), facing the back
of the Bank of England; in Newcastle upon Tyne there is the
campanile of St George's, Jesmond, by Thomas Spence (1888)
and the Mining Institute, Neville Hall, by Archibald Matthias
Dunn (1872). The Mining Institute is a neat reminder that the
reason for the rapid progress in geological thinking during
Ruskin's lifetime was driven by nineteenth-century industry's
need to understand the Earth well enough to be able to find new
seams of coal to fuel the steam engines' boilers, and by the way
to produce the storm-cloud of the nineteenth century.[13]

There are examples of Venetian-style buildings in most UK
cities where there was nineteenth-century expansion, but they
are never predominant in an area to the point that they become
routine. There is always the sense that a special effort is being
made, but then as the buildings were produced by the methods
and with the value system of the nineteenth-century building
industry, the results were always harder and more geometrically
precise in character than was original medieval Venetian work,
and to twenty-first-century eyes it is their nineteenth-century
character that sings through most clearly. In commentaries they

are often labelled as 'high Victorian' in style, rather than Venetian. Despite the close bond between Ruskin and Venice, he did not strongly advocate the use of Venetian style, and although the buildings listed here show an influence that could have been no one's but his, their architects were not perhaps Ruskin's most assiduous readers. 'I have now no doubt that the only style proper for modern Northern work, is the Northern Gothic of the thirteenth century', he said:

> I must [. . .] deprecate an idea which is often taken up by hasty readers of the *Stones of Venice*; namely that I suppose Venetian architecture the most noble of the schools of Gothic. I have great respect for Venetian Gothic, but only as one among many early schools. [. . .] The Gothic of Verona is far nobler than that of Venice; and that of Florence nobler than that of Verona. For our own immediate purposes that of Notre-Dame of Paris is noblest of all.[14]

There were architects who made attempts to vary the details of buildings, to avoid mechanical repetition, for example by varying the species of leaf carved in the capitals of a row of windows, where at first glance the capitals seem identical. There was always a cost implication, as a repeated design would be quicker to produce, and only an unusually committed client would be persuaded to fund such extravagance – as Ruskin himself did at the Oxford Museum. Ruskin's hostility to the machine aesthetic, whether in the railways or in industrialized building products and practices, meant that he was not in tune with the developments in architecture during the course of the generation after his death, which took inspiration from the Crystal Palace and saw the machine as the very soul of modernity. One of the most effective advocates for machine-influenced architecture was Nikolaus Pevsner, who was well versed in the German architectural theory that underpinned the

practical problem-solving involved in trying to reform architecture so as to express the conditions of modern life. Pevsner moved to England during the 1930s, and by bringing German art-historical methods to bear on British architecture, with a tenacity, enthusiasm and vigour that matched Ruskin's own, he transformed the understanding and the knowledge base of the study of architectural history. He was at odds with Ruskin, who encountered the Crystal Palace but failed to see its significance. Even in Pevsner's little book *The Leaves of Southwell* of 1948, which has a title that sounds like one of Ruskin's own, and which one might expect to be a companion piece to *The Bible of Amiens*, there is no empathy with Ruskin on display. The beautifully carved leaves at Southwell Minster are displayed by Pevsner in all their variety, and tied in to sculptural and intellectual developments on the European mainland, without ever mentioning Ruskin. Pevsner's study of the medieval sculptors working at Southwell brings him to the conclusion that, despite masons travelling around and having knowledge of developments in England, Germany and France, and despite various hands with independent ideas being at work, there is a pervasive harmony in evidence that needs a metaphysical cause. '[T]he only explanation which historical experience justifies', says Pevsner, is

> the existence of a spirit of the age, operating in art as well as politics. This spirit works changes in style and outlook, and the man of genius is not he who tries to shake off its bonds, but he to whom it is given to express it in its most powerful form.[15]

For Pevsner Ruskin was an oddball, 'brilliant but warped'.[16] Nevertheless his influence is to be found again with the emergence of the Brutalists – principally Alison and Peter Smithson – who brought a range of social concerns into the architectural discussions organized by CIAM (International Congresses of Modern

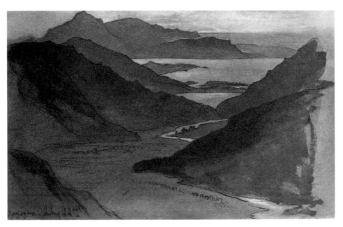

John Ruskin, *View from Vogogna*, 22 July 1845, photogravure by George Allen.

Architecture). This architecture of course had strong links with
Le Corbusier and his use of *béton brut* – exposed concrete – and
its ethos was driven very strongly by attraction to Ruskin's lamp
of truth. It was a question of exposing in the fabric of the building
the truth of the social and constructional conditions that had gone
into producing it. When Brutalist work has been studied overseas
it is seen as having a distinctly British character that is not always
recognized when it is seen from the UK.[17] Its moralistic aspect
– the promotion of the idea of the appearance being generated
as a truthful expression of the circumstances – over the idea of
beauty, which might have softened and compromised the rugged
appearance, could be put down to Ruskin's influence either directly
or at some remove. This tendency to develop a moralistic train of
reasoning when giving an account of design decisions taken about
buildings is quite distinct from that taken by art critics during
the 1950s and '60s, when abstract and minimalist paintings and
sculptures came to the fore. The separation of artworks from
morality which had been asserted by Whistler and popularized
by Oscar Wilde certainly did not go unchallenged, but during the

mid-twentieth century it is more often to be found in the relation between an artwork and its cultural context than in the artwork itself. For example, no one can deny that there are moral aspects to the work that was exhibited by the Nazis as 'degenerate' (*Entartete Kunst*), but the main moral questions that are raised are about human freedom. In a regime that cared nothing for art these works would have been expressions of some varieties of human impulses, which need not have been seen in moralistic terms. Given their suppression, though, it becomes a moral imperative to assert their right to exist, regardless of their artistic merit, and that can make it possible for the works to be important and to have real merit that is not one of the kinds of merit shown in a more traditional artwork.[18]

Philip Johnson, an architect at the furthest possible remove from Ruskin on issues of morality and architecture, gave a talk to Harvard design students in 1954 in which he more or less asserted that principles in art and architecture were beside the point. We make use of principles when we are talking about art and design, but the talk is not art or architecture, and at best principles come in as a way to persuade. At worst they can prevent good things from happening. Therefore rather than thinking of these principles as 'lamps', Johnson presents them as 'crutches', but the title of his talk, 'The Seven Crutches of Modern Architecture', clearly references Ruskin's seven lamps. Ruskin was part of his cultural world, even though the sensibilities are not at all in alignment.

In 1964 Sir Kenneth Clark published an anthology of Ruskin's texts. Clark was a well-known figure in British public life, who had been appointed director of the National Gallery at the age of 30 in 1933, and built a later reputation through television. His decision to rescue Ruskin marks a turning point in Ruskin's reputation, as this was the first time in decades that readers found him on newly printed paper, rather than in libraries or in second-hand book shops. Moreover this was Ruskin for a modern reader. 'Whenever

I see a biblical quotation in the offing', Clark said, 'I have begun to lose interest, because I know that at this point Ruskin will cease to use his own powers of intelligent observation, and will rely on holy writ to save him from further thought.'[19] This rescued Ruskin from seeming sanctimonious, but also diminished the understanding of the interconnectedness of his sense of spirituality, beauty and social reform. Ruskin was repositioned as an aesthete rather than an activist, in an art world that owed more to Whistler than Ruskin would have liked.

That art world has changed since then, and some of Ruskin's pronouncements about art seem more apposite now than they did in the cultural climate of the 1960s. Victorian art is once again valuable, but more importantly than that the narrative aspect of artworks can once more be treated with respect. It was important for Ruskin, and if we insist on seeing Victorian painting in Whistlerian terms then we cannot fail to miss the point. It might have surprised Ruskin that artists can now sign work that has been executed by others, but artists of earlier ages had help from studio assistants and it is part of Ruskin's idea of art that the execution is not what makes it great, so in principle he should not have raised objection. In Ruskin's theory the language of art is in its execution, but it is what is said through the art that really matters, and he responded most powerfully to what he saw as the artist's moral character. It was not Landseer's skill in depicting a dog that made him a 'man of mind', but his decision to depict it, with a posture that expressed its devotion, together with the accoutrements that indicated the dog's master's frugal piety. This distinction between the idea and the execution would be resisted by many artists from Ruskin's day onwards, but it is that distinction that makes artists as diverse as Jeff Koons, Damien Hirst and Ian Hamilton Finlay the 'authors' of their works, which other people's hands have executed. Similarly the investment of sentiment in a scene is praiseworthy in Ruskin's eyes, but has been seen as problematic in much art

appreciation since. However, it has reappeared in such works as Tracey Emin's *My Bed*, where an apparently ready-made object – in fact reconstructed from real materials, not a representation of a scene in pigments – is invested with pathos, and it is the pathos rather than the bed in itself that gives the work its value. The art is in the selection of the object and the articulation of the pathos – arranging the sheets to look as though the artist has just left, and the accoutrements of despair that indicate her near-suicidal state of mind at the time that the bed was occupied. It is curated in much the same way that Landseer curated the scene in his studio, but then instead of depicting the scene the set-up is presented to the viewer as a *mise en scène*. Emin, herself a Royal Academician and, like Turner, a professor in the Royal Academy Schools, works in an art world that has been transformed since Ruskin's day by photography and by Marcel Duchamp's ready-mades, so the craft skill on show in Landseer's paintwork has been supplanted by other techniques for communicating the vision of the 'mind'. It is by insisting on this distinction between the artist's skill and the artist's vision that Ruskin made possible the kind of thinking that is now routine in contemporary art practice.

Another aspect of Ruskin's thought – promoting the importance of the craftsman against the incursions of the machine – finds its way into the contemporary world in the revaluation of craftwork. It is now usually a more expensive alternative to mass-produced fare, but craftsmanship survives and flourishes in bespoke furniture-making, in haute couture, and in ceramics ranging from tableware to the artworks of Grayson Perry RA CBE, who makes his own ceramic pieces. He has also designed spectacular tapestries, which display impeccable craftsmanship (executed by others) so he too, despite being a craft potter, is also a 'man of mind', as was Raphael when he prepared cartoons for tapestries. The craftwork has value not only in engaging the human mind and hand in its production, but also in making experimental work possible because the pieces

are individually made. When it is something that the craftsman has made many times before then a pattern has been established, which can be adjusted to suit new circumstances – a new size, a different colour, a modified shape. This adaptability and responsiveness to local conditions is also a characteristic of work that can be handled through digital processing. The object to be made is defined not by a fixed final form but by rules that generate the form. When these rules are applied in particular circumstances there are new interactions and a form is generated that is not identical to any other in the way that pieces would be if they were repetitively cast from a mould. This sense of the proliferation of form and its responsiveness to local conditions can be characterized as 'digital', and projected back into a past before computers, when the digits were the fingers of a craftsman's hand, and the processes and decisions were made intuitively rather than computationally. A computer can be programmed with sets of rules and can work out what happens when the rules interact in new circumstances – bounded by the edges of a site, or the strength of a material, just as a craftsman is ingrained with habits and traditions, and adapts his rules to new circumstances when he meets them. This 'digital Gothic' is the basis for Lars Spuybroek's appreciation of Ruskin, understanding him as a theorist of the dynamic and organic sense of form that grows from within and adapts to its particular circumstances, as opposed to the 'classical' sense of ideal standard forms that are imposed from outside. Spuybroek's sense of form is experimental and exploratory, but grounded in Ruskin's understanding of Gothic in which the craftsman's improvisations have a role.[20]

Ruskin's ideas are no longer being received in the culture that he had in mind when he wrote. It is always possible for even a contemporary reader's response to take the writer by surprise. The world that was in thrall to the sermon-like aspects of Ruskin's writing has dispersed and the initial reception of Ruskin's ideas has

The Ruskin Monument at Friar's Crag, Derwentwater. This was set up at the instigation of Canon Rawnsley soon after Ruskin's death to mark the place of Ruskin's earliest memory.

faded away, palely surviving in places where a prospect is revered, or where watercolours and brushes are brought out on Sundays; but he has reappeared as a vigorous and vital figure with things to say to the experimentalists who uncover what art and architecture

might yet be able to do. An echo of his thunderous moral tone has also reappeared, most often in connection with concerns about sustainability and the future of the planet. It is not at all clear that we as a species will escape the whirlwind that has been sown. As the storm-clouds gather we hope to find some sort of salvation in the ethical sourcing of building materials and fair trade in the production of food. There has never been a greater popular awareness of our moral responsibilities to others – people, creatures, plants or minerals. Ethical concerns draw the whole process of production into the picture in the way that Ruskin taught. The moral aspect of everyday objects is now firmly back on our agenda and more than anyone else it was Ruskin who first put it there.

References

1 A Start in Life

1 William Wordsworth, 'The Rainbow', written 1802, published in *Poems, in Two Volumes* (1807).

2 *The Works of John Ruskin*, the Library Edition ed. E. T. Cook and Alexander Wedderburn (London, 1903–12) (hereafter cited as *Works*), vol. XVII, p. lxxvii.

3 Ruskin's life is unusually well documented, and the factual matter of dates and events is rarely disputed, though interpretations can vary widely. Tim Hilton's two-volume biography has extensive references: Timothy Hilton, *John Ruskin: The Early Years, 1819–1859* (New Haven, CT, 1985); and Timothy Hilton, *John Ruskin: The Later Years* (New Haven, CT, 2000). John Dixon Hunt, *The Wider Sea: A Life of John Ruskin* (New York, 1982) and John Batchelor, *John Ruskin: No Wealth But Life* (London, 2000) are also valuable for their art-historical and psychological insights. Hilton, *John Ruskin: The Early Years*, p. 2.

4 Ibid., p. 14.

5 Ibid., p. 8.

6 Ibid., p. 4.

7 John James Ruskin to George Gray, 31 August 1848, in Mary Lutyens, *The Ruskins and the Grays* (London, 1972) p. 150.

8 Van Akin Burd, ed., *The Ruskin Family Letters*, 2 vols (Ithaca, NY, 1973), cited in Hunt, *The Wider Sea*, p. 19.

9 John Ruskin, *Praeterita*, in *Works*, XXXV, p. 303.

10 Ibid., p. 28.

11 For example, Francis Coghlan, *The Stranger's London Guide* (1830), p. 53: 'Private Collections of Pictures'.

12 Jane Austen, *Pride and Prejudice* (1813), many editions; chapter 1 of vol. 3 (chapter 43).

13 Ruskin, *Works*, XXXV, p. 63.

14 Hunt, *The Wider Sea*, p. 23.

15 Ibid., p. 38.

16 Ruskin, *Works*, XXXV, pp. 24–5.

17 Ibid., p. 42.

18 Ibid., p. 44.

19 Ibid.

20 Ibid.

21 Ibid., pp. 44–5.

22 Margaret Ruskin to John James Ruskin, 15 March 1823, in Lutyens, *The Ruskins and the Grays*, p. 57.

23 John James Ruskin to Margaret Ruskin, 1827, in ibid., p. 173.

24 Hunt, *The Wider Sea*, p. 28.

25 Ibid., p. 33.

26 Ibid., p. 32.

27 Ibid., p. 33. Robert Jameson, *A System of Mineralogy, Comprehending Oryctognosie, Geognosie, Mineralogical Chemistry, Mineralogical Geography, and Œconomical Mineralogy*, 3 vols (Edinburgh, 1804).

28 Ruskin, *Works*, XXXV, p, 76.

29 Ibid., p. 94.

30 Ibid., p. 96.

31 Ibid., p. 97.

32 Ibid., p. 38.

33 William Gilpin, *Observations, relative chiefly to picturesque beauty, made in the year 1772, on several parts of England; particularly the mountains, and lakes of Cumberland, and Westmoreland* (1786).

34 Sir Thomas Dick Lauder, ed., *Sir Uvedale Price on the Picturesque: with an Essay on the Origin of Taste, and Much Original Matter* (Edinburgh, 1842).

35 Ruskin, *Works*, XXXV, p. 94.

36 Ibid., p. 94.

37 John Ruskin, *Notes on Samuel Prout and William Hunt* (1880) in *Works*, XIV, p. 373.

38 Ibid.

39 Ruskin, *Works*, XXXV, p. 75.

40 Ibid., pp. 140 and 91.

41 Ibid., p. 79.

42 Ibid., p. 81.

43 Hilton, *John Ruskin: The Early Years*, p. 25. Mary was from Perth – the daughter of John James Ruskin's sister, who married Peter Richardson. He was not related to the baker in Croydon who married Margaret's sister Bridget, though he too was called Richardson.

44 Ruskin, *Works*, xxxv, p. 135.

45 Hilton, *John Ruskin: The Early Years*, p. 30.

46 John Ruskin to James Hogg, 13 February 1834, in *Works*, i, p. xxviii.

47 Ruskin, *Works*, xxxv, p. 96.

48 Ibid., p. 115.

49 Ruskin, *Works*, ii, p. 382.

50 Percy Bysshe Shelley, 'Mont Blanc' (1818), lines 1–2.

51 Ibid., lines 34–40.

52 James Hutton, *Theory of the Earth; or an Investigation of the Laws observable in the Composition, Dissolution, and Restoration of Land upon the Globe*, appearing in *Transactions of the Royal Society of Edinburgh* (Edinburgh, 1788).

53 Percy Bysshe Shelley, *The Necessity of Atheism* (Worthing, 1811). The author's name did not appear on the title page, and copies were distributed to the heads of all the Oxford colleges.

54 Shelley, 'Mont Blanc', lines 71–5.

55 Elizabeth Oak Gordon, *The Life and Correspondence of William Buckland, D.D., F.R.S.* (London, 1894) and see: www.earth.ox.ac.uk/about_us/history, accessed 1 June 2012.

56 Horace B. Woodward, *The History of the Geological Society of London* (London, 1907), p. 61.

57 Charles Lyell, *Principles of Geology: being an attempt to explain the former changes of the Earth's surface, by reference to causes now in operation*, 3 vols (London, 1830–33).

58 John Ruskin to Henry Acland, 24 May 1851, in Ruskin, *Works*, xxxvi, p. 115.

59 Karl Alfred von Zittel, cited by Woodward, *History of the Geological Society*, p. 1.

60 Andrew Ballantyne, 'Living the Romantic Landscape (after Deleuze and Guattari)', in *Biographies and Space: Placing the Subject in Art and*

Architecture, ed. Dana Arnold and Joanna R. Sofaer (London, 2008), pp. 17–34.

61 Ruskin, *Works*, xxxv, p. 115.

62 Ibid., pp. 136–7.

63 Ibid., p. 138.

64 Horace Bénédict Saussure, *Voyages dans les Alpes*, 4 vols (Paris, 1740–99). It was reissued in a new single-volume version in September 1834 – too late for the birthday; William Brockendon, *Illustrations of the Passes of the Alps by which Italy Communicates with France, Switzerland and Germany*, 2 vols (London, 1828, 1829).

65 John Ruskin to John James Ruskin, 1834, in Lutyens, *The Ruskins and the Grays*, p. 278.

66 The articles for Loudon's *Magazine of Natural History*, September 1834, 1836 are in Ruskin, *Works*, i.

67 Ruskin, *Works*, xxxv, p. 120.

68 Hunt, *The Wider Sea*, p. 62.

69 Hilton, *John Ruskin: The Early Years*, p. 34.

70 Ruskin, *Works*, xxxv, pp. 143–4.

71 Ruskin, Works, xxv, p. 156.

72 Andrina Stiles and Robert Pearce, *The Unification of Italy, 1815–70*, 3rd edn (London, 2006).

73 Ruskin, *Works*, xxxv, p. 179.

74 'On Adèle, by Moonlight' (1836), in Ruskin, *Works*, ii, p. 16.

75 Hilton, *John Ruskin: The Early Years*, p. 37.

76 Ibid., p. 50.

77 Ibid., p. 52.

78 Joan Evans and John Howard, eds, *The Diaries of John Ruskin*, 3 vols (Oxford, 1956–9), 12 March 1841, vol. i, p. 165.

79 John James Ruskin to William Alexander, 14 December 1854, Pierpoint Morgan Library l ma 1571 (156), in Robert Brownell, *Marriage of Inconvenience* (London, 2013), p. 56.

80 Ruskin, *Works*, xxxv, p. 193.

81 Ibid., p. 610.

82 Ibid., p. 259.

83 John Ruskin, *The Poetry of Architecture* (New York, 1873) was an unauthorized collection of Ruskin papers from *The Architectural Magazine* (1837).

84 Ruskin, *Works*, xxxv, pp. 199–200.
85 Hilton, *John Ruskin: The Early Years*, p. 56.

2 Turner and the Picturesque

1 Samuel Rogers, *Recollections of the Table-talk of Samuel Rogers* (New York, 1856).
2 Samuel Rogers, 'The Pleasures of Memory' (1792) in *Poems* (London, 1814); Samuel Rogers, *Italy: A Poem*, 2 vols (London, 1822, 1828), 2nd edn, 1 vol. (London, 1830).
3 Ruskin, *Works*, xxxv, p. 82.
4 Anonymous, *Catalogue of the Very Celebrated Collection of Works of Art and Vertu, the Property of Samuel Rogers, Esq. Deceased* (London, 1856).
5 Ruskin, *Works*, xxxv, p. 337.
6 Ruskin, *Works*, i, p. xlii.
7 Ibid., p. 7.
8 Ibid., pp. 38–9.
9 Anon., *The Mirror: Literature, Amusement and Instruction* (London, 1829), p. 37.
10 Ibid., p. 131.
11 Erasmus Darwin, *The Botanic Garden: The Loves of the Plants* (London, 1791), Canto iii, lines 237–8.
12 Ruskin, *Works*, i, p. 142.
13 Ruskin, *Works*, xxxv, p. 225.
14 Ibid., p. 224.
15 Ruskin, *Works*, xxv, p. 213.
16 Ruskin, *Works*, vii, p. 9.
17 Andrew Ballantyne, *Architecture, Landscape and Liberty: Richard Payne Knight and the Picturesque* (Cambridge, 1997); Stephen Daniels, *Humphry Repton: Landscape Gardening and the Geography of Georgian England* (New Haven, CT, 1999); Charles Watkins and Ben Cowell, *Uvedale Price (1747–1829): Decoding the Picturesque* (London, 2012).
18 Richard Payne Knight, *An Analytical Inquiry into the Principles of Taste* (London, 1805), p. 191.
19 Ibid., pp. 150–53.

20 Ruskin, *Works*, xxxv, pp. 215–16.

21 Ruskin, *Works*, xv, p. 16.

22 W. G. Collingwood, *The Life of John Ruskin* (London, 1893) pp. 76–7.

23 James Hamilton, *Turner: A Life* (London, 1997).

24 Ruskin, *Works*, xxxv, pp. 257–9; and see James Hamilton, *A Strange Business: Making Art and Money in Nineteenth-century Britain* (London, 2014).

25 Ruskin, *Works*, iii, p. 254; and see Michael Wheeler, *Ruskin's God* (Cambridge, 1999), p. 34.

26 Revelation 10:1.

27 Ruskin, *Works*, xxv, pp. 318–19.

28 Ruskin, *Works*, iii, p. 404.

29 Adele M. Holcomb, '"Indistinctness is My Fault": A Letter about Turner from C. R. Leslie to James Lenox', *Burlington Magazine*, cxiv/833 (August 1972), pp. 557–8.

30 *Modern Painters*, 1, p. 405.

31 Turner, lines from 'Fallacies of Hope', 1812, in Andrew Wilton, *Painting and Poetry: Turner's 'Verse Book' and his Work of 1804–12* (London, 1990).

32 Hosea 8:7.

33 *Modern Painters*, 1, pp. 404–6.

34 See also *Modern Painters*, 5, 369n.

35 Charles Kingsley, *Alton Locke* (1848), in Ruskin, *Works*, v, p. 205.

36 Melissa Gregg and Gregory J. Seigworth, eds, *The Affect Theory Reader* (Durham, NC, 2010).

37 Ruskin, *Works*, v, pp. 201–20.

38 Ibid., p. 204.

39 Ibid., p. 220.

40 Ibid., pp. 201–3.

41 Ruskin, *Works*, iii, p. 8.

42 Ibid., p. 8.

43 Ibid., p. 9.

44 Richard Ormond, *Sir Edwin Landseer, 1802–1873* (Philadelphia, PA, and London, 1981); Richard Ormond, *The Monarch of the Glen: Landseer in the Highlands* (Edinburgh, 2005).

45 Kenneth Clark, *Ruskin Today* (London, 1964).

46 Ruskin, *Works*, iii, p. 1.

47 Ibid. (preface to 2nd edn).

48 Ibid., p. 6.

49 Archibald Alison, *Essays on the Nature and Principles of Taste* (Edinburgh, 1790); Dugald Stewart, *Philosophical Essays*, 3rd edn (Edinburgh, 1818).

50 Knight, *An Analytical Inquiry*, pp. 311–12.

51 Ballantyne, *Architecture, Landscape and Liberty*, pp. 171–81.

52 Ibid., pp. 182–9; and Andrew Ballantyne, '*Specimens of Antient Sculpture*: Imperialism and the Decline of Art', in *Tracing Architecture: The Aesthetics of Antiquarianism*, ed. Dana Arnold (Oxford, 2003), pp. 130–45.

53 Ruskin, *Works*, III, p. 93.

54 Ruskin, *Works*, XXXV, p. 311.

55 Revd John Eagles, *Blackwood's Edinburgh Magazine* (October 1836), in Ruskin, *Works*, III, p. xviii.

3 The Pre-Raphaelites

1 Ruskin, *Works*, XXXV, p. 317.

2 Ibid., p. 36.

3 Timothy Hilton, *John Ruskin: The Early Years, 1819–1895* (New Haven, CT, 1985), pp. 83, 80.

4 Ibid., p. 84.

5 Ruskin, *Works*, IV, p. 38.

6 Ibid., p. 47.

7 Ibid., p. 217.

8 Ibid.

9 Ibid., p. 218.

10 Ruskin, *Works*, V, p. 333.

11 Michael Wheeler, *Ruskin's God* (Cambridge, 1999).

12 Joshua Reynolds, *Discourses on Art, 1769–76*, ed. Robert R. Wark (New Haven, CT, 1975).

13 John Ruskin to John James Ruskin, 4 September 1845, in Harold I. Shapiro, ed. *Ruskin in Italy, Letters to his Parents 1845* (Oxford, 1972), p. 221.

14 Ibid., pp. 221–2.

15 Ruskin, *Works*, IV, p. 101.

16 Timothy Hilton, *The Pre-Raphaelites* (Oxford, 1970); William Holman Hunt, *Pre-Raphaelitism and the Pre-Raphaelite Brotherhood*, 2 vols (London, 1905).

17 Charles Dickens, *Household Words*, no. 12 (Saturday 15 June 1850), pp. 265–6.

18 There was a notable and very popular exhibition of Pre-Raphaelite paintings at Tate Britain in London in 2012 which was importantly revisionist in presenting the Pre-Raphaelites as avant-gardists, rather than the old-fashioned sentimental practitioners they had so often seemed to be during the mid-twentieth century. Tim Barringer, Jason Rosen Field and Alison Smith, *Pre-Raphaelites: Victorian Avant-Garde* (London, 2012).

19 Francis O'Gorman, *Late Ruskin: New Contexts* (Farnham, 2001), p. 34.

20 See p. 39.

21 Richard Payne Knight, *An Analytical Inquiry into the Principles of Taste* (London, 1805).

22 Hilton, *The Pre-Raphaelites*, p. 46.

23 John James Ruskin to W. H. Harrison, Venice 25 May 1846, Bodley MS Eng Letts c 32 fol. 243.

24 Cross reference, chapter Two.

25 Ruskin, Works, III, Section IV, 'Of Truth of Earth' of *Modern Painters*, vol. 1, chapter 1, p. 484 of the iBook.

26 Ruskin, *Works*, IV, pp. 114–15.

27 Eric George, *The Life and Death of Benjamin Robert Haydon, Historical Painter, 1786–1846*, 2nd edn, ed. Dorothy George (Oxford, 1967).

28 Kenneth R. Johnson, *The Hidden Wordsworth: Poet, Lover, Rebel, Spy* (New York, 1998).

29 The first film adaptation of this episode in his life, *The Love of John Ruskin*, dates from 1912, and starred Earle Williams as Ruskin. The most recent authoritative account is Robert Brownell, *Marriage of Inconvenience* (London, 2013).

30 John Ruskin to Sophia Maria Gray, 9 December 1847, Pierpoint Morgan Library MA 1338 (E.07), cited in Brownell, *Marriage of Inconvenience*, p. 110.

31 Hilton, *John Ruskin: The Early Years*, p. 107.

32 John Ruskin to Margaret Ruskin, Sunday 28 March 1847, in Ruskin, *Works*, VIII, p. xxv; and W. G. Collingwood, *The Life of John Ruskin*, 2 vols (London, 1893), page ref., 7th edn, 1911, p. 90.

33 Hilton, *John Ruskin: The Early Years*, p. 114.

34 Brownell, *Marriage of Inconvenience*, p. 106.

35 Mary Lutyens, 'From Ruskin to Effie Gray', *Times Literary Supplement* (3 March 1978); and see Hilton, *John Ruskin: The Early Years*, p. 115.

36 Brownell, *Marriage of Inconvenience*, p. 115.

37 Ibid., p. 114.

38 John Ruskin to Effie Gray, 15 December 1847, Pierpoint Morgan Library, MA1338 (E.08); cited Brownell, *Marriage of Inconvenience*, p. 119.

39 Margaret Ruskin to John Ruskin, 27 November 1847, in Brownell, *Marriage of Inconvenience*, p. 128.

40 The few surviving letters from this exchange are ibid., pp. 131 and 137.

41 Euphemia Gray to John Ruskin, 10 February 1847, ibid., pp. 135–6.

42 Suzanne Fagence Cooper, *The Model Wife: Effie, Ruskin and Millais* (London, 2010), pp. 39–40.

43 Ibid., p. 41.

44 Hilton, *John Ruskin: The Early Years*, p. 117.

45 Brownell, *Marriage of Inconvenience*, p. 168.

46 Mary Lutyens, *Millais and the Ruskins* (London, 1967), pp. 188–92.

47 Ibid.

48 Euphemia Gray to George Gray, 7 March 1854, in Lutyens, *Millais and the Ruskins*, pp. 154–7.

49 See Ruskin's use of 'disgust' on p. 53.

50 For example Louisa, Countess of Waterford, Lady Mount Temple, and Thomas Carlyle; see Brownell, *Marriage of Inconvenience*, pp. 179–80; and Duc Dau, 'Perfect Chastity: Celibacy and Virgin Marriage in Tractarian Poetry', *Victorian Poetry*, XLIV/1 (2006), pp. 77–92.

51 Brownell, *Marriage of Inconvenience*, pp. 167–73.

52 Ibid., pp. 73–5.

53 Hilton, *John Ruskin: The Early Years*, p. 178.

54 William Milbourne James, *The Order of Release* (London, 1948).

55 Hilton, *John Ruskin: The Early Years*, p. 130.

56 Ibid., p. 131.

57 Brownell, *Marriage of Inconvenience*, pp. 253–5.

58 Hilton, *John Ruskin: The Early Years*, p. 139.

59 Brownell, *Marriage of Inconvenience*, p. 171.

60 John Ruskin, Berlin, 6 June 1859, published in *The Scotsman* (20 July 1859); in Ruskin, *Works*, XVIII, p. 539.

61 John Ruskin, letter published in *The Times* (30 May 1851), in Ruskin, *Works*, XII, p. 327.

62 Hilton, *John Ruskin: The Early Years*, p. 156.

63 Ibid., p. 170.

64 John Ruskin to John James Ruskin, 27 December 1851, in Mary Lutyens, *Effie in Venice: Unpublished Letters of Mrs John Ruskin Written from Venice between 1849 and 1852*, 2nd edn (London, 2001) p. 249.

65 Euphemia Ruskin to Mrs George Gray, 8 February 1852, in Lutyens, *Effie in Venice*, pp. 265–6.

66 Hilton, *John Ruskin: The Early Years*, p. 158.

67 Brownell, *Marriage of Inconvenience*, pp. 323–4.

68 Ibid., pp. 332–40; John Ruskin, letter published in *The Times* (2 August 1852).

69 Hilton, *John Ruskin: The Early Years*, p. 178.

70 James, *The Order of Release*.

71 Hilton, *John Ruskin: The Early Years*, p. 182.

72 Brownell, *Marriage of Inconvenience*, p. 359.

73 Ruskin and George Gray may have decided that Effie would need to bring this action. Ibid., pp. 425–50.

4 *The Seven Lamps of Architecture*

1 Augustus Welby Northmore Pugin, *Contrasts or a Parallel Between the Noble Edifices of the Fourteenth and Fifteenth Centuries, and Similar Buildings of the Present Day; Showing the Present Decay of Taste*, (Salisbury, 1836), 2nd edn, 1841; A.W.N. Pugin, *The True Principles of Christian or Pointed Architecture* (London, 1841); Rosemary Hill, *God's Architect: Pugin and the Building of Romantic Britain* (London, 2007).

2 Thomas Rickman, *An Attempt to Discriminate the Styles of Architecture in England from the Conquest to the Reformation* (London, 1817).

3 Ruskin, *Works*, VIII, p. 95n.

4 Kevin D. Murphy, *Memory and Modernity: Viollet-le-Duc at Vézelay* (University Park, PA, 2000).

5 Françoise Bercé, *Viollet-le-Duc* (Paris, 2013).

6 John James Ruskin to W. H. Harrison, 25 May 1846, Bodley MS Eng Letts c 32 fol. 243.

7 Mike Rapport, *1848: Year of Revolution* (London, 2009).

8 Suzanne Fagence Cooper, *The Model Wife: The Passionate Lives of Effie, Ruskin and Millais* (London, 2010), p. 50.

9 Ibid., p. 51.

10 Ibid.

11 Eugène Viollet-le-Duc, *Dictionnaire raisonné de l'architecture française du XIe au XVIe siècle*, 10 vols (Paris, 1854–68).

12 Ruskin, *Works*, VIII, p. 22.

13 John Ruskin, *The Seven Lamps of Architecture* (1849), p. 159.

14 Ibid., p. 160.

15 Ibid., p. 59.

16 Ibid., p. 63. Ruskin removed these remarks from later editions because he had not seen Hagia Sophia for himself, and because on reflection there was much else to commend King's College Chapel.

17 Ibid., p. 81.

18 Ibid., p. 66.

19 William Shakespeare, *Hamlet*, Act I, scene 4.

20 Ruskin, *Works*, VIII, p. 66.

21 Ibid., p. 67.

22 M. F. Hearn, ed., *The Architectural Theory of Viollet-le-Duc: Readings and Commentary* (Cambridge, MA, 1990).

23 Ruskin, *Works*, VIII, p. 258.

24 Ibid.

25 Kate Colquhoun, *A Thing in Disguise: The Visionary Life of Joseph Paxton* (London, 2003).

26 Timothy Hilton, *Ruskin: The Early Years* (New Haven, CT, 1985), p. 157.

27 Ruskin, *Works*, XII, pp. 417–32.

28 Christopher Frayling, *Henry Cole and the Chamber of Horrors* (London, 2010).

29 Ruskin, *Works*, VIII, p. 28.

30 Ibid., p. 27.

31 Ibid., pp. 28–9.

32 Ibid., pp. 30–31.

33 Ibid., pp. 39–40.

34 Ibid., p. 190.

35 Ibid., p. 192.

36 Ibid., pp. 193–4.

37 Ibid., p. 197.

38 Kirkpatrick Sale, *Rebels Against the Future: The Luddites and their War on the Industrial Revolution: Lessons for the Computer Age* (Cambridge, MA, 1995).

39 Fiona MacCarthy, *William Morris: A Life for Our Time* (London, 1994); Peter Davey, *Arts and Crafts Architecture* (London, 1997).

40 Leon Battista Alberti, *De re aedificatoria* (1450), trans. Joseph Rykwert, Neil Leach and Robert Tavernor, *On the Art of Building in Ten Books* (Cambridge, MA, 1988); Anthony Ashley Cooper, 3rd Earl of Shaftesbury, *Characteristics of Men, Manners, Opinions, Times* (1711), ed. Lawrence Klein (Cambridge, 1999); Johann Joachim Winckelmann, *Geschichte der Kunst des Alterthums* (1764), trans. Harry Francis Mallgrave, *History of the Art of Antiquity* (Los Angeles, 2006).

41 Ruskin, *Works*, XVIII.

5 Lapping Waves, Living Stones

1 II Esdras 5:5. The books of Esdras are in the Apocrypha.

2 Ruskin, *Works*, XXVI.

3 Ibid., p. 99.

4 Ruskin, *Works*, IX, pp. 3–4.

5 Ibid., pp. 5–6.

6 Ruskin, *Works*, X, p. 10.

7 Ibid., p. 13.

8 Ibid., p. 14.

9 Ibid.

10 Ezekiel 28:13. This verse is an evocation of the city of Tyre, covered in precious stones.

11 Ruskin, *Works*, IX, p. 17.

12 Ibid.

13 Ibid., pp. 26–7.
14 Edward Gibbon, *History of the Decline and Fall of the Roman Empire*, 6 vols (London, 1776–89).
15 Robert Hewison, *Ruskin on Venice* (New Haven, CT, 2009), p. 73; Gibbon, *Decline and Fall of the Roman Empire*, ed. H. H. Milman, 12 vols (London, 1838–9).
16 Ruskin, *Works*, XI, pp. 4–5.
17 Ruskin, *Works*, XVIII, p. 443.
18 Ruskin, *Works*, X, pp. 191–2.
19 Ibid., p. 193.
20 John Ruskin to Pauline Trevelyan, in Virginia Surtees, ed., *Reflections of a Friendship: John Ruskin's Letters to Pauline Trevelyan, 1848–1866* (London, 1979), p. 88.
21 Ruskin, *Works*, X, p. 82.
22 Ibid., pp. 82–3.
23 William Morris, 'Preface', in John Ruskin, *The Nature of Gothic* (Oxford, 1892), p. i.
24 'Pre-Raphaelitism', in Ruskin, *Works*, XII, pp. 338–93; p. 341.
25 Ruskin, *Works*, VI, p. 475.
26 Ibid., p. 19.
27 Ibid., pp. 390–91.
28 Ibid., pp. 388–9.
29 Ibid., pp. 120–24.
30 James David Forbes, *Travels through the Alps of Savoy and Other Parts of the Pennine Chain* (Edinburgh, 1843; republished Cambridge, 2011); Fergus Fleming, *Killing Dragons: The Conquest of the Alps* (London, 2001).
31 Ruskin, *Works*, XXVI, p. 97.
32 Ruskin, *Works*, VI, p. 224.
33 Ibid., p. 318.

6 Reform

1 Timothy Hilton, *John Ruskin: The Early Years, 1819–1895* (New Haven, CT, 1985), pp. 204–5.
2 John Ruskin to William Ward, 1855, Ruskin, *Works*, XXXVI, p. 186 and note.

3 George Butterworth, Diary, MS, Bembridge, 35; cited by Hilton, *John Ruskin: The Early Years*, p. 239.

4 Ibid., p. 241.

5 John Ruskin to Henry Acland, 1855, in Ruskin, *Works*, XVI, p. xlv.

6 Effie married Millais on 3 July 1855, again at Bowerswell. Suzanne Fagence Cooper, *The Model Wife: Effie, Ruskin and Millais* (London, 2010), p. 137.

7 Fiona MacCarthy, *William Morris: A Life for Our Time* (London, 1994), pp. 130–31; Fiona MacCarthy, *The Last Pre-Raphaelite: Edward Burne-Jones and the Victorian Imagination* (London, 2011).

8 Frederick O'Dwyer, *The Architecture of Deane and Woodward* (Cork, 1997), p. 175.

9 Ibid., p. 227.

10 Ibid., pp. 231–57.

11 Ruskin, *Works*, XVI, pp. xlix–l.

12 O'Dwyer, *The Architecture of Deane and Woodward*, p. 251.

13 Hilton, *John Ruskin: The Early Years*, p. 264; Tim Barringer, Jason Rosenfeld and Alison Smith, *Pre-Raphaelites: Victorian Avant-Garde* (London, 2012), cat. no. 77, pp. 104–5.

14 Ruskin, *Works*, XIV, pp. 236–7.

15 Ruskin, *Works*, VII, p. 4.

16 Ibid., p. 458; Genesis 1:3 – the commands at the creation of the world, especially, here, 'let there be light'.

17 Ruskin, *Works*, VII, p. 458.

18 Ibid., p. 458.

19 Ruskin, *Works*, XVII, p. 92.

20 Matthew 20:1–16.

21 Ruskin, *Works*, XVII, p. 25.

22 Ibid.

23 Ibid., p. 31n; and see Ruskin, *Works*, XI, p. 173.

24 Ruskin, *Works*, XVII, p. 105.

25 Ibid., p. 36.

26 Ibid., p. 41.

27 Ibid., p. 40.

28 Ibid., pp. 41–2.

29 Timothy Hilton, *John Ruskin: The Later Years* (New Haven, CT, 2000), pp. 17–18.

30 John James Ruskin to Pauline Trevelyan, 1 January 1861, in Virginia Surtees, ed., *Reflections of a Friendship: John Ruskin's Letters to Pauline Trevelyan* (London, 1979), p. 165.

31 John Ruskin to John James Ruskin, March 1861, in Ruskin, *Works*, XXXVI, pp. 359–60.

32 Hilton, *John Ruskin: The Later Years*, p. 22.

33 Hilton, *John Ruskin: The Early Years*, pp. 262–3.

34 Hilton, *John Ruskin: The Later Years*, p. 99.

35 Ibid., p. 119.

36 Ibid., p. 127.

37 John Ruskin to Joan Agnew Ruskin Severn, 13 July 1869, in Rachel Dickinson, ed., *John Ruskin's Correspondence with Joan Severn: Sense and Nonsense Letters* (London, 2009), p. 115.

38 John Ruskin to Joan Agnew Ruskin Severn, 10 March 1874(?), ibid., p. 182.

39 Hilton, *John Ruskin: The Later Years*, pp. 276 and 343.

40 Ibid., p. 347.

41 The letters were precious to Ruskin, but were destroyed after his death. The wallet is now on display at Brantwood.

42 William W. Gull, 'Address in Medicine Delivered before the Annual Meeting of the British Medical Association at Oxford', *Lancet* (1868), pp. 171–6, followed up by Gull's 'Anorexia Nervosa', *Clinical Society's Transactions*, VII (1874).

43 Hilton, *John Ruskin: The Later Years*, p. 63.

44 John Ruskin to Thomas Carlyle, 23 October 1871, in George Allen Cate, ed., *The Correspondence of Thomas Carlyle and John Ruskin* (Stanford, CA, 1982), pp. 162–3, 217.

45 Hilton, *John Ruskin: The Later Years*, p. 259.

46 Ibid., p. 559.

47 John Ruskin to Joan Agnew Ruskin Severn, 27 May 1886, in Dickinson, *John Ruskin's Correspondence with Joan Severn*, p. 226.

48 Hilton, *John Ruskin: The Later Years*, pp. 253–4; John Batchelor, *John Ruskin: No Wealth But Life* (London, 2000), p. 202.

49 John Ruskin to Charles Eliot Norton, 11 September 1868, in Batchelor, *John Ruskin: No Wealth But Life*, p. 217, n. 79.

50 Hilton, *John Ruskin: The Later Years*, p. 175.

51 Ibid., p. 219.

52 Ibid., p. 561.

53 Ibid., p. 593.

54 Ruskin, *Works*, XXIX, p. 160.

55 James Abbott McNeill Whistler, *The Gentle Art of Making Enemies* (London, 1904); David Craven, 'Ruskin vs. Whistler: The Case Against "Capitalist Art"', *Art Journal*, XXXVII/ 2 (Winter 1977–8), pp. 129–43; Linda Merrill, *A Pot of Paint: Aesthetics on Trial in Whistler v Ruskin* (Washington, DC, 1992).

56 These letters are at the Armitt Museum and Library, Ambleside.

57 Ruskin, *Works*, IV, p. 137n., 'as respects works of higher art, the pleasure of their hasty or imperfect execution is not indicative of their beauty, but of their majesty and fulness of thought and vastness of power'.

58 William Makepeace Thackeray, 'May Gambols; or, Titmarsh on the Picture Galleries', in *Ballads and Miscellanies* (London, 1899), pp. 419–45, p. 440.

59 The letters to the workmen of Great Britain are collected in volumes XXVII–XXIX of Ruskin, *Works*.

60 Ruskin, *Works*, XXIX, 216n.

61 Ruskin, *Works*, XXVI, p. x.

62 Ruskin, *Works*, XXX, p. xliii.

63 Ibid., p. 310.

64 Ibid., pp. 310–11.

7 Influence

1 'The Storm-Cloud of the Nineteenth Century: Two Lectures delivered at the London Institution, February 4th and 11th, 1884', in Ruskin, *Works*, XXXIV, pp. 7–80.

2 Brian J. Day, 'The Moral Intuition of Ruskin's "Storm-Cloud"', *Studies in English Literature*, XLV/4 (Autumn 2005), pp. 917–33.

3 Herman Melville, *Moby-Dick; or, The Whale* (1851), chapter 36, in Herman Melville, *Redburn, White-Jacket, Moby-Dick*, ed. G. Thomas Tanselle (New York, 1983), p. 967.

4 Timothy Hilton, *John Ruskin: The Later Years* (New Haven, CT, 2000), p. 546.

5 John Ruskin, 'The Bible of Amiens' (1884), in Ruskin, *Works*, xxxiii, pp. 4–187; trans. Marcel Proust, *La Bible d'Amiens* (Paris, 1904).

6 Mohandas Gandhi, *The Story of My Experiments with Truth* (Ahmedabad, 1925–8), part ii, chapter 15. The other two were Leo Tolstoy, *The Kingdom of God is Within You* (1893), and Shrimad Rajchandra's poetry.

7 Aylmer Maude, *Tolstoy on Art* (Oxford, 1901), p. 94.

8 Ibid., p. 95n; and see Leo Tolstoy (1897), trans. Aylmer Maude, *What is Art?* (New York, 1901).

9 Phillip Blond, *Red Tory: How Left and Right have Broken Britain and How we can Fix It* (London, 2010).

10 Ruskin, *Works*, ix, p. 70.

11 Further reading: Chris Miele, ed., *From William Morris: Building Conservation and the Arts and Crafts Cult of Authenticity, 1877–1939* (New Haven, ct, 2005).

12 Further reading on Ruskin and architecture: Kristine Ottesen Garrigan, *Ruskin on Architecture: His Thought and Influence* (Madison, wi, 1973); Rebecca Daniels and Geoff Brandwood, eds, *Ruskin and Architecture* (London, 2003).

13 Francesca Orestano, 'Lava Into Crystals: Ruskin's Dark Materials', in *Essays in Victorian Literature and Culture in Honour of Toni Cerutti*, ed. F. R. Paci, C. Pomarè and M. Pustianaz (Turin, 2012), pp. 159–74.

14 Ruskin, *Works*, viii, pp. 12–13.

15 Nikolaus Pevsner, *The Leaves of Southwell* (Harmondsworth, 1945), pp. 63–4.

16 Nikolaus Pevsner, *Some Architectural Writers of the Nineteenth Century* (Oxford, 1972), p. 140.

17 Dirk Van Den Heuvel, 'Alison and Peter Smithson: A Brutalist Story, Involving the House, the City and the Everyday (plus a Couple of Other Things)', PhD thesis, TU Delft, 2013.

18 'Entartete Kunst', www.vam.ac.uk, accessed 1 September 2014.

19 Kenneth Clark, *Ruskin Today* (London, 1964), p. xiii.

20 Lars Spuybroek, *The Sympathy of Things: Ruskin and the Ecology of Design* (Rotterdam, 2011); Lars Spuybroek, 'The Digital Nature of Gothic', in *Textile Tectonics* (Rotterdam, 2011), pp. 8–41.

Bibliography

Primary Sources

The standard edition of Ruskin's works was published in 39 volumes between 1903 and 1912 by George Allen, edited by E. T. Cook and Alexander Wedderburn. This edition is now in the public domain and can be consulted online: www.lancaster.ac.uk/users/ruskinlib/ Pages/Works.html. Two of these 39 volumes (36 and 37) are filled with Ruskin's letters, including his letters to *The Times*, which were public polemics, but he was a prodigious letter writer and diarist, and more personal letters have been collected. The following books have content by Ruskin, but when he was not writing for publication.

Bradley, J. L., ed., *Ruskin's Letters from Venice, 1851–52*
 (New Haven, CT, 1955)
—, *The Letters of John Ruskin to Lord and Lady Mount-Temple*
 (Columbus, OH, 1964)
Burd, Van Akin, ed., *The Ruskin Family Letters* (Ithaca, NY, 1973)
—, *John Ruskin and Rose La Touche: Her Unpublished Diaries of 1861 and 1867* (Oxford, 1979)
—, *The Winnington Letters of John Ruskin* (London, 1969)
Cate, George Allen, ed., *The Correspondence of Thomas Carlyle and John Ruskin* (Stanford, CA, 1982)
Dickinson, Rachel, ed., *John Ruskin's Correspondence with Joan Severn: Sense and Nonsense Letters* (London, 2009)
Evans, Joan, and John Howard Whitehouse, eds, *The Diaries of John Ruskin*, 3 vols (Oxford, 1956)
Hayman, John, ed., *John Ruskin: Letters from the Continent* (Toronto, 1982)

James, William Milbourne, *The Order of Release: The Story of John Ruskin, Effie Gray and John Everett Millais Told for the First Time in their Unpublished Letters* (London, 1948)

Lutyens, Mary, ed., *Effie in Venice* (London, 1965)

—, *Millais and the Ruskins* (London, 1967)

—, *The Ruskins and the Grays* (London, 1972)

Meynell, Viola, ed., *Friends of a Lifetime: Letters to Sidney Carlyle Cockerell* (London, 1940)

Ruskin, John, *Letters of John Ruskin to Charles Eliot Norton*, 2 vols (Boston, MA, and New York, 1905)

Shapiro, Harold, ed., *Ruskin in Italy: Letters to his Parents, 1845* (Oxford, 1972)

Spence, Margaret, ed., *Dearest Mama Talbot: A Selection of Letters from John Ruskin to Mrs Fanny Talbot* (Manchester, 1966)

Surtees, Virginia, ed., *Reflections of a Friendship: John Ruskin's Letters to Pauline Trevelyan, 1848–1866* (London, 1979)

Viljoen, Helen Gill, ed., *The Brantwood Diary of John Ruskin* (New Haven, CT, 1971)

Wilson, Olive, ed., *My Dearest Dora: Letters to Dora Livesy, Her Family and Friends, 1860–1900 from John Ruskin* (Kendal, n.d.)

Books about Ruskin

Individual articles about Ruskin have not been included, but books where Ruskin has a substantial supporting role are listed.

Anthony, Peter, *John Ruskin's Labour: A Study of Ruskin's Social Theory* (Cambridge, 1983)

Ball, Patricia M., *The Science of Aspects: The Changing Role of Fact in the Work of Coleridge, Ruskin and Hopkins* (London, 1971)

Batchelor, John, *John Ruskin: No Wealth But Life* (London, 2000)

—, *Lady Trevelyan and the Pre-Raphaelite Brotherhood* (London, 2008)

Bell, Quentin, *Ruskin* (London, 1978)

Birch, Dinah, *Ruskin's Myths* (Oxford, 1988)

—, *Ruskin and the Dawn of the Modern* (Oxford, 1999)

—, and Francis O'Gorman, *Ruskin and Gender* (Basingstoke, 2002)

Bradley, John Lewis, *Ruskin: The Critical Heritage* (London, 1984)

—, *A Ruskin Chronology* (Basingstoke, 1996)

Brodie, Ian O., *Thirlmere and the Emergence of the Landscape Protection Movement* (Carlisle, 2012)

Brooks, Michael W., *John Ruskin and Victorian Architecture* (London, 1987)

Brownell, Robert, *A Torch at Midnight: A Study of Ruskin's The Seven Lamps of Architecture* (Ardleigh, 2006)

—, *Marriage of Inconvenience* (London, 2013)

Bullen, J. B., *Rossetti: Painter and Poet* (London, 2011)

Burd, Van Akin, Robert E. Rhodes and Del Ivan Janik, eds, *Studies in Ruskin: Essays in Honor of Van Akin Burd* (Athens, OH, 1982)

—, *Ruskin, Lady Mount-Temple and the Spiritualists: An Episode in Broadlands History* (London, 1982)

Buzard, James, *The Beaten Track: European Tourism, Literature and the Ways to Culture, 1800–1918* (Oxford, 1993)

Camlot, Jason, *Style and the Nineteenth-century British Critic: Sincere Mannerisms* (Farnham, 2008)

Casaliggi, Carmen, and Paul March-Russell, eds, *Ruskin in Perspective: Contemporary Essays* (Newcastle upon Tyne, 2007)

Casteras, Susan P., *John Ruskin and the Victorian Eye* (New York, 1983)

Chantler, Ashley, Michael Davies and Philip Shaw, eds, *Literature and Authenticity, 1780–1900* (Farnham, 2011)

Cianci, Giovanni, and Peter Nicholls, *Ruskin and Modernism* (Basingstoke, 2000)

Clark, Kenneth, *Ruskin Today* (London, 1964)

Cockram, Gill, *Ruskin and Social Reform: Ethics and Economics in the Victorian Age* (London, 2007)

Colley, Ann C., *Victorians in the Mountains: Sinking the Sublime* (Farnham, 2010)

Collingwood, William Gershom, *The Life of John Ruskin* (London, 1893)

—, *Ruskin Relics* (London, 1903)

Conner, Patrick, *Savage Ruskin* (London, 1979)

Cook, Edward Tyas, *Studies in Ruskin: Some Aspects of the Work and Teaching of John Ruskin* (Orpington, 1890)

—, *The Life of John Ruskin*, 2 vols (London, 1912)

—, *Homes and Haunts of John Ruskin* (London, 1912)

Cooper, Suzanne Fagence, *The Model Wife: Effie, Ruskin and Millais* (London, 2010)

Cosgrove, Denis, *Geography and Vision: Seeing, Imagining and Representing the World* (London, 2008)

Craig, David M., *John Ruskin and the Ethics of Consumption* (Charlottesville, VA, 2006)

Cruyningen, Rosanne van, *Oscar Wilde and the Influence of John Ruskin and Walter Pater: An Inquiry into the Image of John Ruskin as the Good Angel and Walter Pater as the Bad Angel on Wilde's Shoulders* (Saarbrücken, 2011)

Daniels, Rebecca and Geoff Brandwood, eds, *Ruskin and Architecture* (London, 2003)

Dearden, James S., *Further Facets of Ruskin: Some Bibliographical Studies* (Bembridge, 2009)

—, *John Ruskin's Guild of St George* (Bembridge, 2010)

—, *The Library of John Ruskin* (Oxford, 2012)

Dickinson, Rachel, and Keith Hanley, eds, *Ruskin's Struggle for Coherence: Self-Representation through Art, Place and Society* (Newcastle, 2006)

Downes, David Anthony, *Ruskin's Landscape of Beatitude* (New York, 1984)

Eagles, Stuart, *Ruskin and Tolstoy* (Bembridge, 2010)

—, *After Ruskin: The Social and Political Legacies of a Victorian Prophet, 1870–1920* (Oxford, 2011)

Ellison, David R., *The Reading of Proust* (Oxford, 1984)

Emerson, Sheila, *Ruskin: The Genesis of Invention* (Cambridge, 1993)

Enaud-Lechien, Isabelle, and Joëlle Prungnaud, eds, *Postérité de John Ruskin: L'héritage ruskinien dans les textes littéraires et les écrits esthétiques* (Paris, 2011)

Fenton, James, *School of Genius: A History of the Royal Academy of Arts* (London, 2006)

Finley, C., *Nature's Covenant: Figures of Landscape in Ruskin* (University Park, PA, 1992)

Fitch, Raymond E., *The Poison Sky: Myth and Apocalypse in Ruskin* (Athens, OH, 1982)

Frost, Mark, *The Lost Companions and John Ruskin's Guild of St George* (London, 2014)

Gamble, Cynthis and Matthieu Pinette, *L'oeil de Ruskin: L'exemple de la Bourgogne* (Paris, 2011)

Garnett, Henrietta, *Wives and Stunners: The Pre-Raphaelites and their Muses* (London, 2012)

Garratt, Peter, *Victorian Empiricism: Self, Knowledge, and Reality in Ruskin, Bain, Lewes, Spencer, and George Eliot* (Madison, NJ, 2010)

Garrigan, Kristine Ottesen, *Ruskin on Architecture: His Thought and Influence* (Madison, WI, 1973)

Hamilton, James, *A Strange Business: Making Art and Money in Nineteenth-century Britain* (London, 2014)

Hanley, Keith, and Brian Maidment, eds, *Persistent Ruskin: Studies in Influence, Assimilation and Effect* (Farnham, 2013)

—, and Emma Sdegno, eds, *Ruskin, Venice and Nineteenth-century Cultural Travel* (Venice, 2010)

—, and John K. Walton, *Constructing Cultural Tourism: John Ruskin and the Tourist Gaze* (Clevedon, 2010)

Hanson, Brian, *Architects and the 'Building World' from Chambers to Ruskin: Constructing Authority* (Cambridge, 2003)

Hardman, Malcolm, *Ruskin and Bradford: An Experiment in Victorian Cultural History* (Manchester, 1986)

Harris, Anthony, *'Why Have Our Little Girls Large Shoes?': Ruskin and the Guild of St George* (Bembridge, 1985, revd 2011)

Hayman, John, *John Ruskin and Switzerland* (Waterloo, ON, 2006)

Helsinger, Elizabeth K., *Ruskin and the Art of the Beholder* (Cambridge, MA, 1982)

Hewison, Robert, *John Ruskin: The Argument of the Eye* (London, 1976)

—, *Ruskin and Oxford: The Art of Education* (Oxford, 1996)

—, *Ruskin, Turner and the Pre-Raphaelites* (London, 2000)

—, *Ruskin's Artists: Studies in the Victorian Visual Economy* (Brookfield, CT, 2000)

—, *Of Ruskin's Gardens* (Bembridge, 2009)

—, *Ruskin on Venice: 'The Paradise of Cities'* (New Haven, CT, 2009)

—, *Ruskin and Sheffield: The Museum and The Guild of St George and its Making* (Bembridge, 2011)

Higton, M., J. Law and C. Rowland, eds, *Theology and Human Flourishing: Essays in Honour of Timothy J. Gorringe* (Eugene, OR, 2011)

Hilton, Timothy, *John Ruskin: The Early Years, 1819–1895* (New Haven, CT, 1985)

—, *John Ruskin: The Later Years* (New Haven, CT, 2000)

Homan, Roger, *The Art of the Sublime: Principles of Christian Art and Architecture* (Farnham, 2006)

Hughes, John, *The End of Work: Theological Critiques of Capitalism* (Oxford, 2007)

Hull, Howard, *Demeter's Dowry: Ruskin and Landscape* (Bembridge, 2012)

Hunt, John Dixon, *The Wider Sea: A Life of John Ruskin* (New York, 1982)

Jackson, Kevin, *The Worlds of John Ruskin* (London, 2009)

Kemp, Wolfgang, *The Desire of My Eyes: The Life and Work of John Ruskin* (London, 1990)

Kite, Stephen, *Building Ruskin's Italy: Watching Architecture* (Farnham, 2012)

Landow, George P., *Ruskin* (Oxford, 1985)

Leon, Derrick, *Ruskin, the Great Victorian* (London, 1949)

Macarthur, John, *The Picturesque: Architecture, Disgust and Other Irregularities* (London, 2007)

MacCarthy, Fiona, *William Morris: A Life for Our Time* (London, 1994)

—, *The Last Pre-Raphaelite: Edward Burne-Jones and the Victorian Imagination* (London, 2011)

McGrath, Alister E., *The Open Secret: A New Vision for Natural Theology* (Maiden, MA, 2008)

Maltz, Diana, *British Aestheticism and the Urban Working Classes, 1870–1900: Beauty for the People* (Basingstoke, 2005)

Merrill, Linda, *A Pot of Paint: Aesthetics on Trial in Whistler v Ruskin* (Washington, DC, 1992)

Miele, Chris, ed., *From William Morris: Building Conservation and the Arts and Crafts Cult of Authenticity, 1877–1939* (New Haven, CT, 2005)

Moyle, Franny, *Desperate Romantics: The Private Lives of the Pre-Raphaelites* (London, 2009)

Newall, Christopher, Jeffrey Ian and Christopher Baker, *John Ruskin: Artist and Observer* (London, 2014)

Newey, Kate, and Jeffrey Richards, *John Ruskin and the Victorian Theatre* (Basingstoke, 2010)

O'Gorman, Francis, *Late Ruskin: New Contexts* (Farnham, 2001)

—, *John Ruskin* (New York, 2011)

Penny, Nicholas, *Ruskin's Drawings* (Oxford, 2004)

Pevsner, Nikolaus, *The Leaves of Southwell* (Harmondsworth, 1945)

—, *Ruskin and Viollet-le-Duc: Englishness and Frenchness in the Appreciation of Gothic Architecture* (London, 1969)

Pezzoli-Olgiati, D., and C. Rowland, eds, *Approaches to Visuality in Religion* (Göttingen, 2011)

Porter, Bernard, *The Battle of the Styles: Society, Culture and the Design of a New Foreign Office, 1855–61* (London, 2011)

Quennell, Peter, *John Ruskin: The Portrait of a Prophet* (London, 1949)

Quill, Sarah, *Ruskin's Venice: The Stones Revisited* (Farnham, 2000)

Randall, Linda, *Effie Gray: Fair Maid of Perth* (Ely, 2012)

Robson, Catherine, *Men in Wonderland: The Lost Girlhood of the Victorian Gentleman* (Princeton, NJ, 2003)

Rosenberg, John D., *The Darkening Glass: A Portrait of Ruskin's Genius* (New York, 1986)

Severn, Arthur, *The Professor: Arthur Severn's Memoir of John Ruskin* (London, 1967)

Smith, Shirley Berry, *Illustrious Friends: The Story of Joseph Severn and his Son Arthur* (London, 1965)

Spuybroek, Lars, *The Sympathy of Things: Ruskin and the Ecology of Design* (Rotterdam, 2011)

Sussmann, Herbert L., *Fact into Figure: Typology in Carlyle, Ruskin, and the Pre-Raphaelite Brotherhood* (Columbus, OH, 1979)

Swenarton, Mark, *Artisans and Architects: The Ruskinian Tradition in Architectural Thought* (Basingstoke, 1988)

Trevelyan, Raleigh, *Effie Ruskin and Pauline Trevelyan: Letters to Ruskin's 'Monitress-friend'* (Manchester, 1979)

Tyler, Diane, *Ruskin and the Sacred* (Lancaster, 2012)

Unrau, John, *Looking at Architecture with Ruskin* (London, 1978)

—, *Ruskin and St. Mark's* (London, 1984)

Walton, Paul H., *The Drawings of John Ruskin* (Oxford, 1972)

Weltman, Sharon Aronofsky, *Performing the Victorian: John Ruskin and Identity in Theater, Science, and Education* (Columbus, OH, 2007)

Wheeler, Michael, ed., *Ruskin and Environment: The Storm-cloud of the Nineteenth Century* (Manchester, 1995)

—, *Time and Tide: Ruskin and Science* (Yelvertoft, 1996)

—, *Ruskin's God* (Cambridge, 1999)

Whittick, Arnold, *Ruskin's Venice* (London, 1976)

Wihl, Gary, *Ruskin and the Rhetoric of Infallibility* (New Haven, CT, 1985)

Wildman, Stephen, *John Ruskin: Photographer and Draughtsman* (Guildford, 2014)

Williams-Ellis, Amabel, *The Tragedy of John Ruskin* (London, 1928)

Woodson-Boulton, Amy, *Transformative Beauty: Art Museums in Industrial Britain* (Palo Alto, CA, 2012)

Acknowledgements

I have taken a quick overview of Ruskin's life and work, which would not have been possible without the careful work of other scholars. I have benefited from the research and insight of such biographers as John Dixon Hunt, Tim Hilton, John Batchelor and Robert Brownell. There is a wealth of Ruskin scholarship, and the Bibliography at the end of this book is far from exhaustive. My aim is to give a quick introduction, which will help the reader to find ways into the parts of Ruskin's work that are of most interest. I have dwelled on his childhood and his major works because I think that through them one best comes to understand Ruskin as a person. There is an overwhelming quantity of material about Ruskin's achievements in later life and his influence, which I have not attempted to summarize, but leads to it are to be found in the Bibliography.

Over the years there have been opportunities to present some of the ideas that are included here, and I have been given platforms to speak and publish by Tim Anstey, Solveig Boe, Kati Blom, Hege Charlotte Faber, Carolyn Fahey, Catharina Gabrielsson, Joseph Masheck, Fredrik Nilsson, Brit Strandhagen, Ruskin's concerns with ethics and natural scenery seem to find particular resonance in Scandinavia.

I want to thank the people who made me feel that my project was worthwhile. There are more Ruskin enthusiasts than I realized when I started. They include colleagues and friends, such as David Ellison, Josep-Maria Garcia-Fuentes, Holly Furneaux, Christine Huguet, Juliet John, Stephen Kite, Hentie Louw, Wendy Parkins, Michael Rossington, Richard Sennett, Katie Lloyd Thomas, Anthony Vidler and Bennett Zon.

Brantwood is now in safe hands, under Howard Hull's care, partly a museum, but also a place whose activities promote Ruskin's values.

My visits there have been regular and inspiring, sometimes alone and sometimes in good company. I cherish the memory of visits with Joke Brouwer, Gerard Loughlin, Dietrich Neumann, Lars Spuybroek and Mary Woods.

This book is dedicated to the builders who have had a decisive effect on my wellbeing in recent years. Our dealings have enriched my understanding of Ruskin's analysis of the nature of Gothic.

Photo Acknowledgements

The author and publishers wish to express their thanks to the below
sources of illustrative material and/or permission to reproduce it:

Abbott Hall Art Gallery, Kendal, Cumbria: p. 9; Ashmolean Museum,
Oxford (photo © University of Oxford, Ashmolean Museum): p. 97;
photos by the author: pp. 24, 220; from E. T. Cook and A. Wedderburn,
eds, *The Works of John Ruskin*, vol. III [*Modern Painters*, vol. I (1843)]
(London, 1903): pp. 34, 110; from Cook and Wedderburn, eds, *Works of
Ruskin*, vol. VI [*Modern Painters*, vol. IV (1856)] (London, 1903): pp. 37, 50,
73; from Cook and Wedderburn, eds, *Works of Ruskin*, vol. IX, frontispiece
(London, 1903): p. 150; from Cook and Wedderburn, eds, *Works of Ruskin*,
vol. X [*The Stones of Venice*, vol. II (1853)] (London, 1904): pp. 111, 147, 163;
from Cook and Wedderburn, eds, *Works of Ruskin*, vol. XI [*The Stones of
Venice*, vol. III (1853)] (London, 1904): p. 210; from Cook and Wedderburn,
eds, *Works of Ruskin*, vol. XVI, frontispiece (London, 1905): p. 78; from
Cook and Wedderburn, eds, *The Works of John Ruskin*, vol. XXVI [*Deucalion
and other Studies in Rocks and Stones* (1886)] (London, 1906): pp. 86, 87;
from Cook and Wedderburn, eds, *The Works of John Ruskin*, vol. XXXVI
(London, 1909): pp. 183, 215; from Cook and Wedderburn, eds, *The Works
of John Ruskin*, vol. XXXVIII (London, 1912): pp. 74, 120, 156, 194; from Ada
Earland, *Ruskin and his Circle* (London, 1910), frontispiece: p. 6; photo
Library of Congress, Washington, DC (Prints and Photographs Division):
p. 6; Museum of Fine Arts, Boston: p. 63; National Portrait Gallery,
London (on loan to Brantwood, Coniston, Cumbria): p. 27; Pierpont
Morgan Library, New York: p. 200; from John Ruskin, *The Seven Lamps of
Architecture* [1849], fifth edition (London, 1855): pp. 15, 128, 133, 136, 141,
207; Ruskin Library and Research Centre, University of Lancaster: p. 178;